C000274882

A RE-ENACTOR'S WAR

This book is dedicated to my mother Olive who, like so many, survived bombings, rationing, hard times and occasional happy days. She lived in London, but on call up was posted to Kent.

I also dedicate this book to all the veterans I have met and especially those I have become friends with including James Kyle, Marion Loveland, Ron Walsh, Fred Nicholas, Nick Berryman (the Pilot) and Gordon Berryman (the Guardsman). And to all the re-enactors who dedicate themselves to the ethos of living history. Last, but not least, I dedicate this book to the men, women and children who have suffered and continue to suffer as a consequence of war.

We Will Remember Them

A RE-ENACTOR'S WAR

THE HOME FRONT
REVISITED AND REMEMBERED

JOHN LEETE

Dover/oct. 2013.

To My Son Steve "The Best Re-enactor".
who also helps to keep in mind.
What the 40's were about.
Mum x

The publishers thank the many contributors who have so generously allowed us to use their photographs and stories. We have made every effort to ensure that the material has been correctly attributed. However, we apologise if any acknowledgements have been overlooked. If this is the case then please contact the publishers and we will ensure that the corrections are made for any future printings.

Cover illustrations: *Front*: Re-enactors and a veteran join in remembrance. (Nick Halling collection). *Back, left*: A re-enactor in full kit supports the standards of the Royal British Legion. (Andrew Wilkinson collection); *middle*: A veteran shares his story with a re-enactor. (Ade Pitman collection); *right*: This re-enactor's smile inspires others. (Nick Halling collection)

First published 2012
by Spellmount, an imprint of The History Press
The Mill, Brimscombe Port
Stroud, Gloucestershire, GL5 2QG
www.thehistorypress.co.uk

© John Leete, 2012

The right of John Leete to be identified as the Author
of this work has been asserted in accordance with the
Copyrights, Designs and Patents Act 1988.

All rights reserved. No part of this book may be reprinted
or reproduced or utilised in any form or by any electronic,
mechanical or other means, now known or hereafter invented,
including photocopying and recording, or in any information
storage or retrieval system, without the permission in writing
from the Publishers.

British Library Cataloguing in Publication Data.
A catalogue record for this book is available from the British Library.

ISBN 978 0 7524 6603 3
Typesetting and origination by The History Press
Manufacturing managed by Jellyfish Print Solutions Ltd
Printed in India.

CONTENTS

ACKNOWLEDGEMENTS 7

FOREWORD 9

INTRODUCTION 11

PREFACE 20

1 Their Legacy, Our Responsibility 34

2 'Vagaries of War' 51

3 Digging for Victory 67

4 A Close Shave 81

5 Those Dance Band Days 93

6 With a Song in My Heart 99

7 The Price of Greatness is Responsibility 111

8 'Playing Their Part' 126

9 Notes from a Wartime Diary 132

10 'Soldiers in Tears' 142

11 Friends from Abroad 152

12 The Changing Face of Re-enactment 163

13 'Run Rabbit, Run' 170

14 The Beginning of the End 183

15 Bells Ring Out Across the Land 190

EPILOGUE 212

GETTING INVOLVED 216

ABOUT THE AUTHOR 224

ACKNOWLEDGEMENTS

I would particularly like to thank the Royal British Legion, the National Memorial Arboretum, Helen Patton, Kate Habberley and Paula Kitchen for their help and participation in this project.

My special thanks go to Dame Vera Lynn DBE, LLD, MMUS for her contribution and support. Her enthusiasm, warmth and sincerity continue to inspire post-war generations.

My thanks are also extended to Sir John Kiszely KCB, MC National President of the Royal British Legion for permitting me to quote from the book, *Lest We Forget*, and to Harold Bagshaw and Lewis Ball who were winners of their respective categories in the National Memorial Arboretum's photographic competition and who gave permission for their work to be used in this book.

I thank, too, every veteran, re-enactor and organisation that have made contributions and have assisted in making this title possible.

I would also like to mention Jenny Stevens and the staff of Aldershot Military Museum and www.candaimages.com for their contribution, which includes the front cover image.

Last, but by no means least, I must thank all the photographers who have kindly supplied the stunning images contained in the book. Their work reflects the depth and breadth of Home Front re-enacting and helps to record the value of living history.

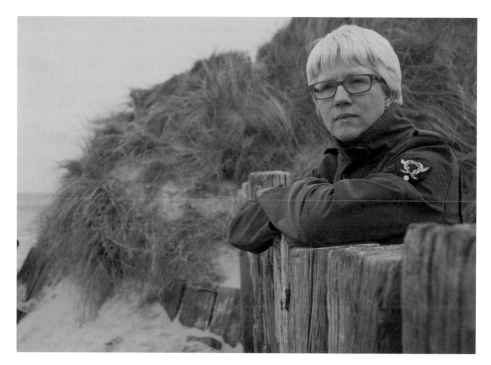

Helen Patton plays a vital role in keeping the legacy of General Patton alive today. Reproduced courtesy of Andrew Wakeford.

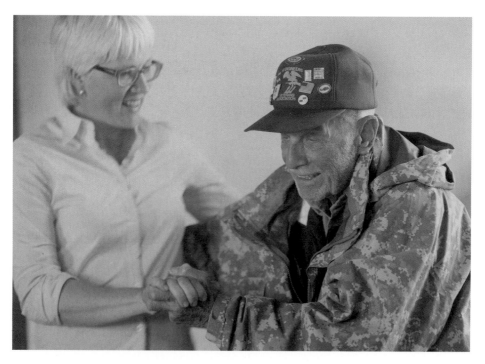

Helen dances with a veteran. Reproduced courtesy of Andrew Wakeford.

FOREWORD

Wear the Uniforms and Insignia with Respect and keep homage as your main purpose for doing so.

Practice Wisdom, Sensitivity and Taste, especially when in the presence of any veteran or active-duty soldier from any army and any generation.

Be Aware that once the last living veteran of the Second World War has departed this earth, your role as the bearer of the history's living flame will no longer be scrutinised by the only persons who have earned the total right to judge your act. Therefore I charge you to hone your methods of keeping one another in check in a stringent yet non-violent way so that those who see *your* witness are transported as near to the truth of what really happened as is humanly possible to experience through re-enactment.

Contemplate your passion for paying tribute through acting the part and accepting that once you make a procession bearing the relics and concrete evidence of conflict, you consider yourselves seekers of an ultimate permanent peace for this war-weary world and guardians of the memory of the future.

Work in Unison with those risking their lives to free others, no less deserving of life, love and the pursuit of happiness than those they liberate, defend or oppose.

Helen Patton
2011

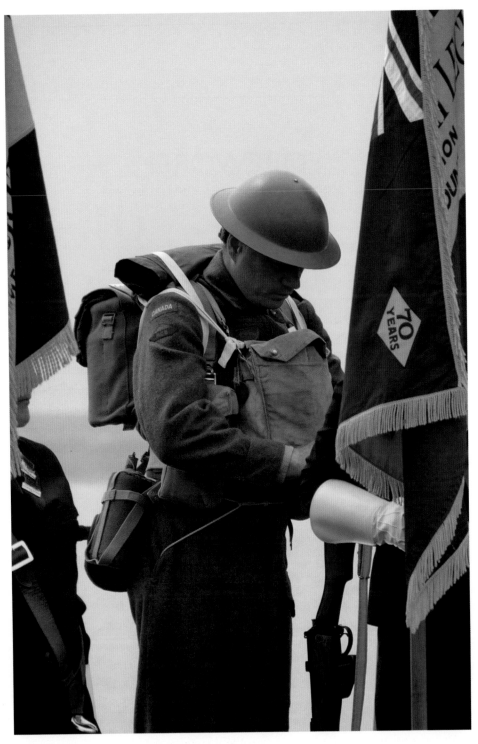

We remember; a re-enactor in full kit supports the standards of the Royal British Legion. Reproduced courtesy of Andrew Wilkinson.

INTRODUCTION

In 2009 it was sixty-five years since D-Day, the Allied invasion into Normandy. In Portsmouth, the city that the Western Allied invasion force set sail from, the Royal British Legion held a picnic event to mark the anniversary. In addition to the thousands of families that turned out in the sun were another group, a group that helped to remind everyone of the year they were marking – the re-enactors. They were there to support the event and the Royal British Legion, and to inform the other visitors of what 1944 Britain was really like. Reminiscent of similar groups in the streets and on the beaches in Normandy, they brought their original vehicles, clothing and artefacts to share with the public and create an atmosphere of celebration and remembrance.

Re-enactors bring aspects of the past back to life in a manner that films and books aren't able to. The Second World War was one of the most decisive conflicts that humanity has experienced. It changed the face of Europe and led to dramatic changes elsewhere in the world. In Britain everyone's lives were affected from the simplest to the biggest things. The war influenced attitudes, music, clothes, cooking and social practices. Whether a person was a child at school, a serviceman or woman, or a grandparent returned to work, life would never be the same again – the war defined all generations. Trying to encapsulate all that for today's world is almost impossible, it can only be done by building a layered picture. One of those layers can be provided by the re-enactors.

The insight that re-enactors can provide into the lives of ordinary people is a valuable contribution to learning about how wars really affect and change society. It

Re-enacting embraces people from all age groups. Reproduced courtesy of Nick Halling.

might be fun to dress in the clothes and to listen to the music, but doing that raises questions of why those fashions were adopted and why certain songs were popular. The clothes were a result of 'make do and mend', the food reflected the shortages and need to make basics stretch, whilst the music carried an air of solidarity, survival and nostalgia for a more peaceful time. All of those things reveal information about the war and its effect on individual lives – all of those things are conveyed by the re-enactors to a new audience. Just look at the pictures in this book to see how that works.

One of the interesting aspects of the re-enactor community is where they are drawn from. Sometimes they are historians working in heritage organisations or museums, but more often than not they are people with non-history-related jobs; they are just people with an interest in the past. They choose to immerse themselves in the character of another period and to learn about that period in incredible detail. They are not paid as experts to know about events, but instead use their own resources to gather information about the detail of the day-to-day world they seek to portray.

Re-enactors give up their own time to learn about historical periods, but importantly also to help others learn about that period. Their enthusiasm for the past is

something they want to convey to present and future generations. For that reason they can play an important role in education. Re-enactors take their enthusiasm out to events, into public areas. They bring history to those audiences that may not be familiar with going to look at exhibits or museums. They attend many of the events that the Royal British Legion organises throughout the year to raise awareness of remembrance and, importantly, who we are remembering.

Re-enactors take great pride in getting hold of original items from the time that still survive. If they can't obtain such originals they create copies that are as close to the real thing as possible. That preservation of items stretches from the small things to the large – visit a re-enactor at an event and they will have as many of the details of what they are portraying as accurate as possible, from the jeep or bus they are sat in to the tie pin or hair clip they are wearing. That preservation of objects is a remarkable contribution to history. It indicates a respect for the lives of the people that experienced those difficult but remarkable times. It also ensures that those details are preserved in a manner that makes them relevant. Observers see how objects were really used, not simply told how they were used. History has a physical reality that re-enactors help us to touch and see. We can see from some of the marvellous photographs that this book contains what life was like, but isn't it fantastic that some people want us still to be able to feel it?

It is not just new generations that the re-enactors speak to, they also speak to the last of the generations from that period that are still with us today. They can provide a link back to that time. That in turn can create an environment where stories are told and information is exchanged. Ordinary people often feel that their experiences or memories are not important or relevant, but actually they all help to build up those layers of the past. Many of the anecdotes in this book are part of building the bigger, truer picture of life in wartime. The many dedicated re-enactors that work across the country can help to create an atmosphere that allows and encourages people to share their memories, even painful ones.

Memories of individual experiences are an essential part of history and of building the historical picture. The twentieth century is the century when it became possible to collect the stories of individuals. The Royal British Legion is dedicated to helping individuals, either servicemen and women or their families. It is not an organisation that only helps those at the top, it is there to stand shoulder to shoulder with all who serve. Over its ninety-year history it has ensured that its membership has somewhere to be supported and valued. The Legion values the way in which the individual contributes to events and in some cases makes the difference between success and failure; it is the individual that makes the ultimate sacrifice and that should be acknowledged.

The spectre of women being called to arms sent shockwaves through the country. From the author's collection.

Across the generations. Reproduced courtesy of Canda Images.

Those individuals create a real picture of the reality of conflict and they should be remembered. The times that they lived through should be remembered and that is often where the Legion and re-enactors come together. During November each year re-enactors can often be seen at events supporting the Legion and collecting money. That money is used to assist the individuals that serve and have served and their families.

However, it is not just in November at remembrance time that re-enactors support the Legion. They attend events up and down the country and abroad – anniversary events, the well-known ones and the less well-known ones, fundraisers and summer fairs. You will see them in the UK and abroad at key events; their dedication to remembering leads them to wherever it is needed.

Throughout the year they can also be seen at events at the National Memorial Arboretum – a dedicated place of remembrance. The National Memorial Arboretum in Staffordshire is managed by the Royal British Legion at a site in the heart of the country. Its purpose is to be a place of national remembrance within Britain that visitors can go to in order to pay their respects. A new visitor, interpretation centre and education building are being planned and built there. A key audience and group of supporters will be re-enactors, who will continue to make a valuable contribution to the developed site.

Pictures of some of the striking memorials at the National Memorial Arboretum are included in this book. They illustrate the beauty yet tranquillity of a place that is dedicated to never forgetting the horrors of conflict. Again it is a place about the people who serve or whose lives are affected by conflict, not about wars themselves. It is a place for individuals to reflect and mourn, but also to celebrate those who have paid the ultimate sacrifice.

The National Memorial Arboretum contains memorials to many groups of servicemen and women and marks the conflicts or campaigns that they served in. Some of those memorials date back to the 1920s and the men killed and injured during the First World War. Other memorials are to conflicts fought overseas and they provide the only UK base for those killed and buried in other countries, sometimes on the other side of the world.

Importantly the National Memorial Arboretum is the home of the National Armed Forces Memorial, the memorial that contains the names of all those who have been killed or died whilst on active service since 1945. Despite no global conflicts since 1945 the panels still look very full and yet there are empty panels ready for more names to be added – and they are added each year.

In today's world the realities of war are not far away. For a service charity like the Royal British Legion, war is not in 1940s Britain, it is now. Men and women are

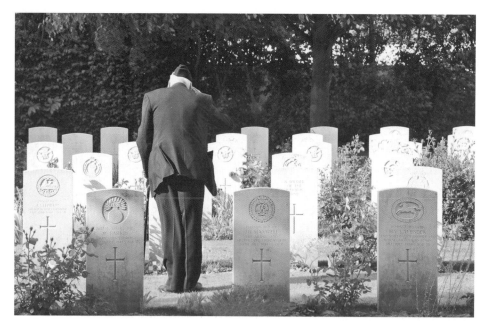

A veteran salutes a fallen comrade; re-enactors salute the fallen and the surviving veterans. This is the core of re-enacting: remembrance. Reproduced courtesy of Ade Pitman.

returning daily from Afghanistan with horrific injuries and memories. The money the Legion raises today continues to support those affected by earlier conflicts, but it is also providing for the very real needs of a new generation of servicemen and women and their families. Just as in the past, today's casualties will need our help for decades to come. It is our job to ensure that they are remembered alongside those who fought in past conflicts.

Whilst the Royal British Legion must make plans for supporting recent veterans and their future needs, it is the communities and individuals like the re-enactors who will help to keep past conflicts relevant. It is the re-enactors who work along-side learning initiatives, including those from the Royal British Legion, supporting remembrance linked to the past.

The pictures and anecdotes in this book are an important record of such remem-brance. For the general public remembering those whose lives are affected by wars is something that happens once a year in November. Remembrance for the Royal British Legion is a daily activity. For those who lived through those experiences or who have family that serve in the armed forces it is a daily reality. A book like this one reminds the general public of remembrance throughout the year. It reminds people of the work that needs to be done all year round for the service community. It reminds us that wars can and do affect our own country and the people who live here.

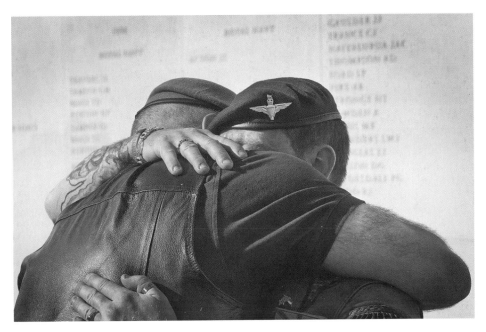

'Comrades in Arms' by Howard Bagshaw. This photograph was awarded first place in the National Memorial Arboretum's 2011 photographic competition, under the theme 'Lest We Forget'. Reproduced courtesy of the National Memorial Arboretum.

'My brother photographs the heroes' by Lewis Ball. Best photograph in the under-11s category of the National Memorial Arboretum's 2011 photographic competition. Reproduced courtesy of the National Memorial Arboretum.

The re-enactors who feature in these pages contribute to remembrance in a unique and valuable way. The dimension they bring to learning should not be underestimated; the support they give to the Royal British Legion is greatly appreciated.

We hope they and all of those who read or look through this book enjoy it. We also hope they learn something about remembrance and an important group of people who are keeping some of the remembrance messages going.

In November and throughout the year re-enactors help to make the remembrance link from the past to the present strong and relevant. Thank you.

The Royal British Legion
2012

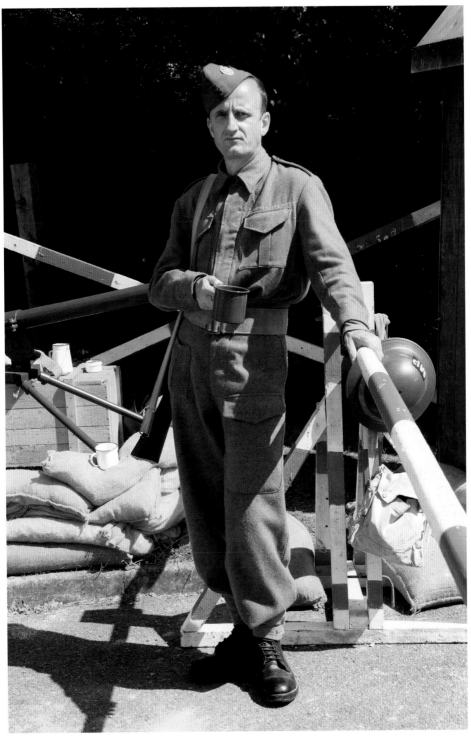

British Home Front re-enacting continues to grow in popularity. Reproduced courtesy of B.J. Wilson.

PREFACE

THE WINDS OF WAR

It was 11.30 p.m. on Saturday 24 August 1940, a few days less than a year since the outbreak of war in Europe, when Ed Murrow, the European Director of Columbia Broadcasting System (CBS), broadcast from Trafalgar Square, London. In the unmistakable tones of this well-known and widely respected reporter, the following message was given:

> This is London, this is Trafalgar Square and the noise that you hear at this moment is the sound of the air raid siren. A searchlight has just burst into action, off in the distance an immense beam sweeping the sky above me now. People are walking along very quietly. We are just at the entrance to an air raid shelter here and I must move the cable over just a bit so people can walk in.

The broadcast continued with details of that evening's events as they unfolded and it was noticeable to many listeners that Mr Murrow was becoming totally immersed in the plight of the city, its people and the country as a whole. Britain was at war and Ed Murrow wanted to ensure that 'the folks back home' knew exactly what this meant.

'London After Dark' was a series of radio broadcasts in the United States, which for the first time took the listener to war, the war that would spread through Europe

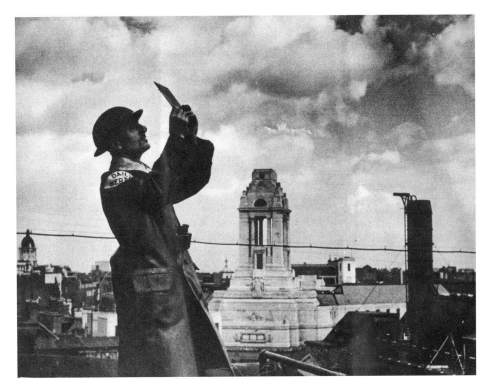

An aircraft spotter on the roof of the offices of the *Daily Herald* keeps watch during an air raid. From *Illustrated London*, 5 October 1940, author's collection.

and eventually involve America and the rest of the world in a devastating fight for the freedom of that generation and for generations to come.

The bombs dropped by the enemy during the air raid of 24 August were let go by accident; it wasn't until two weeks later on 6 September that the attempted total destruction of London and other cities around the country began when 300 German bombers accompanied by over 500 fighters flew over the capital. This, many believed, was the prelude to the invasion. However, Hitler had abandoned his plans to invade and instead opted to terrorise the nation into submission through the bombing campaign, a campaign that had been honed by his Luftwaffe pilots during the Spanish Civil War when mass bombing of the civilian population had proved 'effective'.

By the Christmas of 1940, Ed Murrow's broadcasts reflected a greater affinity with the British people, as his early frustrations at the seeming apathy of the general population changed to an admiration for their stoicism in the face of adversity and the matter-of-fact way in which those affected by the impact of daily raids coped with their plight. His New Year 1941 broadcast, for example, included the following:

You will have no dawn raids, as we shall probably have if the weather is right. You may walk this night in the light. Your families are not scattered by the winds of war. You may drive your high powered car as far as time and money will permit.

Meanwhile, a 'new kind of courage' had emerged across Britain, with tales of brave acts being published regularly in local newspapers, many usually associated with dealing with an unexploded bomb or putting out an incendiary fire that was a risk to life and limb. Air-raid wardens became heroes within the communities that they served. Improvisation was another word for survival with, in particular, medical care and meals available almost 'out of thin air' when the need arose. Rest centres, public information points, emergency hospitals, clothing and furniture depots, air-raid shelters, emergency fire stations, ack-ack and balloon sites and so much more were becoming part of the landscape and part of the whole new 'culture' that life on the Home Front was to embrace if it was to survive. People helped each other as best they could, everyone became aware of the different periodicity of the sirens, the sound of different types of bombs, the boom-boom of the anti-aircraft guns, the sounds of friendly and enemy aircraft, the noise of the barrage balloons as they lifted off from their moorings, which like the guns were scattered across cities and towns, and the unusual but comforting light of the searchlights as they pierced the night sky and picked out enemy aircraft. People quickly became familiar with the many leaflets and posters explaining and showing the difference between British and German uniforms, reminding them to report any 'suspicious or strange characters' to the authorities. Children were separated from their parents and quickly had to adapt to a new way of life:

Dear Mummy

Have you had many air raids there, the all clear has just gone and the warning went just before tea. We had tea in the dugout and we kept sitting on top of it and as soon as we were on top a German aeroplane came over us. Yesterday Mrs White did not know that there was an air raid and Jim told her so she gave him some raspberries with custard on them. Elsie heard the siren first today.

Lots of love and xxxxxx from Jean

Jean Strechlau

Just one of the many hundreds of different posters giving guidance and instructions to the public. From the author's collection.

Special passes were issued to GPs so that they could travel relatively freely to serve their patients. Reproduced courtesy of Brian Hutchings.

Men and women were being called up to serve the nation by taking on roles in addition to those in the armed services. These included roles such as air-raid wardens, Land Army and Timber Corps teams, nurses, housing officers, Ministry of Food representatives, billeting officers, entertainers, munitions workers, aircraft production workers, construction gangs and special constables. In fact, some accounts suggest that by the end of the war over 3,000 new 'roles' had been created in the public services. The Women's Voluntary Service (WVS), established in 1938 in preparation for war, now came into its own; such was its wide and varied remit that it was said by a government minister: 'If no one else can do it, the women of the WVS can.' Indeed, as the war progressed, so too did the remit of the WVS for they became an integral part of the nation's social infrastructure, culminating in their stoic efforts just ahead of D-Day when they helped to pack personal equipment for the troops in record time. They were also celebrated for putting their lives on the line to help others:

In 1940 I was eight years old. My mother, father, brother and I had been to my aunt in the country for a weekend, on returning home late on the Sunday afternoon, we were confronted by soldiers on guard stopping anyone passing beyond that point. My father explained that our house was beyond that point. A soldier reluctantly let us through. When we reached our house, two WVS appeared from nowhere and told us that we must be quick as there were time bombs, one being in our back garden, and that these could explode at any time. They helped us get as many possessions out of the house as we were able.

Although I was young I can remember those two women so clearly – that they were actually risking their lives to help us, without a second thought.

Gladys Holloway, Edgware, Middlesex

So after the mass evacuation of children and other designated persons at the outbreak of war, the internment of 'aliens' and the ramping up of the government's 'voice to the people', also known as the propaganda machine that was the Ministry of Information, came the other harsh realities of a blacked-out Britain with vehicle accidents increasing because of the use of 'dim light', the carrying of gas masks, the rationing and the inevitable parting of loved ones who went off to war, be it firefighting in the streets on the Home Front, training in some far off military camp or by being shipped abroad. Then there were the scenes of destruction, the bodies at the side of the street – if the street could be recognised after a night of bombing – the sudden death of those you knew, the sight of apparently uninjured corpses, devoid of clothing, killed by the blast of a bomb:

I had been on duty for over sixteen hours when I was told to report to the hospital which had been hit. I knew that fortunately it had not been too badly damaged, but some of the patients had to be moved to a makeshift centre and along with a mixed group of off duty soldiers, some firemen and a police officer, I helped to shift nearly two dozen patients. A young girl of about ten years of age was sitting in one of the beds and although she had a bandaged head she was smiling and told me that this was a bit of an adventure. When she was taken out of the bed to be put on a stretcher, it became apparent that she only had one arm. She had been injured in an air raid and had lost her sister, her aunt and her mother. For all that, this courageous little child was smiling. Several days later I broke down in tears, the cruelty and courage in

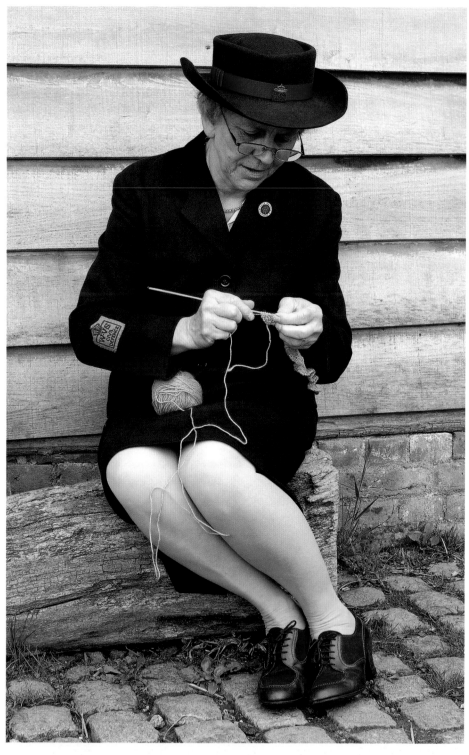

Knitting woollens for the troops, the work of the Women's Voluntary Service is never done.
Reproduced courtesy of B.J. Wilson.

war hit me hard and to this day I remember that little girl and wonder what became of her. In war you often see situations just for a moment, but the memories stay with you for a lifetime.

Roger Elliot, Wolverhampton

So now you are at war, you have a whole new way of doing things, you must adapt to survive. What, before the war, was done by instinct was now something you had to think about, consider what options if any were open to you and what the consequences of your decision might be. The bus may not be running today, the mobile information centre isn't due until the end of the week, you can't telephone relatives because the local call box has been locked up, the letter you want to post will have to wait until you find out if the post office is still open.

Apart from the day-to-day challenges, it was also your job to make sure you knew all the rules which had been introduced in number since the outbreak of war. You had to know how and when to use a stirrup pump, how to remove an incendiary

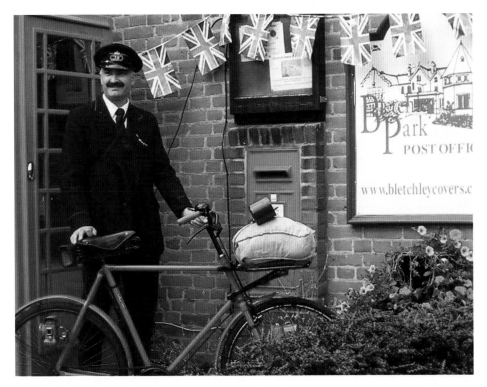

The postman often faced the challenge of getting the mail through the morning after an air raid. Reproduced courtesy of March Re-enactors.

bomb with a shovel and how to recycle almost everything. You had to carry your gas mask at all times. The neat little case could also be used for your ration books, identity cards and a packet of cigarettes, so at least that was jolly useful. But the never-ending raft of rules seemed to envelope everyone to the extent that, quite quickly, it became second nature to follow them. After all, whilst many considered them patronising, most realised that the rules were born out of necessity rather than desire. Newspapers, usually no more than half a dozen pages in size, were censored of course, yet included items or, as some called them, 'joyful snippets' about animals, screen stars, radio programmes and anything else that might 'take one's mind off the war' for a while. Advertisements for products, which in some way would help you through the war, appeared in magazines such as *Picture Post*. These included adverts for lauding the satisfying and calming taste of a cigarette, laxatives that would help those 'tummies' that still couldn't get used to the content of a changed diet, or a pair of shoes that would help you walk your way to happier times.

'Mr Carrot' and 'Potato Pete' helped with the propaganda campaigns associated with rationing and how to get the best from less. Spam (spiced ham) arrived from America and the National Loaf was introduced in April 1942, but there were no onions, no bananas and no oranges, except the odd ration of fruit for the children. 'Bundles for Britain' arrived from Canada, Australia and the United States and were distributed by the WVS. Bombed-out mothers were given priority for these food parcels. You never went to the seaside because almost all the beaches were covered in barbed wire, but you could join in an open-air dance in one of the parks that were still available for public use, rather than being closed off as a prohibited military area. Girls spent their holidays on farms, helping with the harvest whilst soldiers on leave took many baths and slept. However, there was still that endless stream of exhortation from the government: 'Careless Talk Costs Lives', 'Lend a Hand on the Land', 'Buy War Bonds' and an irritating cartoon character, 'Billy Brown of London Town', who advised 'Coughs and sneezes spread diseases' and perhaps the lesser known 'I trust you'll pardon my correction, that stuff is there for your protection' referring to the protective tape on the windows of Underground trains. The tape was removed by passengers who simply wanted to know which station they had arrived at.

One way of taking your mind off the crazy world that was now holding you in its clutches was to do 'what you could' for your country by simply expanding your hobby. For example, knitting socks and scarves for the servicemen and women was a pastime enjoyed by many, as was 'digging for victory' in allotments and gardens throughout the land. Fundraising also became a national preoccupation and there was a bewildering choice of local and national causes, all well worthwhile and all in

...the cart before the horse

"THE Government tell us to eat potatoes and cheese because there are such lots of them." You've heard that remark? Well, it's rather putting the cart before the horse!

These good supplies did not come by accident. The Government planned for them. Why potatoes and cheese? Because these two foods are the solid foundation of a balanced diet — the sort of diet which keeps you right up to the top of your form — fighting fit. And that's how we all need to be these days.

So make the most of potatoes; and always take up your full ration of cheese. Potato Pete's Recipe Book (free on receipt of postcard to Ministry of Food, Room 625H, London, W.1.) tells you of many inviting ways of using these excellent foods. Meantime . . .

——— JUST TRY THESE ———

POTATO PASTRY. This can be used for sweet or savoury dishes. Mix 4 oz. flour with ½ teaspoonful of salt, rub in 1 oz. cooking fat, then add 8 oz. cooked potato and rub lightly into the other ingredients. Mix to a very dry dough with a small quantity of cold water. Knead well with fingers and roll out.

EGG AND BACON PIE. Make 8 oz. potato pastry and line a pie plate with half. Beat one reconstituted Dried Egg and mix with ½ oz. stale breadcrumbs, 2 rashers of grilled bacon, chopped. Pour mixture on to the plate, cover with rest of pastry and bake in a moderate oven for ½ hour.

CHEESE FRY. Melt a little fat in a frying pan; press into it, pancake shape, some mashed potato seasoned with salt and pepper. Sprinkle a good thick layer of grated or shredded cheese on the top, and continue cooking until the cheese is softened. Turn out whole with a broad-bladed knife on to a hot plate. Chopped watercress or parsley is an appetising addition to the mashed potato.

POTATO SOUP. Scrub, peel and slice 1½ lbs. potatoes and a stick of celery. Place in 1¾ pints boiling salted water or vegetable water, cook with the lid on until soft. Rub through a sieve or mash well with a wooden spoon. Add 1 teacupful of milk or household milk, salt and pepper to taste, and reheat but do not reboil. Sprinkle in two tablespoonsful coarsely chopped parsley just before serving.

ISSUED BY THE MINISTRY OF FOOD

(S48)

'Digging for Victory' was a major part of the government's Home Front strategy. From *Home Notes*, 7 November 1942. From the author's collection.

need of support. 'Spitfire Week', 'Red Cross Week', 'Warship Week' and 'Wings for Victory' were but a few of the national appeals, whilst local country parishes asked their congregations to raise money to feed and clothe orphans and refugees:

> To raise money for the wounded Soldiers, Sailors and Airmen Association, my mother would organise concerts at Poolmouth chapel. The women used to meet at each other's houses to knit gloves and balaclavas for the troops. I used to collect old bone and pieces of metal for the war effort, I even had a special badge[1] which enabled me to go into people's garden to hunt.
>
> Graham Roberts, Crewe

Then, of course, there was dancing. Theatres, dance halls and cinemas had been closed at the outbreak of war, but were soon re-opened in recognition of the fact that the value of entertainment in terms of morale boosting was far greater than

A community affair, raising funds for one of the many wartime appeals. Reproduced courtesy of Robert Baker.

1 It is likely that Graham was a member of COGS, the organisation set up by the WVS and comprising of children who volunteered to collect scrap.

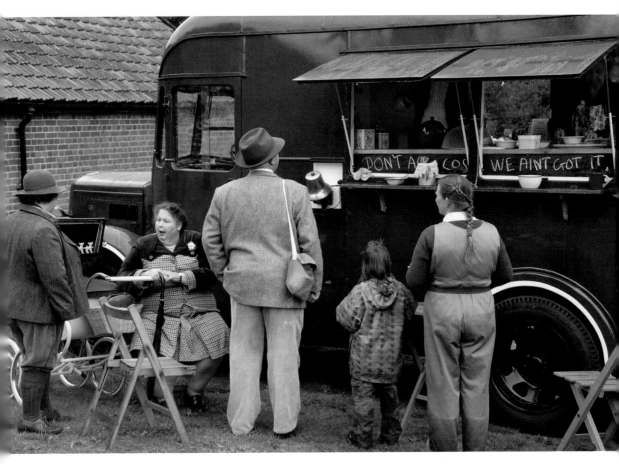

Always time for a cuppa, the nation's favourite beverage. Reproduced courtesy of Gressenhall farm.

anything the government could 'dream up'. Dancing – whether it was in the open air or in a proper dance hall of which there were many hundreds at the time in army huts, canteens, church halls and barns – became the most popular 'home-made' entertainment of the war. The radio, impromptu music by anyone who could play an instrument, a sing-song around the pub piano and going to the 'flicks' (the cinema) were all part of the wonderful tapestry of things to do to raise the spirits and to take your mind off your troubles, well for a few hours anyway:

Our local hall in the village was very popular with the Americans who were based at a camp about five miles away from about the third year of the war. Almost every Saturday there were dances and the lads come down in about three or four lorries to meet the girls and to have a good time. None of

us knew what was in store for us so you enjoyed the moment. We had no alcohol, but instead made do with squash and home-made ginger bear and we danced to a band that the village shopkeeper had put together with about six or seven people and there was a girl singer, Rose, who had a lovely voice. I wonder what happened to all of the people who spent their wartime Saturday evenings at the hall.

Elizabeth (Betty) Martin, Australia

Our knowledge today enables us to take a more considered view of life in the 1940s and, although we cannot fully understand how the people met and overcame the challenges they faced, we can appreciate the fact that despite the adversity, the human spirit persisted against the odds. This was helped in no small way by the morale-boosting cornerstones of music, dance, song, camaraderie, communities pulling together and by sheer 'guts and determination':

We believe individual liberty, rooted in human dignity, is man's greatest treasure. We believe that men, given free expression of their will, prefer freedom and self-independence to dictatorship and collectivism.

General Dwight D. Eisenhower

Now, many decades after the end of the Second World War, in a new century, we face new challenges and conflicts. In this climate it would be easy and understandable to forget the extreme challenges, conflict and hardship experienced by the generation who fought to ensure a free and just society here in Britain and in countries throughout the world. We are the beneficiaries of the sacrifice made by men and women during the years of 1939 to 1945. Whilst people still engage in conflict in many parts of the world, thankfully a global war has been avoided and the freedom most of us enjoy is a lasting legacy that we must rightly attribute to the heroes of yesteryear. However, as the years pass, many will be less aware of significant historic dates such as those of Dunkirk, the Battle of Britain and the Normandy campaign. The Normandy campaign, which began with the invasion of Europe on D-Day 1944, was to herald the final phase of the Second World War, at least in Europe. The war years saw change on a vast scale, in engineering and technology, in lifestyle and in human relations, yet we know, of course, that the surviving wartime population wanted to move forward and further away from the years of

'blood, sweat and tears'. Despite this, they could never imagine the legacy that they have left for us.

What relevance, though, to post-war generations and the generations of the twenty-first century does the Second World War have and what tangible evidence is there that the spirit of remembrance lives on? Well there are parades and services as well as the dedication of new memorials. Perhaps, crucially, there remains the telling of personal stories from those who endured life in the armed forces and on the Home Front. Re-enactors actively support veterans, service charities and many other activities such as those described. We are indebted to those individuals and groups of today's generation who help to keep the spirit of remembrance alive through word and deed, and through a desire to ensure we never forget the legacy of those who served and those who perished for our future. No more clearly is the message of remembrance spoken than by the increasing numbers of re-enactors who portray the life and times of civilians and service personnel during the 1940s.

With this in mind, in this book we take a journey of discovery through conversations with veterans, contrasted with anecdotes from some of those who carry the message forward. It is a medley of chapters devoted to personal wartime experiences and others reflecting on the place of re-enactment in the modern world.

Whilst here we are giving a considered synopsis of Home Front re-enacting in the United Kingdom, we are happy to acknowledge the portrayals by other groups and individuals that dedicate themselves to re-enacting, for example, the Red Army, the Axis forces and the many other Allied and Commonwealth services.

A Re-enactor's War simply offers a snapshot of the war years and how the spirit of the time continues to influence the re-enactment community today. It offers an insight into what it means to re-enact and why re-enactors are dedicated to ensuring that we remember and honour the experience of past generations:

It is my earnest hope that pondering upon the past may give guidance in days to come, may enable a new generation to repair some of the errors of former years and thus govern in accordance with the needs of man, the awful unfolding scene of the future.

Winston Spencer Churchill

1

THEIR LEGACY,
OUR RESPONSIBILITY

It's one thing to 'dress the part' and another to 're-enact'

In June of every year on the Anniversary of D-Day, what is known as the friendly invasion, takes place. Where once the machinery of war rumbled and the boots of a powerful army fell heavy on the soil, ambassadors of peace now march on the beaches and in the streets and the lanes of the Normandy countryside.

This is, unashamedly, a time of great pride and patriotism, yet a time still undeniably burdened with memories of lost comrades, fallen friends and family members who perished on the all too fragile, Home Front.

'Titch' Taylor, retired journalist, living in France

Life on Britain's Home Front during the Second World War, as portrayed in television programmes and in films, whilst informative and whilst giving fairly comprehensive accounts of daily life under fire and under duress, does not always 'register' with today's generation. However, anecdotal evidence, particularly to schoolchildren, helps to make history a more interactive subject, and it is to the re-enactor that many organisations turn for a more 'realistic' presentation of our heritage.

Whatever role a re-enactor chooses to portray, be it a serviceman, a service-woman or a civilian, the usual 'starting point' is to make sure that they have a very

An example of the fashion of the era. Reproduced courtesy of Nick Halling.

School days were often divided up to cope with an influx of evacuees. Reproduced courtesy of Manor Farm.

good understanding of their character. It is one thing to 'dress the part' and another to be able to 're-enact' the person convincingly in front of the public and, more importantly, in front of the veterans.

Living history probably first came to the public's attention when the Sealed Knot civil war society and the Ermine Street (Roman) Guard began appearing at events around the country. Their authenticity, attention to detail and sheer enthusiasm won plaudits and a substantial following. Meanwhile, a number of history-themed visitor attractions employed guides dressed in appropriate period costume and the public became enthralled by this new experience of history 'coming to life'.

Other periods of history then began to be portrayed by individuals and groups with an affinity for a particular era, a social theme or event. In turn they found a niche and enjoyed success with ever-growing audiences. Now, amongst the most popular living history portrayals are those depicting characters from Britain's Home Front. This popularity is being bolstered by a revival of interest in that period of history and a remarkable about turn in the nation's desire to remember the wartime generation and the sacrifices they made. In tandem there has also been a marked revival of interest in the music, song and dance of the period, and new audiences are being attracted to classic wartime black-and-white films. Additionally there has been considerable emphasis on retro and vintage clothing and memorabilia in the fashion and decorative arts, and this has inspired a generation to become collectors, or rather caretakers, of 1940s ephemera.

Demand for re-enactors to support events, both public and private, has increased year on year, as has the recognition of the knowledge and dedication that re-enactors have both relevant to their portrayals and their reasons for 'turning back the clock' to a bygone era. The diverse mix of people involved in re-enacting come from all walks of life and all backgrounds, and the majority have but one aim. That is to take forward the spirit of remembrance. It is the accuracy and the empathy that the majority of re-enactors have for their craft that has gained them so much applause and respect from the public and indeed the veterans they meet and support:

The Home Guard portrayal is based on my grandfather who was in the Home Guard in Birmingham and although my family has quite a lot of information about him, I checked up on the protocols used by the service in that area. As with all service personnel either Armed Services or Home Front Emergency Services, it's important that your portrayal is based on actual events and procedures in each theatre of operation. What was an acceptable protocol based on the local situation in Edinburgh for example may not have been the recognised

procedure in Bristol. So research the people involved and the circumstances relevant to their role. Don't forget that many procedures and methods of operation were issued as guidelines by the Authorities and it was the responsibility of the local controlling bodies to adapt those to prevailing conditions in their own areas of operation. With the Red Cap portrayal, I contacted the RMP Museum which I think was in Chichester at the time[2] and they were very helpful. There are also some good inexpensive books about military police.

Mike Carter, who portrays Home Guard and Redcap

In the first instance many re-enactors turn to the internet to research their chosen 'character' and the period in general; however, other useful resources include libraries and branches of the Royal British Legion, whilst service specific museums and research facilities will almost always be a good choice towards achieving a successful outcome. By the way, a 'Letter to the Editor' of local newspapers appealing for information is a tried and proven way of reaching some very useful contacts and for securing anecdotes from people who lived through the war. There are a large number of re-enacting groups throughout the United Kingdom and most are very happy to receive enquiries about kit, protocols and training opportunities associated with their specific portrayals. However, more and more groups are diversifying and have members portraying a mix of civilian and service personnel, as well as a variety of Allied and Axis forces, so their knowledge base can be quite broad rather than specialised.

There are many established and many 'new' portrayals within the Second World War re-enactment community, so consider the following, by no means exhaustive, list: vintage photographer, shopkeeper, postman, vicar, singer (if you have the voice for it), dancer (if you really want to get into the swing of living history), musician (ENSA) – yes, the ukulele is possibly the best instrument to start with – RAF, British and American army, USAAF (United States Army Air Force), Royal Navy, Merchant Navy, Royal Marines, Fleet Air Arm (of which I have only ever seen three portrayals), Home Guard, housewife, WVS (Women's Voluntary Service), ARP (air-raid precaution warden), fire warden, policeman, ambulance orderly, evacuee/schoolchild, newspaper correspondent, newsreel cameraman, BBC reporter, 'pin-up' – in the style of Jane Russell or Patricia Roc, perhaps – Ministry of Food officer, billeting officer, WAAF (Women's Auxiliary Air Force), ATS (Auxiliary Territorial Service),

2 The RMP Museum is now at Southwick Park, near Fareham, Hampshire.

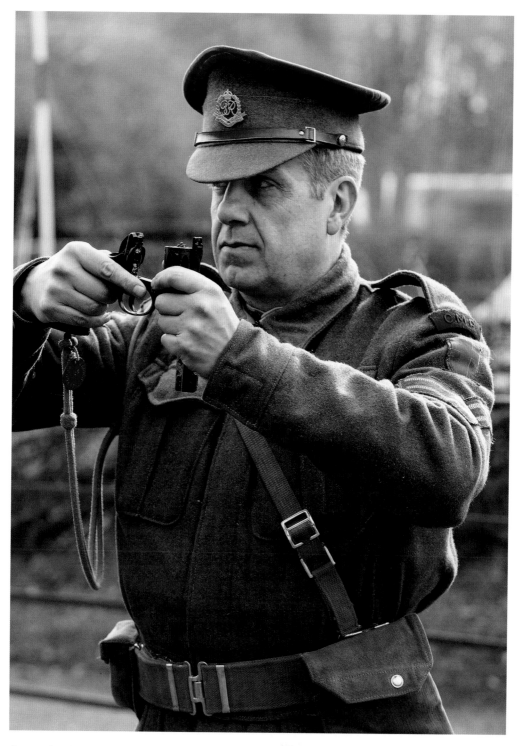

An eye for detail, one of the attributes of being a military policeman (Redcap). Reproduced courtesy of Nick Halling.

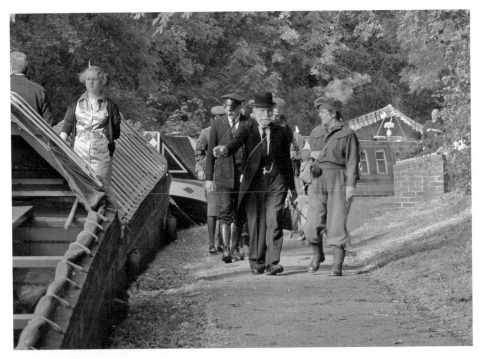

Working the waterways was an essential task. Reproduced courtesy of SBCM.

military policeman (MP) or provost, Red Cross nurse, NAAFI (Navy, Army, Air Force Institute) staff, Royal Observer Corps and spivs:

> As far as possible, re-enactors present themselves to the highest standard at all times. Anything less than that would be an insult to the veterans and to the legacy of the people they are portraying.
>
> Oliver Tobias, Film Producer

By adding period photographs, ephemera and personal items, the re-enactor can create an authentic story about their character. For example, a wallet or purse could contain a period bus ticket, a cinema ticket, some photographs, a book of stamps (reproductions are available), some paper money (original and reproductions widely available) and so on. Whenever possible, many re-enactors purchase original and authentic uniforms, usually to add to their personal collection of wartime memorabilia. The average size of wartime uniforms was smaller when compared to today's sizes and so 'modern man and woman' often simply cannot squeeze into old kit.

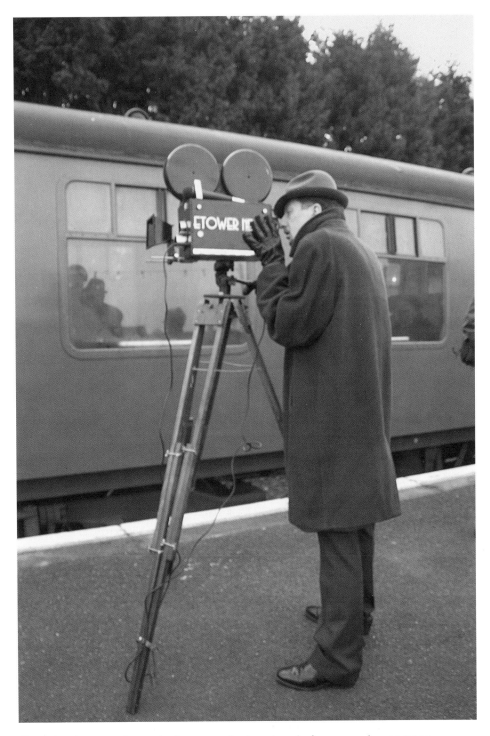

Capturing the scene for posterity, an excellent portrayal of a newsreel cameraman. Although film was scarce, it was put to good use for propaganda purposes. Reproduced courtesy of B.J. Wilson.

NAAFI, the mainstay for the armed services on the Home Front. Reproduced courtesy of Simon Thomson.

That said, however, from time to time larger sizes are found and promptly snapped up by avid re-enactors who will wear the kit for special occasions. There are many good reproduction uniforms available, although original 'correct pattern' personal equipment and artefacts are easier to obtain than uniforms are. Family portrayals are becoming more popular, with the children taking the role of evacuees, mother perhaps as a WVS, with dad home on leave from the services. From a young para-trooper to a member of the Home Guard, an ARP warden to a firefighter and a member of the ATS to a nurse, there is a place for you and you will be made very welcome. However, a word of caution:

> The world of re-enacting does not appreciate '18 stone paratroopers' and '20 year old Colonels' because it reflects badly on the vast majority who, having researched their portrayals thoroughly, also match their age with their portrayals to ensure authenticity and credibility.
>
> Paul 'The Cad' Lewis

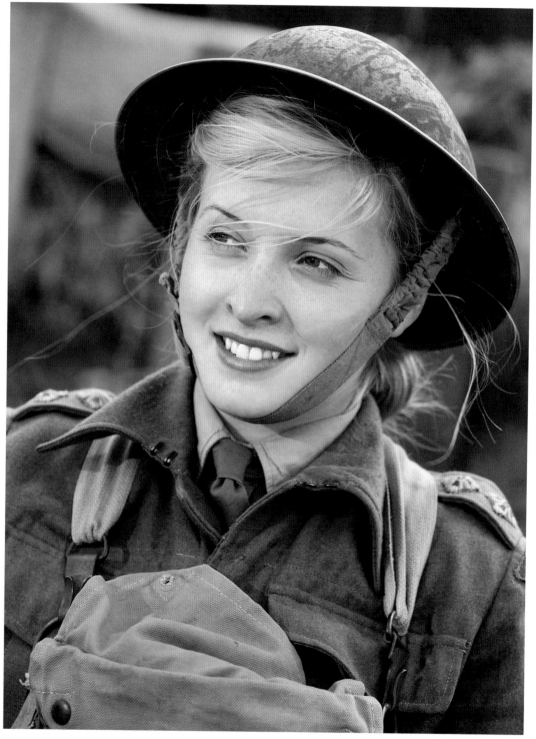

Like many who had their photographs taken for wartime propaganda, this re-enactor's smile inspires others. Reproduced courtesy of Nick Halling.

A not untypical family photograph. All the boys in the Kemp family served in the armed forces. Barbara was later to marry a GI who had been based in the United Kingdom. Reproduced courtesy of Barbara Ashton.

Nik Wyness of the Tank Museum sums this up perfectly:

> **Well led and self-regulating re-enacting groups have become trusted partners of organisations such as The Tank Museum. With high standards of professional conduct and historical accuracy, they are intolerant of those who are insensitive or irresponsible in their portrayals.**

Those engaged in living history do so with the utmost respect for and gratitude to all those who served during the Second World War. Many re-enactors have family members who lost their lives serving in the armed forces and therefore that respect is all the more heartfelt. One of the privileges of being a re-enactor is the invitations to attend veterans' events, including those organised by the Royal British Legion and others services charities. In the past twenty years or so, like many of my fellow re-enactors, I have been involved with these functions and events. For my part, these include supporting the Landing Craft Association and the Parachute Regiment, the

Chelsea Pensioners and the D-Day Map Room, police forces and fire services, local authorities, museums and visitor attractions. Re-enactors also instigate and enjoy supporting educational projects and events at schools and assisting with the making of documentary programmes and films:

> One of the many enjoyable aspects of re-enacting is when we attend educational events at schools and assist with the making of documentary programmes and films. I have been directly involved in seven documentary programmes, at least 12 educational programmes and in excess of 50 commemorative events. But being with the veterans is the most memorable experience.
>
> Gary Webbern

The provost occasionally took on traffic control duties, much to the obvious amusement of this GI. Reproduced courtesy of Canda Images.

When questions are asked by the public, re-enactors 'come into their own' and welcome the opportunity to explain who or what they are portraying, what relevance that portrayal has and why they have chosen that specific role. After all, unless the portrayal is explained, then the purpose of re-enacting is lost. For a time, I portrayed a veteran friend of mine, Flight Lieutenant James (Jimmy) Kyle DFM with whom I had also worked on documentary programmes. Jimmy flew with 197 Typhoon Squadron from airfields including Drem and Tangmere, and one of his aircraft, IB JP 682, was commemorated by the issue of a postage stamp, several paintings and has been widely featured on television and in the media. Jimmy also flew with the late Douglas Bader and was one of the pilots selected to lead the flypast over London at the end of the war in Europe. Jimmy was very supportive of my representation and indeed he helped me to get my uniform correctly set up. I did not wear, nor would I have attempted to wear, a replica DFM medal, however. Jimmy realised and appreciated the value of what I and others like me are trying to do by keeping the 'spirit' of those times alive. It was by natural progression that I got into conversation with members of the public who were keen to know more about the RAF and, in particular, home-based airfields. During some conversations I was given information and personal anecdotes about RAF life during the war, which I could then add to my knowledge base and subsequently pass on to others.

Veterans understand the role of living history and the fact that re-enactors present themselves ethically, with respect and with consideration. At major events, marked by huge official ceremonies in many areas of the United Kingdom and at events in France to commemorate the Normandy landings, many hundreds of re-enactors in authentic uniforms are warmly welcomed by the veterans of all services. Last but not least, many re-enactors contribute directly to fundraising for various services' charities and a good example is set by members of the 101st Airborne (Screaming Eagles Living History Group) who take on the annual challenge of a sponsored march through 'Band of Brothers' country in Wiltshire. Also, in November throughout Britain local re-enactment groups turn out to help launch and collect for the Royal British Legion Poppy Appeal. This is one of very many tangible ways in which re-enactors demonstrate that even away from the spotlight of public events they still continue to support those they seek to portray.

Of course there are, as within any community, those individuals who have their own agendas and politics which, needless to say, do not sit well with the ethos of re-enacting. Some hide behind re-enacting for other reasons, be it personal promotion, the belief that they can exercise some authority over the membership or because they simply like 'dressing up and throwing their weight around', as one re-enactor suggested. Fortunately these individuals and groups are small in number and they

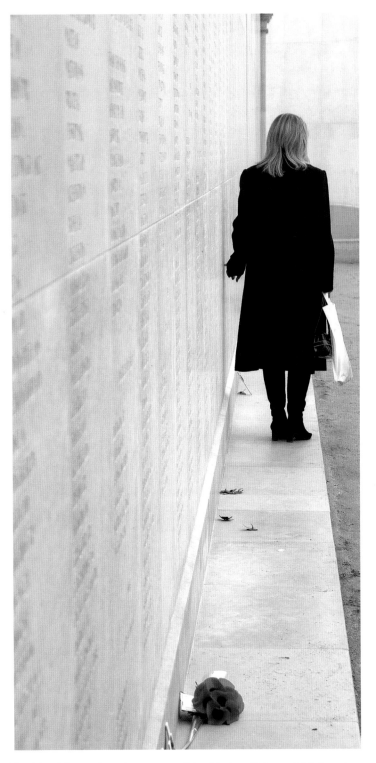

'A widow.' Reproduced courtesy of the National Memorial Arboretum.

either eventually drop out of mainstream re-enacting or their reputation becomes their downfall and they simply find no favours with, or support from, the rest of the community. However, as individuals or as part of a group, the majority of re-enactors never lose sight of why they have the freedom to enjoy their portrayals, so it is right and proper that they never hesitate to pay their respects to the wartime generation, as well as to those who are involved in current conflicts:

> Through our portrayals, we can in some small way, carry forward our thanks for the sacrifice of a generation that endured the horror of war so that we could enjoy the benefits of peace.
>
> Roy Clarke, Yorkshire

The years roll by and time puts further distance between the remarkable events of the Second World War and our lives in the twenty-first century. In our modern times it would be so easy to forget what happened both on the Home Front and overseas during a conflict that changed the world forever. To some people it has little significance or relevance to the society in which we live. As survivors of the wartime generation fade in numbers the easy excuse of 'it's a long time ago' is given by those who perhaps wish to absolve themselves of any responsibility towards ensuring that the spirit of remembrance lives on. The sacrifice made by servicemen and women, civilians and the Home Front emergency services cannot be underestimated for to do so would effectively delete part of our history. The understanding that 'we will remember them' is at the core of the wartime living history movement with an ever-increasing number of new members being drawn to this unique pastime and many more members of the public becoming more aware of the need to remember those who serve and those who have given their lives for their country.

Remembrance and the act of remembering through religious and non-religious acts, the dedication of memorials and the establishment of places of pilgrimage, such as the National Memorial Arboretum in Staffordshire, where those who mourn and those who observe gather, has become part of our culture, recently enhanced by the loss of life in current conflicts. A national awareness of the need to remember was a consequence of the aftermath of the First World War when, it is said, every family in the country experienced the loss of a loved one on the killing fields of Europe. The creation of the Royal British Legion in 1921 and the building of a national memorial, the Cenotaph in London, helped to galvanise the population in a common aim to remember the fallen.

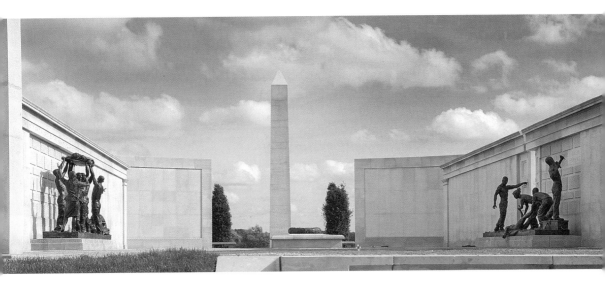

The Armed Forces Memorial. Reproduced courtesy of the National Memorial Arboretum.

Remembrance Sunday ceremonies over the past ten years have been growing in significance and war memorials remain an integral part of our nation's landscape. As Lieutenant General Sir John Kiszely KCB, MC, National President of the Royal British Legion writes in his foreword to the book *Lest We Forget*:

Museum exhibitions also are reflecting an increased interest in memory pilgrimage and contemporary memorials are being placed in new physical spaces, constructed from modern material in ways that challenge and provoke.

Sir John goes on to say that, 'We also need to be aware that most people in today's diverse society have not shared the experience of national war beyond the popular representations in films and museums'.

A not untypical re-enactor will enjoy the music of the era, have their homes crammed with period ephemera and rooms full of kit and equipment. They are collectors who attend militaria fairs and visit charity shops in the hope of finding more period items to add to heavily laden shelves and already bulging wardrobes. When it comes to their uniforms or period suits they are very meticulous in every detail, ensuring that everything is as authentic and original as possible. However, whilst they enjoy 'dressing up', dancing to period music and driving their period cars and trucks, they get the greatest enjoyment from rubbing shoulders with and learning

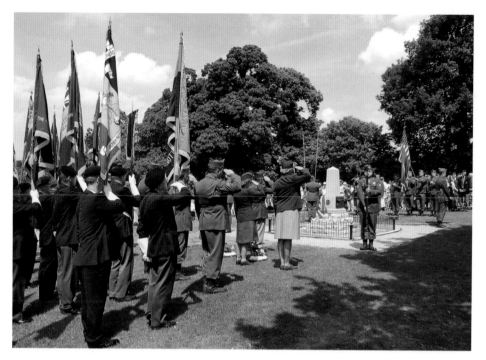

The ethos of the dedicated re-enactor, 'Lest we Forget'. Reproduced courtesy of Ade Pitman.

from veterans, former evacuees and anyone else who endured the years of the Second World War.

Re-enacting, though, is certainly not about people 'dressing to impress', it's about dedicated individuals coming together in the true spirit of remembrance. These are the men and women who are determined to make a difference by ensuring that our history lives on.

2

'VAGARIES OF WAR'

Those bearing the brunt of the enemy's attacks on our cities and our towns, those who take shelter as night falls and those who tackle the aftermath of the bombings are not just citizens of our great country, they are the very embodiment of a free spirit and a spirit that will survive for centuries to come.

Winston Churchill

During the inter-war years various committees considered the measures that would need to be taken should another war occur, although by the mid-1930s many learned people were saying that it was no longer a matter of 'if', more a matter of when. Likely attacks from the air were regarded as being either 'mass attacks', which would cause widespread destruction and death, whereas lighter 'raids' would be used by the enemy to panic and alarm the population. Interestingly, the conclusions were that in the first twenty-four hours of the outbreak of another war, an air attack on London would claim over 1,500 killed and over 3,000 wounded. In every subsequent period of twenty-four hours, a further 2,500 people would become casualties.

Whereas mass attacks were considered suitable enough reason to issue warnings to civil organisations, mere raids apparently would not justify any advance notice. The warnings themselves were to be defined in two categories with the first warning issued only to bodies such as the fire services, the police and organisations which needed time to put their anti-aircraft system into operation. A second warning was

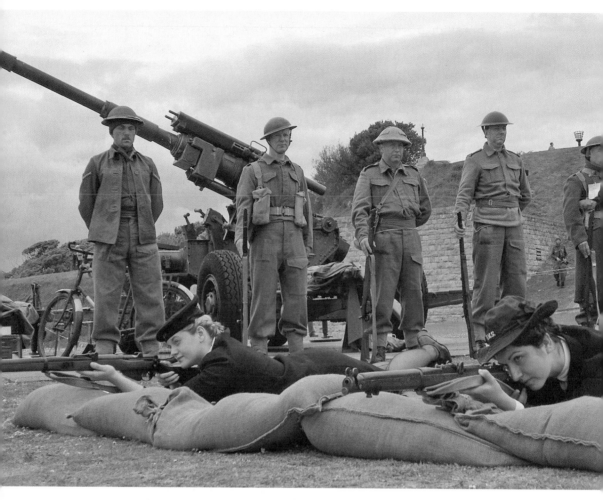

An anti-aircraft unit in readiness.

to be given about fifteen or twenty minutes later when an attack was imminent and this would be timed to ensure minimum disruption of 'normal activities' as the people went about their daily business.

It was recognised that:

> ... in organising the whole civilian population to protect themselves they must be organised on a civilian basis in their civilian organisations of the categories named. The ARP service must create and maintain its own honourable status and prestige and not lean upon some other service. It would be contrary to the

principle of this civilian organisation to resist attack upon civilians if it were to be incorporated in the Territorial Army or any other military organisation.

Within the subsequent programme were details of the matters which were deemed to require immediate action and funding from the 1934–35 financial year budget. In addition to, for example, the organisation of a full-scale ARP exercise and a thorough test of the destructive capabilities of a 500lb bomb, emphasis was placed on the need to create a firefighting organisation on a huge scale as never previously envisaged, as well as the consolidation of the fire brigades operating in and around London.

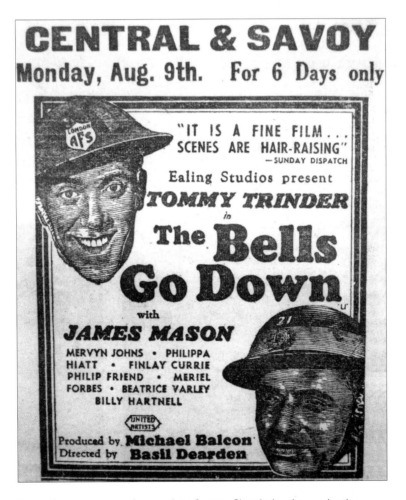

One of the most popular wartime feature films helped to make the public aware of the service given by the firefighters. From the author's collection.

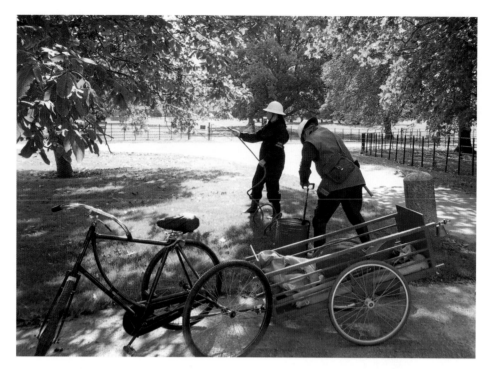

Firefighting forms part of the presentations given by many groups; this group is in Cambridgeshire. Reproduced courtesy of March Re-enactors.

In conversation with David Moore (a fire service re-enactor), we consider the contribution made by the men and women who were fighting the war in the streets of Britain. David says that his interest in the wartime fire service really started when his stepson showed him a magazine advertisement for a Bedford 'Green Goddess' appliance which was being sold off by the Home Office a few years ago:

Where else could you get 6 tons of a 50-year-old, fully equipped classic commercial that had been dry stored and done so little mileage that it was barely run in? All for the princely sum of £2,500! One thing led to another, I purchased the vehicle and I then had to get the hang of using the pump, and find out what all the equipment was for.

Meanwhile, I had been driving a 1935 Brough Superior car for a number of years and had been enjoying civilian re-enacting at 1940s events. It was a pity that I couldn't take the Goddess to those events; no, what I needed was some 1940s firefighting equipment and so the first item, a Dennis No. 2 pump from 1938, was bought from an auction website and we worked on it

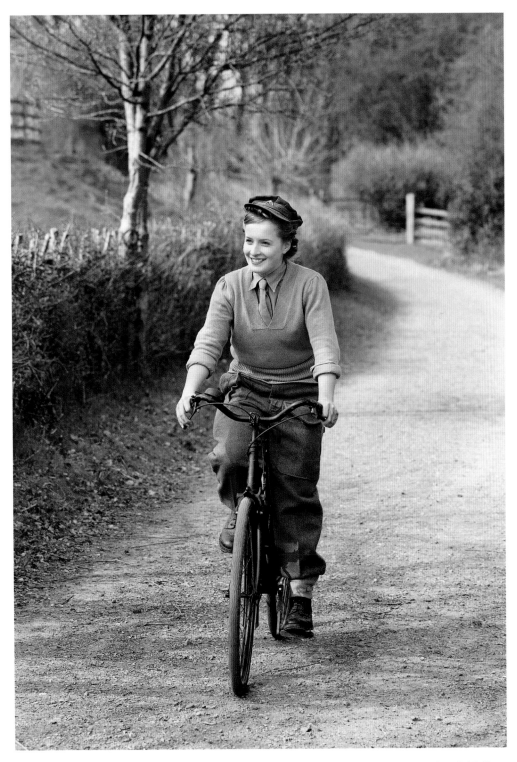

The trusty bicycle was the only transport for many people. Reproduced courtesy of Nick Halling.

and bought it back to useable condition. About that time, I stumbled across the NFS [National Fire Service] Display Group which was organised by the Townsley brothers and a few friends. They had a makeshift 'fire station', a tent with all the correct period accessories including the right teapot, as well as the proper equipment – this was real living history as far as I was concerned. I started to collect uniform items and my wife dresses as civilian or WVS, as the mood takes her.

David then became good friends with a family that share his interest, the Sutcliffe family in his home village:

In parallel to the '40s interests, John Sutcliffe and me started planning a major Green Goddess event by way of remembering the Mobile Columns of the Auxiliary Fire Service in the 1950s and '60s. That was very successful and included four Goddesses in the arena, pumping 900 gallons per minute round a 200-yard circuit from a 2,500 gallon tank. At this stage the group didn't have a name, or any membership. It was a case of inviting anyone we found who had suitable vehicles to join in.

We then 'acquired' an Austin K2 towing vehicle which looks great with the Dennis pump and that quickly became our most useful vehicle. It has space inside for all the 'stuff' that you need for a weekend away at re-enacting events, both the modern camping bits and all the firefighting equipment. This was jointly owned by me, John and the Townsleys, and we did a few very enjoyable seasons of events with them as part of the NFS Display Group.

One of the best events we did at that time was a weekend in Coventry during the 70th anniversary of Moonlight Sonata, the Blitz that destroyed the medieval cathedral and much of the city. We spent the Saturday at the transport museum at their Blitz memorial event. It was also Remembrance Sunday and my wife and I in WVS and NFS uniform wandered through the remains of the old city ending up in the old cathedral as the clock struck eleven. Spontaneously, the hundred or so people there stopped talking, stopped moving and together we remembered those who died. It was the first time I had ever spent that moment of remembrance so close to tangible evidence of the war as I stood among the ruins of the old cathedral. Wearing the NFS uniform added a real affinity to the men who served and who gave their all to help save the nation from destruction by fire.

The gentleman that had sold us the K2 also had an Austin K4 turntable ladder that John and I coveted, and later bought. It needed a lot of work and that was a long, slow process. Towards the end of 2010, I was concerned at the complete lack of any official event in Nottingham to mark the 70th anniversary of the Blitz on Nottingham, 8 May 1941. So I 'put the word around' that I was interested in doing something about this. That bore fruit, because in February 2011 I got a call out of the blue from David Needham who also wanted to mark the event. He had the organisation and the venue, but needed some wartime fire engines! David is a retired fire service Divisional Officer and he had arranged open days over the anniversary weekend at Nottingham Central Fire Station, which was built in 1939, had bays for six appliances, but only three (modern) vehicles stationed there. 'They can be moved out' said David, 'we would like to recreate a 1940s fire station for the weekend with use of fire hydrants, the drill yard and training tower'.

We had just eight weeks to organise this and get the K4 working properly so life was pretty hectic in the run up to the event. By the way, some years ago David Needham wrote a book, *The Battle of the Flames*, about the Blitz in Nottingham and naturally he is very knowledgeable about his subject. Having been a professional fireman, David is very much aware of the dangers that firemen face and he has become the major instigator behind the Nottinghamshire Firefighters Memorial Fund, which is an organisation working towards a memorial to the firefighters and Civil Defence workers who died in the war. His enthusiasm rubs off and we now make a collection for the fund after every display we do.

At about the same time, a Fordson V8 Escape Carrier, complete with all the equipment, was up for sale. With a bit of care, I could get it back to Nottingham in time for the weekend even if it had to arrive on a recovery truck because it had broken down on the way! Another vehicle to fix and a very short deadline in which to do it! Then we had an amazing offer – would we like to do a major demonstration outside the Council House in the Old Market Square right in the middle of Nottingham's shopping district and get the Lord Mayor involved as well? Indeed we would, and so all the planning, recruiting, training and mechanical activities were only interrupted by our day work and occasional sleep! Thankfully, in the end, it all worked out OK, despite a few things being a bit unpolished and some technical problems experienced with some modern props. Fortunately all the 70-year-old equipment worked fine! We got mentioned in the local papers and local television, and that gave the group a big boost. The Mayor, despite getting wet, said it was the best civic occasion of his year in office.

Unfortunately during a recent season, tensions began to appear between those who are more interested in the heavy equipment and those interested in the living history detail. At the last event attended by the NFS Display Group, there were very clearly two different factions, some who put out incendiaries with stirrup pumps and then sat down and had tea and cake, and those who pumped 500 gallons of water to the top of a 60ft ladder. It became clear that the different aims and interests could not work together as a single group.

Within a few days, we decided that we would form our own group, the NFS Vehicles Group, reflecting our interests in vintage vehicles, heavy machinery, big pumps, impressive displays and firefighting from a more professional point of view. We would buy out the Townsley share of the K2, and part on very good terms. We agreed that we would ask organisers to place us adjacent at future events so that we could benefit from the display's superb living history and, in turn, they would benefit from being alongside an appropriate set of vehicles.

David was asked what the group's ethos is:

We are all interested in large vintage vehicles and using them for what they were originally made for. At the moment the group does not have a formal membership and we invite people to take part where they can. We have a certain amount of uniform to loan so the initial hurdle to getting involved, having kit, is not a problem. As people become regulars, they are expected to source their own uniform. Our aim is to be a welcoming, friendly and sociable group.

We involve children, not only because they are interested, but also their parents are taking part. We want to promote a true sense of history to youngsters.

All of us find that talking about what the men and women of the NFS did and by demonstrating their equipment and wearing their uniforms, it helps to create a real empathy with them and a respect for all that they did. For example, we hold a branch (hose) for five minutes and get a bit wet on a summer Sunday. The wartime firemen held a branch for five hours through the night, with bombs falling, often in the freezing cold and always in extreme danger. We get water from a peaceful pond or high-pressure hydrant, but they had to run hoses through the city to a river, or the flooded basement of a bombed-out building. We go home to a warm bed, but they worked through the night.

We hold them in the greatest respect, hence our support for the Firefighter's Memorial.

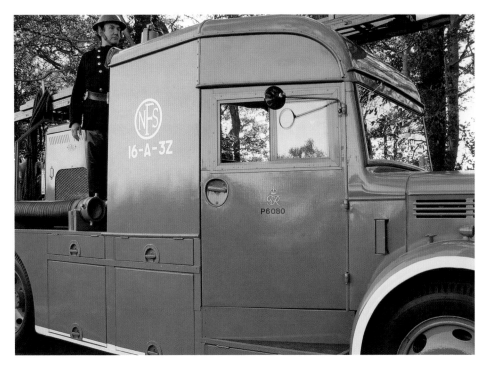

Many re-enactors also have original period vehicles to complement their portrayals. From the author's collection.

A veteran receives a gift of thanks on behalf of a local authority during a ceremony dedicated to the wartime National Fire Service. From the author's collection.

Anecdotes from those who lived through the war on the Home Front often feature stories of air raids, rationing and camaraderie, but they are each unique. There were lots of smiles too against such a grim background:

Living through the Blitz in Marchwood, with its closeness to Southampton Docks just across the water was an exciting, if not frightening experience for any young child. Our home was a thatched cottage and one of our fear was that incendiary bombs would land on the roof and set the house on fire, so we drenched the thatch regularly with water using a large stirrup pump. Another of our concerns was the Royal Naval Armament Depot about half a mile from our home, but fortunately when it was hit there was very little ammunition stored here, nevertheless the explosions were sufficient to hurl timbers the size of railway sleepers several hundred yards in all directions.

On the night of the big raid on Southampton Docks we were sheltering indoors our homemade Morrison type shelter when we heard an almighty swoosh followed by a thud and the sound of broken branches coming from the garden. Daring to go outside we saw, glowing in the light of the fires burning in Southampton, nestled in an apple tree a large cylindrical object. We called the RAF men manning the barrage balloon next door to come and look. One braver soul than the rest approached the awesome object and came back laughing, for it was not the UXB we thought it was, but a harmless empty flare container. The laughing RAF men returned to their own air raid shelter, only to find later an incendiary bomb had landed at its entrance. One man following the usual practice at the time went to kick it safely out of the way, when it exploded damaging his leg. It appeared the Germans had started to add a small explosive charge to their incendiary bombs and our barrage balloon man was one of its first casualties.

The flare container we thought dangerous was in fact safe, the incendiary bomb he thought was harmless was deadly, such are the vagaries of war.

Unknown Diarist

★★★★

Three weeks after my eighteenth birthday in June 1943 my parents gave their consent for me to join the WRNS if I could be 'immobile' at Falmouth – HMS *Forte*. I reported to Moorfield, Seymour Avenue, Plymouth which had suffered bomb damage and we were set to sweep up the debris such as

plaster. On the first day we learnt how to make a bed with 'hospital' corners. The first two weeks basic training dealt with First Aid and poison gas. On squad drill we learned to 'line up our thumb nails with our back suspenders'.

At the end of the two weeks we were issued with our uniform which consisted of a great coat, rain coat, suit, white shirts, stiff collars, wool stockings and underwear. We learned the right and the wrong way to lace up our service shoes. Incidentally, I have recently found my uniform in the 'dressing-up' box in the loft!

My first draft was to Falmouth where I served as a steward in the Mess, washing up dishes, peeling potatoes, scrubbing the galley floor and writing letters for the men. In the build-up to D-Day, it was as if the whole area was one enormous camp. When the Landing Craft suddenly disappeared from their moorings, we knew that it was imminent. An accident, when I fell and cracked my elbow, meant that I could no longer work in the galley and so I was recommended for the writer's course at Headingley in Yorkshire. My second draft was then to Portsmouth Dockyard, to the Provost Marshall's office at the top of the semaphore tower which is opposite HMS *Victory*. From here we all had a good view of the Royal Navy ships bringing back prisoners of war from the Far East after the fall of Japan. My third and final draft was to HMS *Drake*, Plymouth to the Drafting Office. I was quartered in Penlee Gardens and when I was 'Duty Wren' I had to check everyone was in by 23.00 hours, for lights out. Post-war, I remember in the ferocious winter of 1947 trying to keep warm in bed with one's clothes still on, but I also remember summer walks on Dartmoor and swimming at Jenny Cliff Bay.

<div style="text-align: right">Vivian, WRNS Veteran, 1943–47</div>

Evacuated to Dorset, a young girl had much news to write about. Two of her notes to Mummy and Daddy are published below:

Dear Mummy and Daddy,

Has Daddy planted the plants yet and are the radishes ready to eat, if they are will you bring some. We had some strawberries Sunday. Every morning and afternoon we go round Mrs White's chicken and duck egg collecting, Mrs White gave us a drawing set it has got 6 pencils a pen a ruler, a rubar and a thing to keep nibs in and 4 crayons. This is one of the pencils. Uncle Owen made Jim and I a money box out of two tins we cannot open them very well.

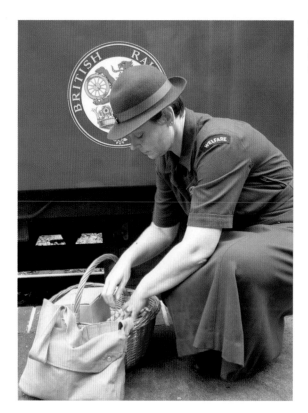

Waiting to welcome evacuees on a station somewhere in the south of England. Reproduced courtesy of Arthur Cook.

Jumbo has just dug up a bone that he buried in the garden. Will you show this letter to Auntie Gladys?

Lots of love from Jean and Jim

Dear Mummy and Daddy,

Auntie thought I had been good enough to wear stockings but sometimes Auntie thinks I will be wearing socks when I am an old lady. At Sunday school we are going to have prizes at Christmas and I think we are going to have a Christmas tree and then we shall have to say recitations and sing hymns. Daisy Pomeroy and me are going to sing 'Hark the Herald Angels Sing' At school we are going to have a post box, we have got to send cards to each other, we have to take them to school and put them in the box and then Mr Harvey gives them out and then Mr Harvey is going to get a sack and we put parcels in it and when he takes them out he stamps on them like they do at the post office. Uncle has just come home from Verwood

the men that supposed to take them to Wimborne did not come to fetch them so now uncle is in bed with a headache. Now I am finishing this letter Sunday night and uncle has been to bed, got up again and been to work. Last week was our examination week and Miss Thomas is going to give out our old examination papers. The Aunties from Bournemouth wanted to go to Rockborne so Aunt Gladys went to where the bus stops with them and when they got there they had a long time to wait, the bus only took six minutes so they thought they would walk then they asked somebody how far it was and they said it was two and a half miles so they went back to where the bus stop was. Will you and daddy come here instead of us coming home if Aunt Mabel will let you? Uncle says that those winkles that you did not send were jolly good because they had such long tails, I hope yours had long tails.

Lots of love from Jean

Jean Strehlau, Southampton

★★★★

I was evacuated a little later than most children as my mother had taken my baby brother and me to Wales originally to relatives. I was three years old and can remember my mother and grandmother taking me to a reception centre, I believe it could have been in the Regents Park area as we lived in the St Johns Wood area then. I stayed there all night; I remember crying all night for my mother. Next morning I was collected by two WVS ladies and driven in a small black car to a village near Wimborne in Dorset. I was sick most of the way, a small miserable little charge.

They delivered me to a thatched cottage to a marvellous family who cared for me for nearly six years like one of their own.

On returning to London in July 1945 I remember my mother taking us, I had three brothers by then, to a clothing store possibly run by the WVS to exchange our out grown clothing.

Sandra Banks, Swansea

★★★★

I lived in Rickmansworth in Hertfordshire, we kept bees then during the war. The WVS either owned or had the use of a small shop on the High Street and they asked my father for a display of bee keeping equipment to put in

the window with leaflets about bee keeping and if available, to offer someone who knew about bees.

I was thirteen years old then, and at weekends I was the person who talked to people about bee keeping. The WVS ladies were collecting bundles for jumble sales and dead foxgloves so they could use the seed heads to make digitalis. I used to help with this if I had time.

Jean Parsons, Ryde, Isle of Wight

In 1940 I was eight years old. My mother, father, brother and I had been to my aunt in the country for a weekend, on returning home late on the Sunday afternoon, we were confronted by soldiers on guard stopping anyone passing beyond that point. My father explained that our house was beyond that point. A soldier reluctantly let us through. When we reached our house, two WVS appeared from nowhere and told us that we must be quick as there were time bombs, one being in our back garden, and that these could explode at any time. They helped us get as many possessions out of the house as we were able.

Although I was young I can remember those two women so clearly that they were actually risking their lives to help us, without a second thought.

Gladys Holloway, Edgware, Middlesex

I come from a Welsh village called Brynteg, near Wrexham. My mother, the late Mrs Freda Roberts was asked to form a branch of the WVS for our village and to cover some of the other small villages in the area. To start with they had no uniforms, just a badge. Meetings were held in the local chapel schoolroom. My earliest memory is of the head WVS staff visiting my mother to discuss what could be done when the war in Europe intensified.

On one occasion, we had as many as three or four families sleeping on the floor in our house in transit overnight from Manchester and Liverpool. My mother gave them tea and sandwiches because we hadn't much food in the house. But the real cost was in the morning after they had left and we noticed clothing coupons, jewellery and other items had been stolen. The police were not interested, but it was the same with the other WVS members who had families staying overnight. My mother was not put out

by this, she just insisted that all WVS hosts locked everything away when families stayed.

Graham Roberts, Crewe

So talking of 'the police', what does walking the beat on the 'Home Front' mean to a civilian police re-enactor?

Home Front re-enacting is important because everyone is most likely familiar with the war on the frontline and what the Armed Services did, and that of course is how it should be. However, whilst we have knowledge about the Home Front, it is not a subject that has such a high profile in contrast, so it's good to profile the efforts of the Air Raid Wardens, the Auxiliary Fire Service and later the National Fire Service and of course, the civilian police officers. Then there are all the women working in factories, the men down the pits and so on. It was a concerted effort by everyone else that helped stop this country from 'going under'. Some said it would have been so much easier to sue for peace as opposed to going through all the hardships, but just

Many re-enactors take on duties at events, including 'mix and mingle' and 'meet and greet'. Here a police re-enactor is given responsibility for traffic control. Reproduced courtesy of John Morgans.

about everyone on the Home Front got on with it and endured life at war for nearly six years. I portray a civilian police officer with the Monmouthshire Constabulary and it really is quite surprising just how many people respond well to seeing the old 'plod' walking the beat. Even when I am 'working' out of the area, the reaction is the same, a very positive one. Members of the public approach you to ask questions, many ask if I am 'real', others will of course ask me for the time, but the majority are fascinated by the role that the police had in wartime. Retired police officers that I meet are always full of useful tips and anecdotes and even serving officers will want their photograph taken with 'an old time copper'. So I learn from these experiences and in turn, I can pass that knowledge on. For me, it's fulfilling being able to explain to people about aspects of life on the Home Front, it's an important part of re-enacting.

Darren Woolvin, Cardiff

Constable Bailey of the City of Plymouth Police patrols the station. Reproduced courtesy of Guy Channing.

3

DIGGING FOR VICTORY

With the emphasis on the history of the Women's Land Army (WLA), wartime re-enactments at Gressenhall farm and workhouse in Norfolk are considered a vital part of the educational service that they provide for visitors and scholars.

Hannah Jackson and Jan Pitman tell the story:

Enactment is one of the methods of interpretation employed at Gressenhall farm and workhouse, the Museum of Norfolk Life. The 50 acre site is part of Norfolk Museums and Archaeology Service (NMAS) whose overarching aim is to bring history to life by collecting, preserving and interpreting evidence of the past. Through museums such as Gressenhall, NMAS seeks to stimulate creativity, inspiration and enjoyment. At the former workhouse and working farm, re-enactors play a major role in supporting the experience of the 70,000 plus visitors who come to the museum each year. This is never to the detriment of the historic site or to the collections held. Re-enactors are 'employed' to help bring these spaces and objects to life, complementing the other methods of interpretation, to aid understanding and to provide an enriched experience for all.

In the Mardlers' office at Gressenhall farm and workhouse, the base for a group of volunteer costumed interpreters who work predominantly with school groups who visit the site, there is an oft-quoted maxim hanging on the wall. This proclaims:

Re-enactors of the Scottish Home Front. Reproduced courtesy of South Ayrshire Council.

Tell me and I will forget,
Show me and I will remember,
Involve me and I will understand.

The Gressenhall 'Mardlers' (named after a Norfolk dialect word for someone who talks a lot) have certainly embraced this philosophy. For them, and the other re-enactors who regularly work at the museum, re-enactment is about making history accessible to the widest possible audience, involving everyone in the work and pursuits of the past. Regularly, the site focuses on recent history, with enactments relating to the Second World War. Having identified the importance of enactment as a way of engaging with a wide range of audiences, this chapter will explore how

Gressenhall farm and workhouse utilises Second World War portrayals for those who experienced the period first hand, for the wide-ranging interests and understanding of those visiting an on-site event, to the schoolchildren learning about this period for the first time.

We should not forget that for some of the population, the Second World War is still a recent and often painful history. We are fortunate to still be able to talk to many of those who experienced the period first hand. With this era, as with all historical re-enactments, such portrayals must always be carried out with respect and courtesy for those whose lives and experiences are being evoked. Independent re-enactor Catherine Stafford portrays individuals involved with the Women's Land Army and Women's Voluntary Service. She recently joined the museum for the launch of a new gallery devoted to the Women's Land Army and Timber Corps. Catherine was keen to emphasise the importance of respect within such re-enactments:

> We seek to bring accurate portrayals of wartime civilian roles to such events. We aim to widen the public's knowledge of the period and the specific roles and so on, but equally we hope to learn from the knowledge that the public bring to us. Most of all, we believe we bring to events a profound awareness that those who actually went through the war, involved in the roles we portray, deserve our respect and admiration. Occasionally there are those whose wartime memories, whether of their own experiences or those of a relative, are very painful and they often ask why we want to portray such an awful time. This is where the element of respect comes in.

When asked if it made a difference to her re-enactment to have an audience who had experienced the period first hand, Catherine replied:

> I don't think it does affect the way I enact the roles because I aim for accurate and respectful portrayals all the time. However, I always acknowledge to such audiences that I am simply representing the role to the best of my ability. It can be very emotional for me and for the audience, especially when people want to share very personal memories and emotions. Where at all possible I move away from my 're-enactment station' at these times so I can listen with proper attention to the stories they want to share with me. There have been occasions when their memories have reduced them and me to tears, not

It was hard work, but healthy working on the land. Reproduced courtesy of Gressenhall farm.

just because they are upsetting, but also because they are so glad that their experiences are being acknowledged, portrayed and kept alive at enactments. I do enjoy having the opportunity to speak with those who experienced the period first hand and always try to engage them in conversation and glean a bit more knowledge from them! It has to be said that I rarely have to begin the conversations, most audiences are longing to tell me how they did things, what their experiences were, whether or not they think I'm doing a good job and in the early days they certainly told me when I got things wrong!

The importance of accuracy in such re-enactments is essential. From the authenticity of the costumes and objects to the precise details of the scenarios depicted. There is a danger that perhaps in part, because we still have audiences that suffered great hardships and loss during this period, we tend to gloss over some of the

horror. This is no doubt in fear that to do otherwise might in some way glorify that horror, we look back with rose-tinted glasses.

Gressenhall farm and workhouse has had strong connections to local veterans of the Women's Land Army and Timber Corps for a number of decades. Since the 1970s, in fact, reunions of the surviving members have taken place at the museum, including an active reunion of the group which was captured on film for Anglia TV. This programme showed the veterans taking on their former roles on the working farm. In the intervening years, this role has been taken up by re-enactors, but the aim remains the same, to portray faithfully the tough jobs that the women had to undertake with limited training and instruction, together with the sense of camaraderie felt by many of those who joined up.

Annually, Gressenhall farm and workhouse steps back to the 1940s and the Norfolk home front with its Village at War event. On the Sunday and August Bank Holiday Monday, re-enactors from across the region join together to recreate the sights and sounds of the period. These range from civilian and military groups and individuals, to a period Girl Guides' encampment, music and entertainment.

Feedback from visitors to the event in 2010, carried out by the Renaissance East of England evaluation officers, reveals the importance of re-enactors at such an event. Over 80 per cent of the responses received rated the events, re-enactments and activities as the most popular part of their day. With the Home Guard and soldiers, music and radio shows, 'make do and mend' demonstrations, army drills and period school lessons, there was a real period atmosphere. Almost one in six remarked specifically on the 'atmosphere' of the event, the sense of 'living history' and the opportunity to 'talk to people in costume' as being most enjoyable for them. At least two of the visitors questioned likened the museum to *Doctor Who*'s TARDIS in terms of the opportunity to experience time travel, with one commenting that 'Gressenhall is the gateway to the past'. In many of the comments received there was a clear message that visitors to Village at War came wanting to experience the recent past, either to bring back their own memories of wartime or to relate to older relatives who had experienced it first hand. One visitor remarked that they 'Wanted to see the things my parents put up with'. Ian Clark of Allied Assault 44 has been attending Village at War for a number of years and describes their re-enactment as a 'visual tribute' to the British and Commonwealth forces of the Second World War. For Ian, accuracy is paramount and the opportunity to meet and speak with veterans has given him the chance to gather information to inform his re-enactments and also his work on books and multiple films and documentaries: 'Over the past forty years I have had the honour to meet and talk to many Second World War veterans. This knowledge is then passed onto others.'

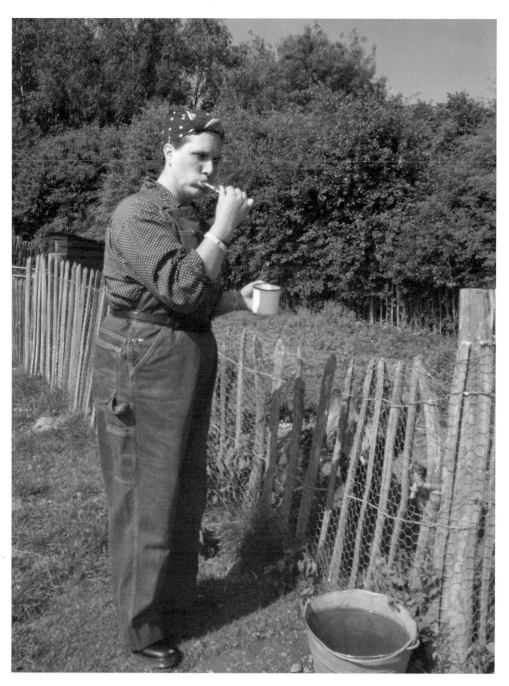

Over 80,000 women served in the Land Army during the Second World War. Reproduced courtesy of Manor Farm.

Indeed, the group's publicity emphasises that as an organisation they 'enjoy interacting with the general public and encourage them to ask questions which they will try to answer in a way that is both instructive and enjoyable'.

The opportunity to ask questions marks out re-enactors from other forms of museum interpretation. A static display or graphic panel can only make you understand or feel so much. The opportunity to engage with someone, to enter their world or to walk a moment in their shoes can be far more eye-opening. For some audiences, however, it is difficult to break through that barrier and to believe in the character being portrayed. Catherine Stafford again:

> Reaction seems to depend on the age of the people concerned. Older people love to look at artefacts we bring along and will often comment that they have the same things at home. They enjoy a 'trip down memory lane', and share a lot of their reminiscences with us.
>
> Most children are fascinated by the objects we use and want to know all about them. They find the whole concept of wartime living very interesting and ask lots of pertinent questions about rationing, the blackout and other aspects of wartime living on the Home Front. They especially seem to want to know how many sweets people had a week, and if people really kept pet rabbits then killed them and ate them. The age group that shows least interest seems to be the middle generation. In family groups, it is usually the grandparents and grandchildren who look and ask.

One aspect of wartime re-enactment that certainly seems to appeal to all is the entertainment of the period. Gressenhall is fortunate to have two acts that joined the museum for its 2011 Village at War event: Timescape 1940s Singers bring alive the sounds of the era with favourite songs from home and across the sea, evoking memories for the older generation and entertainment for the younger audience, and Time Travel Team perform live wartime radio shows with music and advice from the period, providing an insight into the entertainment of the era. Both groups commented on how their performances prompted a barrage of questions from the audiences: typically, where they got their inspiration, who makes the women's dresses or how long it takes to do their hair in a 1940s style.

With an event such as Village at War, there is the opportunity for chance meetings between characters as re-enactors work side by side. This can in itself add greatly to the event for visitors with enactors reacting to the situation in character.

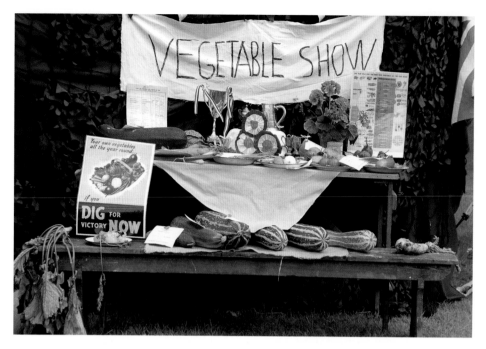

The rewards of hard work on the land. Part of a re-enactor's display. Reproduced courtesy of B.J. Wilson.

The Second World War also provides opportunities for Gressenhall farm and workhouse to use costumed interpretation to work with school groups. Many primary-age schoolchildren undertake a study of the impact of the Second World War as part of their history curriculum and the Learning Department runs regular 'Evacuees' Day' events to support their studies. Their Evacuees' Day gives children the chance to learn about the impact of war through engaging in a series of active sessions led by costumed characters. Children find out about 'make do and mend' and rationing from a housewife and help the Women's Land Army girl with the farm work. They learn how to keep safe in an air raid from the ARP warden and practise bayonet drill with the Home Guard officer.

The Second World War is a perfect subject for schools' events using costumed interpretation. Costumed characters can develop empathy and help children understand the different effects of the war. Children meet the housewife, worried about her husband in the army and desperately trying to prepare for her young son's birthday against a backdrop of shortage and rationing. The Women's Land Army girl has swapped a comfortable urban existence for life on an isolated farm in rural Norfolk and is both lonely and a bit scared. However, she is learning new skills and independence and knows that after the war, life will never be the same. The Home

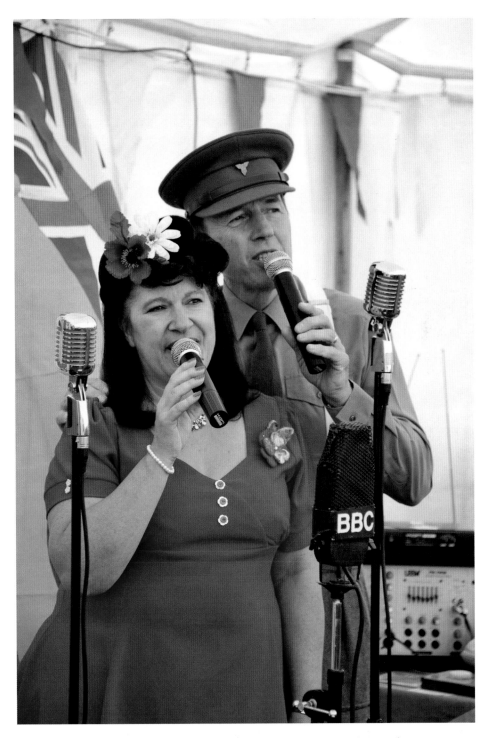

There was no excuse needed for entertainment; strolling players sang popular songs of the day to put colour into a grey day and to boost morale. Reproduced courtesy of Gressenhall farm.

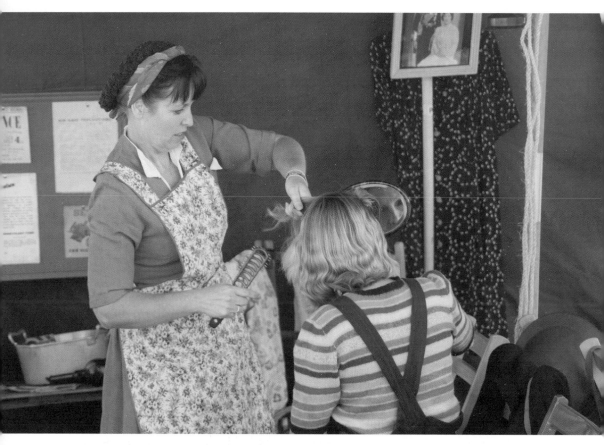

If you worked on the land having your hair done made you feel grand. Reproduced courtesy of B.J. Wilson.

Guard officer served in the trenches in the First World War; he is prepared to do his bit, but understands the cost of war. He knows that should the invasion come, the Home Guard will have little chance against professional soldiers.

At Gressenhall, the children are asked to play roles during the day. They pretend that they are evacuees from London, arriving at Gressenhall on their way to being billeted in the Norfolk countryside. The team invite children to come in costume and it makes a tremendous difference to the day when they arrive 'dressed up', often with 'gas-mask cases' over their shoulders and address labels around their necks.

Rachel Duffield, live interpretation officer at Gressenhall, says:

'Dressing-up' helps children to engage with the day. It also involves their families in the preparation and so helps to extend learning outside the

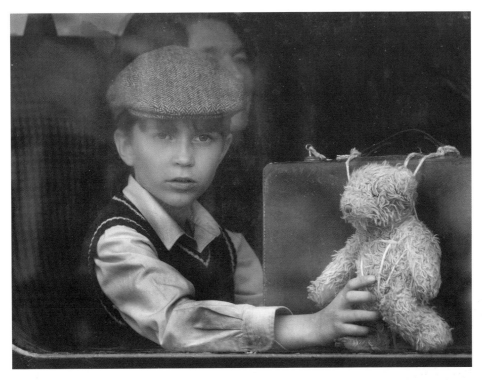

A young lad portrays his wartime counterpart. Reproduced courtesy of Nick Halling.

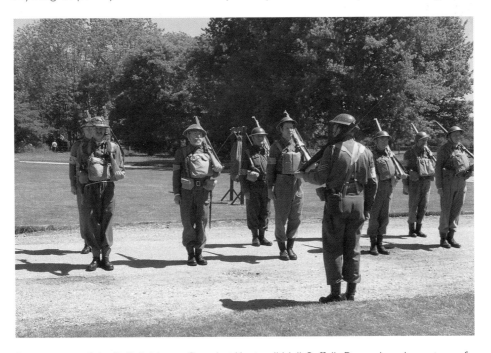

Re-enactors of the Suffolk Home Guard at Kentwell Hall, Suffolk. Reproduced courtesy of Robert Baker.

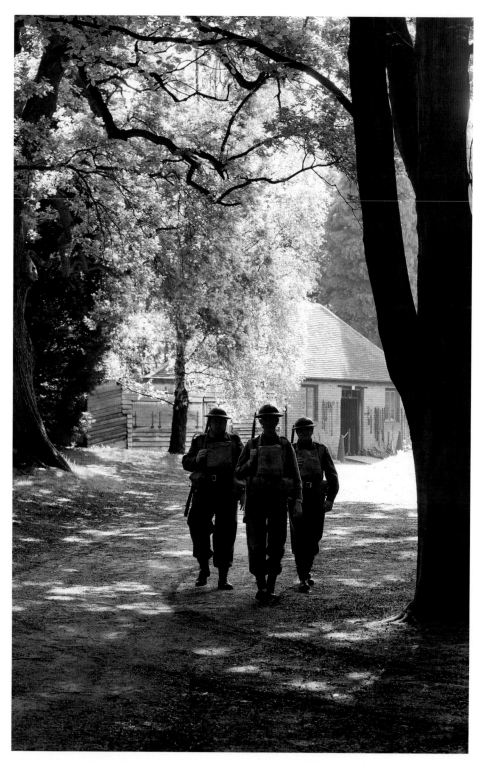
Watching and listening, the daily patrol heads out on a summer's day.

Children love to play, wartime or not. Reproduced courtesy of Nick Halling.

classroom. It is relatively easy for families to find 1940s-style clothing for their children, jumpers or tank tops and caps for the boys, plain knee-length skirt and blouse for the girls. Actually this brings home the fact that, unlike some of the other periods that children study, the 1940s are part of the modern world. Interestingly, children seem to identify most with a character that does not actually exist, Tommy, the housewife's son. Will his birthday present arrive in time? Will there be enough food for him to have a nice party? Of course there are differences in circumstances, lifestyle and attitudes, but the world is recognisable and the people are very much like people today – they could be us. This makes it much easier for children to make connections, identify differences, and put themselves in other people's shoes.

From re-enacting to interpretation, impressions and portrayals, whichever way you view the subject, one thing is very apparent: dressing in period costume, having the knowledge to portray a role and giving that role an educational content is without doubt one of the best mechanisms to pass on historical information. Certainly, none more so than when passing on information about our own Home Front during a period which remains 'within living memory'.

4

A CLOSE SHAVE

Portraying Royal Air Force (RAF) personnel is favoured by many re-enactors, whilst the Women's Auxiliary Air Force (WAAF) provides vital support from the operations room.

Here is an account of the type that inspires such portrayals. 'Once upon a school day during the Battle of Britain', a personal story kindly contributed via a friend in America by Russell Baker, who recalls that moment in history with great clarity:

It was August 16th 1940 and in the little village of Rownhams there were certainly no indications that England was engaged in a deadly struggle for her very existence. The German air armadas were now daily pounding the cities with high explosives with the intention of weakening the will of the people rather than profit from the intrinsic value of destroying factories and other strategic targets. I was ten years old and really too young to be frightened by the war. I knew no different, to most of the children, it was an adventure. I was attending the small church school in Rownhams because my own school in the neighbourhood of Maybush had been taken over by the Army to accommodate some the many French troops that had recently been rescued from the beaches of Dunkirk. The three mile uphill walk to Rownhams from my home was a tiring one for me and my sister because we were very, very tired from the many sleepless nights spent in the back yard air raid shelter.

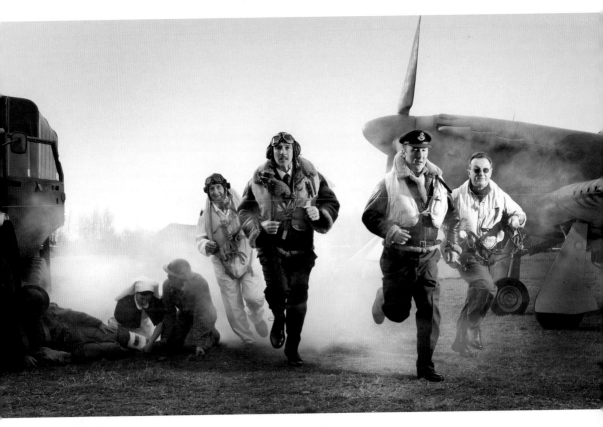

Action stations! Reproduced courtesy of Nick Halling.

Our mum was an ambulance driver for the First Aid Rescue Squad and her duties kept her away from home during the air raids, Dad was away in the Merchant Marine and so the responsibility of looking after my sister and me, fell on my own shoulders. I think this was a common situation with a lot of family's [sic], we were not unique in that respect.

The Rownhams school house was very small with a hawthorn hedge surrounding a dirt covered yard for our recreation area. When war broke out, two fairly big air raid shelters had been built and partly sunk into the yard to accommodate the fifty plus children who attended the school. The shelters, which I think are still standing today, were nothing more than sheet metal domes placed in a hole in the ground and covered with soil. They were meant to protect us from shrapnel, but they were certainly useless against a near or direct hit from bombs. Over time, weeds and wild flowers grew over the shelters and turned them into delightful high mounds to tumble and play about on during play time breaks.

It was about ten thirty on the morning of the 16th while we were seated in class that the sirens began to wail. Quickly, but quietly the usual procedure of leaving the classroom and being led to the air raid shelters was carried out efficiently. Because we were quite a distance away from the main built up areas, the threat of danger from a raid was not apparent to any of us, masters and children alike. Therefore the older boys were allowed to hang around the entrance to the shelter with Mr Adcock, our teacher, so we could watch the inevitable drama of combat between British and German aircraft. Most of the air battles took place several miles away, but still visible from our school yard. Mr Adcock would only insist on us going into the shelter if the aerial combat drifted in our direction and there was danger of falling bullet casings and shell fragments from anti-aircraft gunfire.

Anyway, soon the buzz and drone of aircraft and the high pitched screams of the over worked engines, coupled with the sporadic chatter of machine

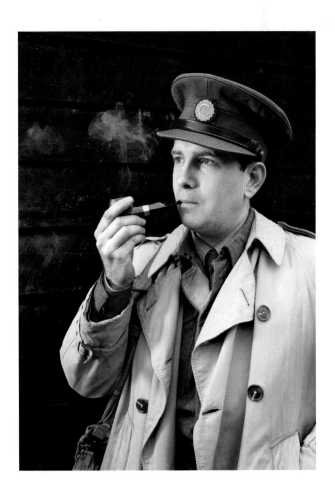

A war correspondent reflects on the day's events. Reproduced courtesy of Nick Halling.

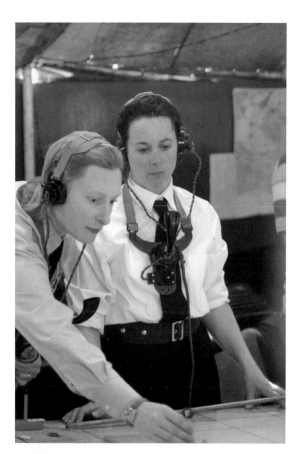

WAAFs at the plotting table, monitoring the movements of enemy aircraft. At its peak the WAAF had nearly 200,000 members.

guns gave us very noisy evidence that aerial combat was underway. Suddenly, we were all pointing in various directions, shouting out to one another in our youthful excitement as the struggle for life filled the skies. On this particular morning there seemed to be to be a considerably large number of aircraft taking part in this battle and we all watched with intensity as life and death was determined by the flying skills of the individual pilots involved. Most boys in my age group were able to identify the various aircraft of both sides and the talk while we were watching would be things like 'Look at that Spit on the tail of the 101'. We were totally engaged with what was happening and there was no real appreciation that war in the skies over our country meant the difference between freedom and surrender. Our references to the German 'planes were made using their numbers, the JU 87's and 88's and the FW 190 and ME 109's and 110's. Our own planes were the 'Hurries' and the 'Spits'.

Suddenly, one boy pointed to the sky to draw our attention to an unfolding drama that immediately had us engrossed. A Messerschmitt 110 was on

the tail of a Hurricane and we seemed to become caught up in the frantic manoeuvres of the British pilot as he sought to evade the enemy aircraft. The two planes seemed to be locked together as they dived and climbed in unison. Then with a mixture of groans and youthful profanity, we expressed our horror at seeing the Hurricane burst into flames. However, instead of spinning to earth, the aircraft continued in its quest to evade the Messerschmitt and finally due to the skill of the pilot, it positioned itself so that despite being on fire, it was able to shoot the enemy out of the sky.

Both pilots bailed out simultaneously however the German fell and disappeared out of sight without ever opening his parachute, the Hurricane pilots parachute thankfully opened almost immediately and we saw the large

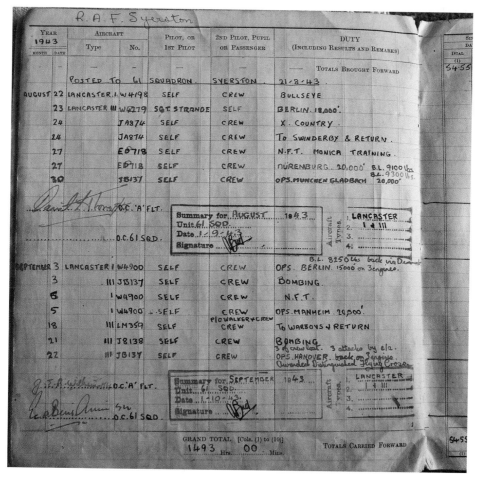

A page from Tony Bird's log, a reminder of the perils that RAF pilots like him faced. Reproduced courtesy of Cathy Hughes.

canopy unfold above him and he began his gentle descent to earth. Mr Adcock shouted out that we must all get into the shelter because the stricken Hurricane, which was on fire and trailing plumes of black smoke, was in its death glide and it appeared to be heading towards the school.

Inside the shelter we sat silent and with great expectancy, where would the aircraft come down? Then there was a high pitched whine and a rush of air just like you get when you stand on a station platform and an express train rushes past. A huge explosion caused the ground to shake beneath our feet and then came the sound of exploding ammunition. Where had the plane crashed, our master went out to investigate and it soon became clear that the school was untouched and had remained intact. We were told that the plane was in a field just behind the school so it was a very close shave for all of us.

After all that excitement, I made a mental note to check the wreckage after school for a souvenir for my collection of mementoes. Most boys in those days had their own treasured collections of aircraft bits and pieces with the highly prized item being Plexiglas from the aircraft cockpit which we would cut away with penknives.

When the all clear sounded and the local fire brigade had extinguished the burning wreckage, our master was told that there would be no further fear of exploding ammunition and so it was safe for us to return to the classroom. There were no further air raid warnings that day, just as well because we had had enough excitement already. I waited patiently for school to finish and then made my way to the crash site. To my great disappointment however, my plan to get a souvenir or two was thwarted by members of the Home Guard who were now standing guard over the wreck of the Hurricane.

When he arrived home Russell was impatient for his mother to return so that he could tell her of his experience that day and the fact that he and his school pals had all had a very lucky escape, and that the pilot whose plane was in flames still managed to shoot down the enemy aircraft:

So over supper the story was told and my mother then said how she had also been involved in this incident. She had been called out in the ambulance to attend to the downed Hurricane pilot who was in a terrible way with burns on his arms and legs. The heat inside his plane has been so intense that the plastic face of his watch had melted into his flesh. Although badly injured,

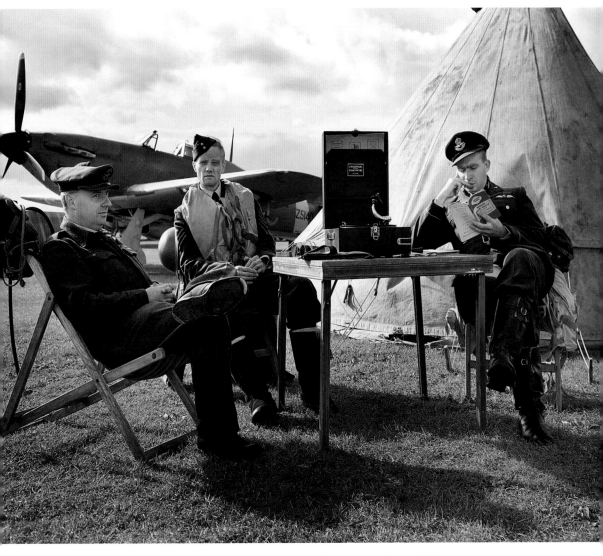

A few moments' rest between sorties. Reproduced courtesy of Nick Halling.

the pilot who my mother had told me was named Flight Lieutenant James Nicolson, expressed concerns about someone who had been shooting at him while he was descending by parachute. Upon investigation it was discovered that some younger members of the Home Guard, worrying themselves about possible airborne invasion, mistook the pilot for a German paratrooper and so were firing at him. In due time, they were severely reprimanded by the proper authorities. Thank goodness their aim was as bad as their judgement.

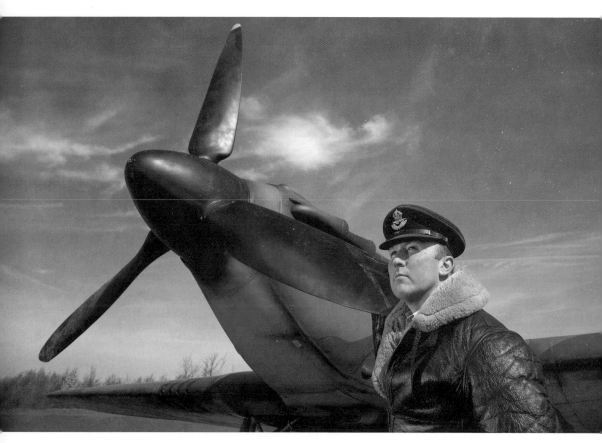

Reflecting on the last sortie. Reproduced courtesy of Nick Halling.

Russell adds a postscript to his fascinating account:

> We later learned that the 16th August 1940 had been Flt Lt Nicholson's first day in combat and he was just 23 years of age. His perseverance to continue the fight against the enemy even though he was very badly injured, earned this brave and inspiring pilot the first Victoria Cross of the war and I had been witness to this amazing event. He was given a very slim chance of survival after the crash, but the dedication of doctors when James reached the hospital, thankfully saved his life.[3]

3 Flight Lieutenant James Brindley Nicholson VC survived the war, but fate was cruel to him because in 1945 he died in a plane crash in Egypt.

It is vital we remember men like him, brave young men who put their country before their own lives.

Another incident from the Battle of Britain was later recalled by Alan C. Deere DSO, OBE, DFC:

We opened fire together and immediately a hail of lead thudded into my Spitfire. One moment the Messerschmitt was a clearly defined shape, its wingspan nicely enclosed within the circle of my reflector sight and the next it was on top of me, a terrifying blur which blotted out the sky ahead. Then we hit. The force of the impact pitched me violently forward on to my cockpit harness, the straps of which bit viciously into my shoulders. At the same moment, the control column was snatched abruptly from my gripping fingers by a momentary, but powerful reversal of elevator load. In a flash it was over, there was clear sky ahead of me and I was still alive.

With smoke now pouring into the cockpit, I reached blindly forward for the hood release toggle and tugged it violently. There was no welcoming and

The sentry, often the least popular duty. Reproduced courtesy of Nick Halling.

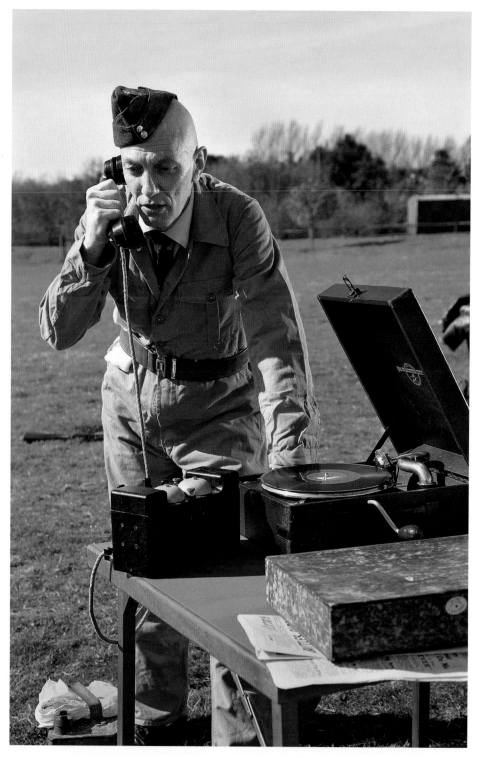

Taking instructions, keeping the station alert. Reproduced courtesy of Nick Halling.

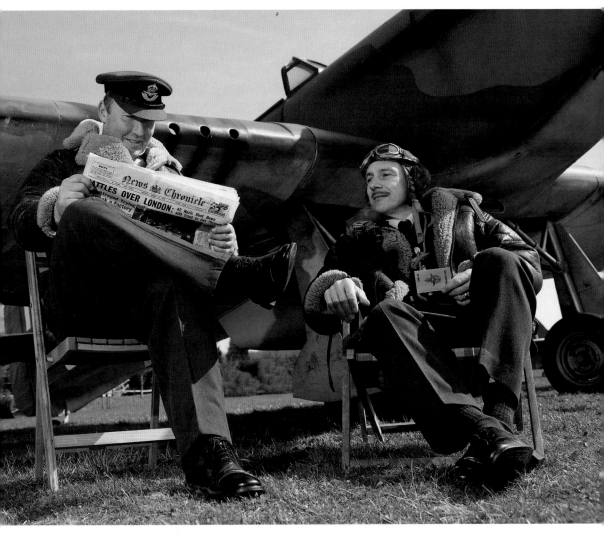

Waiting was the most arduous time. Reproduced courtesy of Nick Halling.

expected rush of air to donate that the hood had been jettisoned. Again and again I pulled at the toggle, but there was no response. In desperation I turned to the normal release catch and exerting my full strength endeavoured to slide back the hood. It refused to budge, I was trapped. There was only one thing to do, try to keep the aircraft under control and head for the nearby coast.

The Battle of Britain played a central role in Britain's air war strategy:

You ask what is our policy, it is to wage war by sea, land and air with all our might and with all the strength God can give us. To wage war against a monstrous tyranny never surpassed in the darkened catalogue of human crime. That is our policy. You ask what is our aim. I can answer in one word, Victory.

Victory at all costs, Victory in spite of all terror, Victory however long and hard the road may be. For without Victory, there is no survival. The Battle of France is over and the Battle of Britain is about to begin.

I have nothing to offer, but blood, tears, toil and sweat. We shall defend our island whatever the cost may be. We shall fight on the beaches, we shall fight on the landing grounds, we shall fight in the fields and in the streets. We shall fight in the hills. We shall never surrender.

Let us therefore brace ourselves to our duties and so bear ourselves that if the British Empire and its Commonwealth lasts for a thousand years, men will still say, 'This was their finest hour'.

Winston Churchill, 1940

Such speeches as this and the previous anecdotes have helped formulate our under-standing and memory of the Battle of Britain in the national consciousness. Indeed, the Battle of Britain has probably become one of the most immortalised episodes in the Second World War in terms of art, film and television. It is, therefore, unsur-prising that so many re-enactors choose to portray it, and their portrayals continue to inform and develop our appreciation of the incredible courage of the RAF pilots and those that guided their flight on the ground.

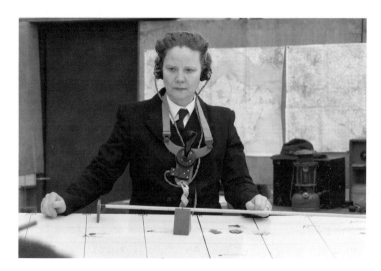

An operations room in service. Reproduced courtesy of Nick Halling.

5

THOSE DANCE BAND DAYS

At the beginning of the war, cinemas, theatres and dance halls were closed by order of the government because they were considered potential 'mass graves' when the country came under attack from enemy bombers. The ban was soon lifted when the benefits of morale-boosting music, song, dance and films were identified as being 'good' for the people.

One of the country's leading exponents of music from the 'Dance Band Days' explains why music, and particularly music of that era, remains as popular today as it ever was amongst audiences young and old, and with re-enactors especially:

I grew up surrounded by the sounds of Big Bands and music of the era, my father Eddie Curtis was a professional band leader and trombonist and my mother was a vocalist for Peter Knight and George Mitchell. And then there was me, Debbie! I remember going with my parents to Big Band gigs, shows, concerts and dinner dances and from a very young age I was amazed, fascinated and excited by the huge sound, the atmosphere and the ambience surrounding it. I still feel the same to this day, every time I stand in front of the band it is the most fantastic feeling and an unbelievable place to be, like no other and still just as exciting as it was in those early days.

Some time ago I took over my dad's band when he passed away and it was around the same time that I received a phone call from a re-enactor who invited me to an event at the Chiltern Open Air Museum. Fortunately this

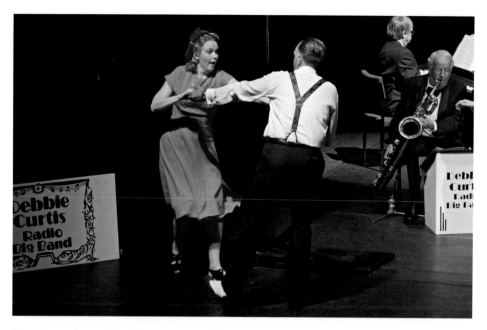

Dancing to the music of the era was, and still is, very popular. Reproduced courtesy of Debbie Curtis.

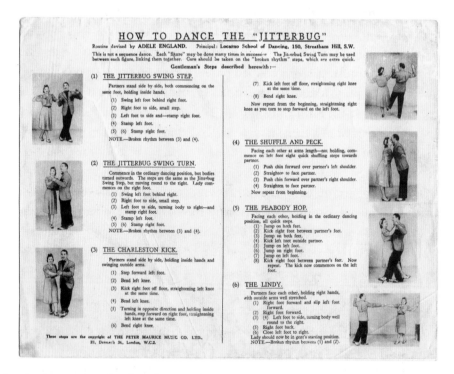

Dancing became a national pastime; music and dance moves from America were brought over by the GIs, such as the 'Jitterbug' featured on the back of a printed score for *In the Mood*. From the author's collection.

was only down the road from where I was based at the time and this three-day event turned out to be something that would change my life forever.

It was a re-enactment event, acting out three days from the 1940s. There were men, women and children all dressed in clothes of the era, some of the children were as young as two or three years of age and they carried gas masks and tin boxes. It was effectively like 'going back in 'time' with hundreds of people in outfits from RAF to ARP and Home Guard, the list of portrayals was endless. Not long after that I came up with the idea of hiring a Routemaster bus and filling it with re-enactors and driving to London to promote my bands forthcoming shows at the London Palladium. Well that's just like you do, isn't it?

So that's exactly what happened. Debbie gathered together thirty-two re-enactors and filled the bus, which, as luck would have it, belonged to the owner of her local pub:

Anyway we ended up with two 1940s policemen, a 'Spiv', a couple of RAF chaps plus dancers in WAAF uniform and civilian dress. To add to the numbers and the occasion, my daughter and some of her friends wore original tea dresses and snoods. Because this was themed on the Home Front, I also enlisted the help of two GI re-enactors, some British 'Tommies', sailors dressed in whites, a Montgomery lookalike, a couple of ARP Wardens and a gangster in a 'Zoot Suit'. I was dressed in a tailcoat and carried a top hat, which in fact was the usual dress for a band leader of the time. Well, a male band leader anyway. With the exception of the Ivy Benson All Girl Band and one or two others, female bandleaders were few and far between in the forties and to be honest it's not much different from today. Funnily enough though, many people have compared me to the legendary Cab Calloway although to be honest that's a comparison I have never fully understood. Cab was noted for his elegant style, so maybe that's why people comment!

Thus off they went, this mixed bag of re-enactors en route to the busy metropolis. The double-decker bus and those on board, however, held up traffic at various points. Tracks from one of Debbie's own 'Radio Big Band' CDs blasted out whilst the passengers precariously, yet with great enthusiasm, danced the jitterbug, the jive and the lindy hop. They then hopped off the bus and did the 'Stroll' on the pavements:

We went from Westminster Bridge to both the BBC and ITV studios and also the central London studios of BBC Radio. Needless to say we were attracting much publicity and generating a lot of interest so much so that the result was we ended up with a snippet on the Graham Norton Show and the news that same evening. So my somewhat off-beat attempt to attract interest and make people aware of Big Bands and re-enactment had actually worked.

By the time of Debbie's first London Palladium show, she had already notched up a lot of radio and magazine interviews, as well as plenty of attention and positive public reaction. She adds:

On the day of the show there were over 500 re-enactors outside the London Palladium. It was an amazing thing to see, people were dancing in the street and long queues started to form to see the show. These queues soon began to block traffic because people were trying to see what was happening and masses were standing in the roadway outside the Palladium. It was more than I could have hoped for, just like a scene from the King of Swing [Benny Goodman] that caused riots in August 1935, I was in my element.

Once on stage the atmosphere was electrifying and even before the curtains went up I could hear we had a good audience. The band was ready to go and as the curtain finally went up I can clearly remember hearing the audience gasp as the band and our dancers appeared. We created quite a spectacle because at one point there were sixty of us on stage. The band were all in black tuxedos and there were as many re-enactors as I could fit on the stage. We had set up some old-fashioned street lamps, under one of which stood 'Viv the Spiv' with his case containing nylons, corned beef and various goods unavailable in the war.

The RAF chaps helped by doing 'meet and greet' front of house; we even had a lady with a pram wandering round. She was depicting someone who had been bombed out. By the interval it was obvious we had created something very special, not least because I had the country's top musicians and a unique, if not unusual, stage show. The second half of the show was even more spectacular. We played the tune 'Hot Toddy' a number which involved everyone on stage demonstrating a dance which was originally done by women during the war when their partners were out fighting for the country. I could see people dancing in the aisles although secretly I knew the health and safety

people would not be happy! By the end of the show we had a standing ova-tion from the audience, which included Chris Tarrant. He later said some fantastic things about the show. The audience reaction was unbelievable, but later this was to cost me a lot of money because I had to pay excess fines for overrunning time wise!

So this was the start of something very special and was a template for all our subsequent shows. Within a few weeks we were like one big and very happy family as the band and the re-enactors all began to get to know each other. We now work out routines that involve the band and the re-enactors and dancers, one of the most popular we play is Tommy Dorsey's 'Song Of India', during which each member of the band wears a fez and the dancers and re-enactors do a 'Wilson and Kepple'-style dance routine!

I have even bought a 1938 Austin 12 car, marked up as a period police vehicle which we travel in for promotions and interviews! Re-enactors always accompany me on these occasions. Since then we have attracted a great fol-lowing of re-enactment groups which I try to involve on every show. We have also performed at some great 1940s-themed events including the Ramsay Weekend and various hangar dances. One of the most memorable events was 'Liberation Day', an event in Guernsey, when we had a seventeen-piece band, staff and crew, and a team of re-enactors and dancers. The event consisted of a tea dance to an audience of 5,000 in the day and then in the evening and late into the night, a new audience was brought in for a dinner dance. The event was televised because of its importance to the history of the Channel Islands and I know our presentation helped to make it special for those that had lived through the occupation and eventually enjoyed freedom on 8 May 1945.

Debbie says that one of the most satisfying things of all is to know you are passing history on to new people and audiences of all ages:

I have taken the show to a lot of colleges and universities and these new younger audiences. Most are taken aback by the huge sound that a band this size creates and they are keen to know where they can get the outfits and uniforms that the re-enactors wear. Many of these young people have since become full-time followers of the band and frequently travel all around the country to support us. Some had never heard of a war-time 'Spiv' or an ARP Warden until they have seen our show and the re-enactors. We try to

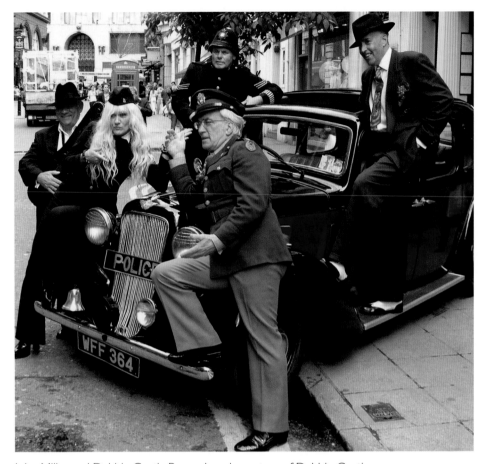

John Miller and Debbie Curtis. Reproduced courtesy of Debbie Curtis.

demonstrate how it was then, and, for me, of course this includes the music that was very effective in inspiring everyone and also helping to lift the burden that they all carried bravely. In the future I hope more and more people become aware of this history and I hope they find enjoyment in the music, the clothes, re-enactment, the dances and the ambience of the era. I hope they will in turn pass it on to future generations to understand and enjoy.

As for me, well, 'simple' bandleaders were known in the 1940s as 'Generals in a tuxedo', but of course the real heroes are those that fought for our country. They are the reason why we are all here today and enjoying the freedoms they gave us. I consider myself privileged to have been able to better understand that period of history through the music we play and in my role as a bandleader.

6

WITH A SONG IN MY HEART

In conversation with Arthur Cook, one of the country's longest-established ENSA (Entertainments National Service Association) performers, we discover the depth and breadth of interest and the dedication that is common amongst entertainers who are also dedicated re-enactors:

My own interest in militaria and the British Home Front started when I was a small boy playing in the streets of Exeter. I would talk to the war veterans of two world wars, who lived in the prefabs opposite our house. These prefabs had been erected post-war because of the devastation of the Exeter blitz of May 1942.

One day, one of these veterans gave me his old Fire Guard helmet which he used during the Second World War. I loved the fact that this helmet had been used during the blitz by someone I knew. It was dated 1941 and that it had its own smell of damp canvas which I now always associate with things from the war years. This really gave me the 'bug' for collecting things from the war years and encouraged me to question both my grandfathers and my father about their life during this period of history.

In 1985, when it became obvious that the city council were not going to organise a commemoration of forty years since the end of the war, Arthur, then aged

A concert party supports 'Spitfire Week', somewhere in England. Reproduced courtesy of Blitz and Peaces.

twenty-five, organised an event on Exeter Quay which involved military historians, living history groups, vehicles, music and displays. The veterans and residents of the city really got behind the event, which was well attended and a great success, raising a considerable amount of money for the Royal British Legion. Realising the importance of bringing together veterans, historians and families, and sharing memories of Britain's heritage, Arthur continued to organise similar fundraising events over the following years:

Blitz and Peaces was formed by my partner Lesley and me in 2005 in Exmouth Devon. Our aim is to provide quality, experiential entertainment tailored to the needs of Second World War Living History events. We provide live music using period instruments, static displays of wartime Home Front equipment and also help with aesthetic decoration at events.

As time has moved on our ranks have been steadily growing. We have four people in the main vocal group and our photographer and communications specialist John Dyer is now becoming more involved at the events. John's

own particular interest is to photograph re-enactors, displays and scenarios at events to make them look as realistic as possible. He manages to create a real feeling of being there in some of his remarkable shots. He is also responsible for the overall design of the Blitz and Peaces' website which is updated weekly and encourages other living history groups to link in to the site. It also provides a comprehensive contact hub for living historians and the general public.

John, for his part, adds:

I've known Arthur for many years. When he first approached me about a website, I thought a couple of pages about the band and some pictures would be the kind of thing that he would want. I hadn't reckoned on Arthur's enormous collection of memorabilia being featured on the site. We initially had some discussion for the look and feel of the site and we both agreed that we didn't want to go for the 'corporate' style. I was particularly keen for it to have a unique feel to reflect the forties' style and times.

After a few months of work it became very apparent that it was not going to become a short-term project and having been swept away with Arthur's enthusiasm and intensely positive approach I was hooked, not only on the building of the website, but I also discovered my true passion for photography. We started photographing every piece of Arthur's collection as it was sourced, mended if needs be, cleaned and researched. This is an on-going exercise, a project we plan to complete sometime this millennium!

I also started visiting and photographing some of the Living History events, in terms of primarily photographing the re-enactors and the veterans. What was obvious to me was the overwhelming sense of enjoyment that the veterans have for re-enactors and Living History. Talking to them about their experiences became a real interest for me. By using the camera to record the events, free from any sight of 'tell-tale' modern sights in the background so they are as realistic to the period as possible, I manage to get great results and positive comments.

However, John quickly became aware that he himself was too noticeable at events in his modern attire and he realised that he didn't fit in with the backgrounds either:

I had no uniform and was clearly defeating my own aims and objectives, so Arthur lent me an American paratrooper's uniform, with hundreds of pockets for lenses and other items. Shortly afterwards I purchased my own uniform and equipment and I now portray a US Army war photographer so this reflects and acknowledges the role of the photographers on the frontline in real combat situations during the Second World War. I have looked at many period photographs and have tried to get every detail as accurate as possible. I believe it is important to present re-enacting as an extension to the 'look' of those past times. The spirit of camaraderie between veterans, re-enactors and the public always makes for a memorable day out. From veterans who are busy re-living their first-hand experiences to the families who dress the part, of all these things, listening to the veterans talking to the young children is the most rewarding experience. The veterans know that the children will remember them and their comrades and in turn, the entire wartime generation will never be forgotten. I wouldn't miss being involved in re-enacting events for the world.

Arthur now 'chips in' with more information about Blitz and Peaces' living history presentation:

We have created an online museum at our website www.blitzandpeaces.co.uk. We started this about five years ago and although it's very time consuming we have had great fun putting the various sections together. This is a free facility and is used by schools and enthusiasts all over the world who are either studying or researching the Second World War. There are now specialist sections for militaria, vehicles and military modellers on the site. With over 2,500 high quality photographs of wartime items in the museum section alone, it's growing all the time.

We have supplied photographs to many periodicals and publications from all over the world and the website includes a series of selected photographs taken at events which we have performed at over the last six years. We work with many Living History events and groups, such as the Military Vehicle Trust, Museums, the National Trust, Schools, Age Concern and many residential care homes all over Britain.

Jane Hindle, a member of the team, portrays a WRNS second officer and is very committed to the ethos of remembrance:

A complement of Wrens stationed at one of the Royal Navy shore stations, in this case a communications centre. Reproduced courtesy of Marion Loveland.

Blitz and Peaces is more to me than just singing the wonderful songs from the 1930s and 1940s. We also spend many hours talking with members of our audiences and listening to them as they recall their memories which are 'jogged' by familiar songs, uniforms and objects we take with us. On many occasions it has been a very emotional and humbling experience for all of us.

By regularly performing the songs from the period, we help to keep their memories alive and we also ensure that future generations will remember and respect with sensitivity, the price that was paid for our freedom.

I have two children of my own and like any other parent, wish them a happy and peaceful lifetime. Having served in the WRNS myself during the Falklands conflict, I saw how some lives were adversely affected by the horrors of war and I also understand the responsibilities faced by the Armed Forces in serving their monarch and country. Through Blitz and Peaces, I feel that we remember the hope and spirit of a nation at war, whilst celebrating the importance of peace in our lifetime and for future generations.

Back to Arthur now who has a lot more to tell us:

We give Home Front talks with music and songs in schools and this is a very rewarding experience for everyone. By exploring the meaning of the lyrics in the popular songs of the time we are reflecting the school curriculum at Key Stage 2. We help children learn about the short- and long-term effects of war.

This also stimulates them to understand the principles of the recycling drives, healthy eating, fuel conservation and 'make do and mend', all schemes which were in place during the Second World War, but which are being rediscovered again as an everyday necessity.

To conform to government recommendations, Blitz and Peaces members have current enhanced CRB checks. They are also sponsored by Britain's leading living history event insurers and have public liability insurance cover of £2 million, which is the minimum cover required now by schools, local councils and the National Trust:

It is a large outlay for most living historians, but we feel it is important to meet with present professional standards of Health and Safety and liability and so are very fortunate to have this sponsorship.

The four-piece band gives cabaret concerts or sing-alongs and living history walka-bouts at events. They entertain people with history, humour and harmony vocals, using restored period instruments and wearing period dress whilst performing at events and venues all over Britain.

Blitz and Peaces encourages all generations within families, children, parents and grandparents, to get together to celebrate Britain's heritage through song and light-hearted humour. They also carry wartime artefacts at events and offer them for discussion and comment to the public. It helps the public to relate to how life in wartime Britain did or would have affected their lives. By making these experiential comparisons between then and now, children especially can learn so much about their own history and how it contributes to their future. It also creates photo opportunities for people to take away as memories of a fun family day out.

Arthur recalls how his interest in re-enacting was inspired by music:

My own love affair with the songs from the era started around the same time as my interest in militaria. We had a large garage at home filled with ex-military radio equipment and other delights such as magic lanterns and wind up record players. My grandfather's and father's early Shellac 78 records were stored in this Aladdin's cave of a garage, I used to go out on hot summer days

and put on records by the Merry Macs, Glen Miller, George Formby, the Mills Brothers and a host of other well-known artists from the 1930s and 1940s. I still have the record player and records now and by the way, the record player is still in good working order. It was around this time that I started investigating how mechanical things worked and how I could develop the skills to repair them. I have subsequently spent many years finding old, abandoned instruments and have repaired them to bring them back to their former glory and I use these during our performances. I have also spent many enjoyable hours learning and working on the songs I heard in my youth, giving them unique musical arrangements with the most sympathetic treatment to the original tunes. It gives me great pleasure at performances to hear the veterans and older generations singing along with songs of the war years, bringing back memories of their own youth.

Developing Second World War characters is a more recent activity that the very energetic group has now embraced. Paul Boeree is a new member of the team and has been developing has own characters, including Chester Drawers, the local spiv. He has been studying how these 'black market bounders' created, for example, smoking clubs for children who, in return for a supply of 'smokes', would be sent into bombed houses to loot the premises. The spivs knew that looting was a capital offence for an adult in wartime Britain, but was merely a cautioning or at most a 'birching' offence for a child.

Paul has also investigated the role of the 'Fence' and the 'Pram Raider' and says that he has a lot of fun with families as he tries to encourage them to buy black-market goods from his original vulcanised fibre suitcase.

Paul adds that:

So one of my favourite characters is 'Chester Drawers', the Spiv. I talk to the children at events about how many sweets they could get with their sweet ration coupons and I also give away wartime sweets such as Kit-Kats with the wartime blue wrappers. I tell them about the old money too and how it compares with today's money, usually giving them an old wartime dated penny or thruppeny bit as a keepsake. The other main character I portray is Captain Bernie Bridges of the Royal Engineers. The 70-year-old uniform I wear is really comfortable and is in incredibly good condition. It makes me look like I'm someone in authority! The audience often gets quite a surprise

Preserved steam railways provide an excellent background for portrayals. Reproduced courtesy of B.J. Wilson.

when they see me dressed like this before a performance, then when changing character, I talk about egg rationing and keeping chickens during wartime whilst playing a ukulele bass and believe it or not, making chicken noises!

The wide remits of re-enacting can sometimes take us all by surprise! Arthur adds:

Other characters that we've been working on recently are Winston Churchill and his most famous wartime speeches. I have been teased for years by the rest of the members about my resemblance to him, not least for my portliness and love of mimicking his voice. Lesley meanwhile has been working on the vamp

The camaraderie of re-enacting is unquestionable. Reproduced courtesy of Arthur Cook.

look and performance style of Marlene Dietrich, teasing the audiences with performances of Lili Marlene and 'Falling in Love Again'. Not quite Home Front, although of course the songs were well known in Britain at the time.

I asked Lesley to tell me more:

Social history will always be an interesting subject for many people. I think that the 1940s holds a particular fascination because there are so many facets to the period. For example, the music, the fashions, the home front and the changing roles of women in particular all still have a resonance today.

Furthermore, most families still have a connection to this period through their parents' or grandparents' experiences. As a singer and historian with Blitz and Peaces, it is lovely to engage with people through music, especially with families where the older members are included and genuinely enjoy their trip down memory lane.

By giving the public a hands-on living history experience, engaging them with the songs, characters and feel of the Home Front, the team hope that their audiences will enjoy the performances and share a greater understanding of what life was like in Britain during the war years. Even if they were not members of the wartime generation, Blitz and Peaces hope to give them a real opportunity to experience the sights and sounds of the Home Front. Lesley explains the importance of this role to the Blitz and Peaces team:

> We particularly enjoy working with Living History societies, and museums because we can work in conjunction with the staff and exhibits to bring a new dimension to a special event. We also help to publicise and promote events for these organisations, from our website and occasionally with on-street leaflet distributions.

Over the years, Arthur and Lesley as the creators of Blitz and Peaces have met and performed for hundreds of veterans and other members of the wartime generation that were struggling against the privations of the Home Front. They have willingly shared tales of their own experiences, some horrific, some tragic and some highly amusing. One of the most common of all comments that these people have shared is that, whatever their experiences, they felt that the community spirit was stronger during the war years and whatever hardships they faced they felt alive and fulfilled, however small their part was in securing the future.

It must never be forgotten that they also represent our diminishing first-hand, primary resource from this period of our social history and, as they reach their twilight years, it is important to listen and learn from their experiences. By encouraging them to share their memories we can learn by past mistakes and help to empower future generations: 'We have worked with many veterans' charities over the years to help raise funds. D-Day Revisited, the Royal British Legion, the Royal Marines Association and Help for Heroes are a few that we regularly perform for,' adds Lesley.

Re-enactors reflect the fashions of the era. Reproduced courtesy of Robert Baker.

Resting on their laurels is not a situation Blitz and Peaces will even consider. Despite their already hectic schedules, they manage to find time to organise and lead war walks in their home town of Exmouth in Devon. These take place on Wednesdays and some Sundays and they last for an hour and a quarter following an easy route round the town. Participants are told about Exmouth's role during the Second World War and they also look at the changing face of the town. The town was attacked and bombed many times during the war so there is plenty of information to pass on so, not surprisingly, the walks have been well received by locals, schools and visitors to the town. They also give war talks to clubs and societies all over Britain. Titles include: 'The Home Guard', 'The Home Front and Women's Roles in World War Two' and 'Children's and Evacuees' lives in Wartime Britain'.

Re-enactors always welcome the opportunity to support our veterans. Reproduced courtesy of Andrew Wilkinson.

Blitz and Peaces have their own radio show on Exmouth's Bay FM (107.9 FM) community radio station. They produce three, two-hour wartime shows a year, aptly called 'White Christmas' and 'Sentimental Journey'. The shows feature live music and interviews with war veterans, local history, menus and, above all, humour. These shows are broadcast during the annual Exmouth Festival and during Off Com test broadcasts, prior to the station gaining its full broadcast licence, scheduled for 2012 when it will serve the south-west.

It is in this way that groups like Blitz and Peaces use the music of the era to engage with a whole new audience through re-enactment, education and living history.

7

THE PRICE OF GREATNESS
IS RESPONSIBILITY

A good portrayal is only limited by one's knowledge and one's finances.

Whilst this probably applies to almost all re-enactors, it is even more applicable to those who portray high-profile wartime characters. With this in mind I could not miss the opportunity to discuss the finer points of being 'in the spotlight' with two established and well-known re-enactors. I also met up with a re-enactor who has made a great impression in the short time she has been attending events with her unique portrayal. It's no coincidence, however, that we consider first the impressions of Winston Churchill, for there are many portrayals of this great man within the re-enacting community even though, based on height, weight, stature and the unique voice, it is one of the most difficult to present well and convincingly. So it is to Linda Herbert I turn for details about her husband Derek who, over many years, has delivered one of the most recognised and well-known Churchillian portrayals. Linda tells me how 'from an early age' Derek has been fascinated by the 1940s era, 'particularly the music', and as he has grown older his keen interest in the Second World War has increased. This is not least because his father had seen active service during the war and was awarded the Military Medal for acts of bravery in El Alamein and Monte Cassino. Of all the well-known wartime figures, it is the great wartime leader, Winston Churchill, that Derek admires most and his special interest is in Churchill's role in the Second World War. Derek is a natural mimic so when a friend suggested that because he could change his voice to impersonate so many characters, he should pursue a career as a Winston Churchill portrayer, Derek decided to rise to the challenge.

Derek Herbert's portrayal of Churchill is one of the most recognised. Reproduced courtesy of Derek Herbert.

One of Derek's favourite Churchill's quotations is 'Cometh your hour, cometh your man'. As a true professional and a stickler for perfection, Derek throws himself wholeheartedly into the character. He has painstakingly sourced clothing and accessories to best replicate Churchill's appearance. These include a dark, heavy, three-piece suit, the famous Homburg hat, navy-blue and white-spotted bow tie, the correct Romeo and Juliet 'Churchill' cigars and the pocket watch with chain. Not forgetting, of course, another essential and one of the most important accessories, the Churchill spectacles. Interestingly, because of the Churchill 'connection', Derek was approached by the spectacle manufacturer that had supplied Winston Churchill and several Churchill family members for over a hundred years with many spectacles. They wanted his assistance in bidding for an original pair of Churchill's spectacles when they came up for auction. Derek was dressed in full Churchill attire and was given the opportunity to wear these original spectacles for photographic and publicity purposes. When he was subsequently interviewed by a radio station, he remarked what good fortune and what an honour it had been to wear something that his 'hero' had worn.

Indeed, the perk of many portrayals is the opportunity to be involved in promotions, television and film work, as well as corporate events; however, the driving force for most re-enactors is to explain to an audience what the characters they are portraying endured during the war, what life was like on the Home Front and how important it is to continue educating new generations about the sacrifice and dedication of a past generation, whose experiences are still within living memory.

Linda continues:

> When performing at functions or events, Derek aims to demonstrate to all age groups, particularly teenagers and children, how much Churchill loved Great Britain and what he did for the British nation. The fact that Britain has freedom and democracy today is due in part to Winston Churchill's strong and inspirational leadership and the British people's resolve to survive against overwhelming odds, especially during the country's darkest days.
>
> Derek will converse in character as Churchill with the general public at these events and functions and because of his knowledge and awareness of Churchill's role during the Second World War, he will engage in healthy debate about Churchill's involvement, policies and decisions made at that time. Derek is so eager and passionate to keep the memory of this wonderful man alive and prominent in history and educate those who are unaware just how Winston Churchill helped to save the British people from defeat.

Derek's appearances as Winston Churchill have taken him to many events and locations throughout the United Kingdom, including Goodwood and Bletchley Park. He continues to travel widely to fulfill his commitments, be they veterans' events, public events or private functions and dinners; in fact, like many of his contemporaries, Derek is in demand throughout the year. His dedication and attention to detail are frequently rewarded by favourable comments, such as one from Radio Merseyside: 'What a great impersonation, his tone of voice, inflexions and pace were precisely those of the great man', and from a professor of history at York University: 'Almost better than the real thing.'

At these events Derek mixes and mingles with the public and guests, providing photographic opportunities. If required, and without too much encouragement, Derek will deliver one or two of Churchill's famous wartime speeches, including the oft-quoted but always moving Battle of Britain speech.

Following in his father's footsteps (in his later years his father was an after-dinner speaker at many golf functions), Derek decided he wanted to share his interest in the life of Winston Churchill. Therefore, not only is he a very convincing Winston Churchill impersonator, but he also delivers an interesting and informative talk on the life of Winston Churchill, culminating with the Battle of Britain speech, 'in character'.

Many people see Churchill as embodying the salvation of Britain against tyranny during the war and Derek admires Churchill for his many varied talents and achievements including his sturdy leadership during the difficult times. Winston Churchill was not only a brilliant orator, but he also wrote prolifically and was awarded the Nobel Peace Prize for Literature. Winston Churchill was truly a unique person, the like of whom we may never see again. This is one reason why Derek is so determined to keep the memory of him alive.

In contrast, another prolific portrayal is that of one of America's finest, the legendary, sometimes controversial and always memorable General George S. Patton. Until my meeting many years ago with George Patton Kimmins, I had never come across a re-enactor who portrayed one of the war's legendary military leaders, especially one who was known for his belligerence. I was therefore unsure as to

George Kimmins has gone to great lengths to research and present his well-known portrayal of General George S. Patton. Courtesy of B.J. Wilson.

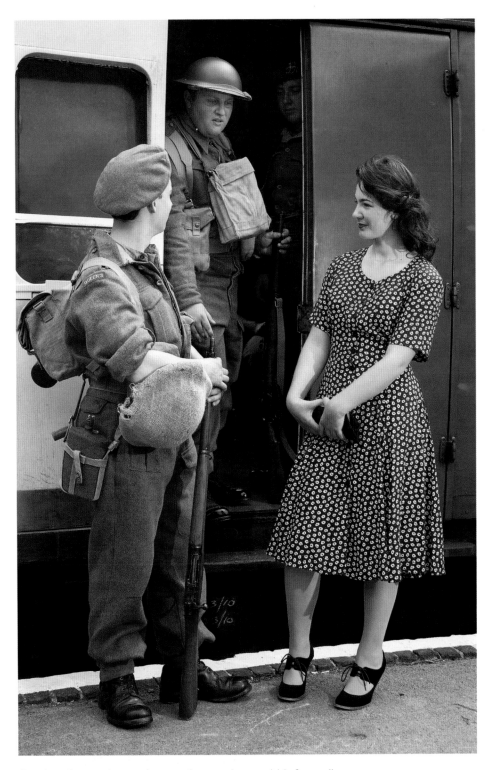

Another day, another station; another serviceman bids farewell.

what I would make of such a re-enactment. Yet George the re-enactor was from the outset not only very knowledgeable about his subject, but also the complete opposite of the man he was portraying, not least, as he said, 'because I want to be approachable and I want to be known as much as an historian, as a re-enactor'.

At the time of our first meeting, George and I spent about an hour or so sitting and talking about re-enacting, his passion for Second World War history and, in particular, his total fascination for General Patton. Over the years George, the re-enactor, and I have crossed paths many times, always taking time out to share a few words about our mutual fascination for and enjoyment of re-enacting.

George was born in the village of Chailey in Sussex and one of his most abiding memories is playing with his 'Dinky' toys, all of which were models of army vehicles: 'I recall assorted full-size military vehicles travelling backwards and forwards along the road outside my home and the Italian POWs marching past.' For a child of the war years this was all exciting stuff. 'Sheffield Park House nearby was a base for the French Canadians so there was always a lot of military activity in the area,' said George, who mentioned that Sheffield Park is now a station on the Bluebell Line preserved steam railway, which is, incidentally, one of the longest established and most popular 1940s re-enacting venues.

He recalls:

When I left school I had no real idea as to what I wanted to do and I almost drifted into what was called a machinist carpenter. This was followed by a brief spell in the army and I was posted to Windsor and later I went overseas to Aden. I returned to the building trade, however my association with the military did not stop there. I had an interest in motorcycles and in 1959 I turned that interest into stunt riding.

It was during this time that George met Peter Grey, who started what became the Military Vehicle Trust (MVT), and then Joe Lyndhurst, whose militaria fairs in Sussex in the early 1980s became renowned: 'I became part of the "Hell on Wheels" show which did a lot of events, most of those were in the Brighton area.'

In the early 1980s, when George joined the Fort Newhaven Display Team, his photograph appeared in the local paper and the caption to the photograph referred to him as General George Patton. This was apparently an assumption made by the caption writer, possibly because George, in American military uniform, was photographed with a Montgomery re-enactor:

Gill Turrell is amazed at the positive response she receives from the public. Reproduced courtesy of Alex Fyfe.

I subsequently began portraying the great man and in 1984 I travelled to the United States for the purpose of researching my 'character'. Getting the correct uniform, boots and side arms has been a challenge and a labour of love. Out of respect to the General, I have spent many thousands of pounds on achieving the most accurate portrayal. I am particularly proud of my original 1916 riding boots which are in superb condition for their age. However, most people are interested in the pistol I carry which is a Colt Peacemaker. I carry just the one gun, I don't use a back-up Smith & Wesson .357 Magnum which is the type also associated with Patton.

Patton was an expert shot, of course, and admired by many of his men for his skills with a handgun.

Some of the many highlights in the 'career' of George Patton the re-enactor include, significantly, his name change from 'Mr Kimmins' to George Patton Kimmins and being giving 'official recognition' by the Patton family, with whom he has become firm friends. Not least, George also cites taking part in a 'huge' parade in the town of Spencer, Massachusetts, where he received a rapturous reception for his portrayal: 'I started the Patton Appreciation Society in 1991, membership is still growing even

Alan Oliver is well known for his portrayal of Bernard Law Montgomery. Reproduced courtesy of Alan Oliver.

Tony Bird, veteran RAF pilot and former POW meets General George Patton the re-enactor. It was Patton's army that liberated the prison camp where Tony had been held. Reproduced courtesy of Cathy Hughes.

today and I have followers in many countries, they contact me regularly and others travel to see me at shows.'

'However,' said George, 'I still have an ambition and that is to appear in a movie in a proper speaking role. Although I was in the 1979 film *Yanks* playing the part of an MP, to have a recognised part would be wonderful.'

We may never know the real truth behind the life and death of General George S. Patton and the events of December 1945, yet one man has dedicated many years of his life to portraying the general so that we never forget his contribution and that of the troops he led. It is through re-enacting that we all carry forward the memory of and remembrance for those who served for the cause of freedom. George Patton Kimmins, as one of the longest established, most respected and most well-known re-enactors continues to wave the flag of history. During the war, General Patton spent time in the United Kingdom and his 'association' with the Home Front includes his albeit brief stay at Breamore House on the Hampshire–Wiltshire border where he had a headquarters unit. George the re-enactor is regarded as one of the most genuine, affable and most well-liked re-enactors, taking as his lead the words of Patton himself, 'If a man does his best, what else is there'.

From established high-profile re-enactors, we consider another re-enactor who, although she is fairly new to the community, has become almost an 'overnight success' with her excellent and unique portrayal of Her Majesty Queen Elizabeth (the Queen Mother). Gill Turrell is a very unassuming, friendly and dedicated woman who, like most re-enactors, has thoroughly researched the character chosen to be portrayed. To achieve authenticity to the highest degree, out of respect to the character she portrays, Gill says, 'Realising that unlike many re-enactors who find it relatively easy to source uniforms and kit, I couldn't buy items off the shelf, I decided to have replicas made of some of the Queen's most iconic dresses, hats and coats'.

She tells me in conversation during a break from one of her many engagements that:

My husband and I have been taking part in re-enacting for nine years. Ray is always looking for new projects and about four years ago, he came up with the idea that I could do a portrayal of Queen Elizabeth. He thought there was a similarity because I am the right height and size and have dark brown hair, just like Her Majesty. So we began our research by viewing documentaries and we also sourced royal related books for photographs of Queen Elizabeth in the 1930s and 1940s. We then studied the style of clothes she wore during the Second World War and fortunately were able to source a designer and dressmaker who

HM Queen Elizabeth, the Queen Mother (Gill Turrell) with her official party. Reproduced courtesy of Alex Fyfe.

HM Queen Elizabeth and Home Secretary Herbert Morrison meet some new recruits to the fire service. From the author's collection.

could make copies of the outfits. We managed to find natural fabrics in the right colours and replicated the Queen's jewelry and furs from antique fairs.

Having gone to great lengths to achieve the right look, the big test was just ahead. What would the reaction be to this unique portrayal? 'The first big event I took part in as Queen Elizabeth was "Salute to the Forties" at the famous Chatham Historic Dockyard in Kent', said Gill:

We were overwhelmed by the reaction we received. We arrived by car and as we turned the corner we could not believe the size of the crowd that had lined the route on my way to board HMS Cavalier. It was such an enjoyable and unforgettable experience. I have been told of comments that have been made, such as when I got out of the car I sent 'shivers' down the back of some veterans and members of the public. And 'I light up the room' with my smile, just as Her Majesty did back then. I later took part in an event at a preserved steam railway and again received great reviews from fellow re-enactors, veterans and the public.

Of all the events attended so far, I asked Gill which one proved to be the highlight:

The highlight for me has to be 'Heroes at Highclere', a huge charity fundraising event which was staged in the grounds of Highclere Castle in Berkshire. This event was to raise money for the Royal British Legion, the Army Benevolent Fund and Help for Heroes and my role included sitting in the Morning Room talking with my 'Lady in Waiting' as VIP guests came past on a private visit. Afterwards I mixed and mingled with the thousands of visitors in company with Ray who portrays my private detective. I was one of a 100-strong team of re-enactors that was specially invited by the organiser to help create atmosphere and add an experience for the visitors on the day. It was a superb event and for a lot of great causes. I have a great regard for the soldiers who fought for their country and left their families behind. Times were hard, but the nation pulled together and supported each other. It was real community spirit. It's wonderful to be able to remind the veterans of some of their memories, and also to help recreate a part of their history and the nation's history.

Often imitated, never bettered applies to Iain Dawson's well-known portrayal of Viv the Spiv. Reproduced courtesy of Iain Dawson.

The *Spivs Annual.* From the author's collection.

The pin-up derived simply from servicemen 'pinning up' a photograph of their loved ones. Reproduced courtesy of Annie Andrews.

Gill's efforts have received wide acknowledgement and acclaim and in a short space of time she has been invited to attend some of the re-enacting communities' most prestigious events:

I am overwhelmed by the support shown by the public and by fellow re-enactors. I didn't realize how amazing the 1940s community is, the enthusiasm, the commitment, the length that people go to in portraying their characters and the knowledge they have. The reaction is quite incredible. I enjoy every moment of the experience and in my own way I am contributing to keeping our history 'alive' and in the public consciousnesses.

There are, of course, other re-enactors who portray well-known characters, including Iain Dawson; his character Viv the Spiv is well established and very much part of the re-enacting culture in the United Kingdom. He says, 'Home Front re-enacting is important because by keeping the past alive, we can all appreciate and honour all those who endured so much in so many ways.'

We must not forget Montgomery. Leading exponents in this role include 'Mickey' Barr and Alan Oliver, who have made many hundreds of appearances between them. In contrast and on a lighter note are the portrayals of George Formby, portrayals based on some of the glamorous starlets and pin-ups of the era and some wonderful singers and groups, including Lola Lamour, Heather Marie Hale, Marina Mae and Kitten Von Mew, as well as the Swingtime Sweethearts. They are each in their own way helping to create the vast jigsaw that is the reflection of life on Britain's Home Front during the Second World War.

8

'PLAYING THEIR PART'

Living history has many roles including the most important, those of education and remembrance. This is recognised at one of the world's foremost museums.

One port of call on our voyage of discovery relevant to re-enacting and the contribution it makes to education and remembrance is the military enclave of the Royal Armoured Corps Camp in Dorset and the world famous museum that has painstakingly created a historical tribute to the tank. For 361 days of the year the Tank Museum's doors are open to visitors who wish to explore the world's finest and most historically important collection of tanks.

The Tank Museum, Bovington, like the annual act of remembrance itself, was a product of that early twentieth-century cataclysm, the First World War. In the first 'industrial' war, the world's leading powers sought battlefield advantage in the deployment of new technology. One such development was the tank, which made its debut on the Somme in September 1916. The Tank Corps established their training centre in Bovington and this garrison village still remains the home of the Royal Armoured Corps, as well as, not unsurprisingly, the home of the Tank Museum. Some people have argued that the tank was introduced to save lives because its *raison d'être* was to restore mobility on the battlefield and break the stalemate of trench warfare. Unlike the vulnerable infantry, the tank could cross no-man's-land with its crew reasonably protected in the steel shell, then it would attack the enemy in their trenches.

One example of how successful the tank could be was recorded on 20 November 1917. At Cambrai, the Royal Tank Corps made the first massed tank attack in history. It was devastatingly effective and, in the most rapid advance of the war, the tanks breached the German lines and pushed on for 7 miles in just a few hours. To put this in perspective, a similar sized penetration by the infantry had taken three months at a cost of 250,000 casualties. Nik Wyness, the museum's marketing communications manager, explains that 'On that day The Tank Corps, the unflinching pioneers of armoured warfare, sealed their place in history. It is a day marked by the Royal Tank Regiment every year with soldiers remembering and reflecting on the achievements of history's first "Tankies".'

The months and years that followed the end of the First World War saw an exhausted nation grappling with the tragedy of its wartime experiences. The first Remembrance Day to mark the anniversary of the armistice took place in 1919, at a time when almost every town and village in the country had at least begun to undertake the commissioning of a memorial to their war dead. The Imperial War Museum was opened to the public in 1920 as a record of the 'toil and sacrifice' of 'everyone who took part in the war'. There was clearly a national desire to remember and commemorate in order to come to terms with the collective trauma of the First World War.

During this time, the vast amount of redundant tanks were being returned to Bovington from France. On the fields on which the Tank Museum now stands, the majority of tanks were cut up for scrap. However, in 1923, the writer Rudyard Kipling visited Bovington. Kipling had lost his son in the fighting at Loos in 1915 and was serving as a member of the Commonwealth War Graves Commission. It is said that he had seen the rows of tanks being broken up and petitioned the War Office to ask that one of each type was saved for posterity. This foresight ensured the survival of 'Little Willie', the world's first tank, amongst a number of others and the subsequent establishment of the Tank Museum with what has now become regarded as the finest and most historically significant collection of its kind in the world.

Nik Wyness adds:

At first, the Tank Museum was a part reference collection and a part training facility providing designers with inspiration and helping to instil *esprit de corps* in a new generation of recruits in training at Bovington. The 'war to end all wars' failed to live up to its promise and as a result the Tank Museum's collections continued to grow. The close of the Second World War, during which the tank 'came of age', then had an influx of new vehicles from all belligerents

as well as a number of rare prototypes and experimental vehicles. It also heralded the Tank Museum opening its doors to the general public for the first time.

Now an independent museum and registered charity, a close association with the Royal Armoured Corps and Ministry of Defence has ensured that the Tank Museum has been gifted contemporary vehicles as they become available. This has always enabled the museum to tell the story of the Royal Armoured Corps to its most recent deployments. In 2011 an exhibition was completed which examines the most recent conflict in Afghanistan. Today, the Tank Museum is the most successful regimental museum in the country, a vast indoor museum and visitor attraction at the heart of the 'Jurassic Coast'.

Nik adds:

The role of The Tank Museum is to tell the story of the development of the tank and the story of the men that served in them. Any historic collection reflects the human desire to create a focus for education, reflection, empathy and the respectful commemoration of past events, human acts, and people. The Tank Museum is no exception. Visitors to the Tank Museum are, perhaps at first, stuck by the size, range and number of the objects on display. Unlike other forms of military transport, there is no civilian equivalent of the tank and there are few places in the world you can come face to face with what is an iconic weapon of war.

Our exhibitions introduce the visitor to the reasons why the tank was invented and how the rudimentary nature of the early tanks made life for the crew far from pleasant. The development of the tank is put in to context with the economic and political factors of the time, and, where possible, the story is told in the words of the soldiers themselves. Our medal collections tell stories of individual acts of courage and bravery, and our supporting collections bring the human aspect of our narrative to life.

Whilst there can be no doubt that a museum visit is an informative and educational event, a visit to the Tank Museum is one that often gives the visitor a more immersive and contextual experience. The visitor cannot help but put themselves in the shoes of the soldier and wonder what it was like. They will surely leave with

a much greater understanding of and respect for past and present servicemen. For evidence of this, you need look no further than the museum's visitor book – it is certainly worth spending a few moments to ponder on the comments.

Nik believes what makes the Tank Museum such an engaging experience is the way in which it is able to bring the subject to life in a way few others can:

Our 'Tank Action' displays add another layer of understanding to our subject because by hearing the roar of the engines, the thunder of the tracks and by feeling the ground vibrate, everyone then can start to truly appreciate the power and impact of the tank. In tandem with this, the Tank Museum has come to value the support of Living History re-enactors during its key events of the year. More and more museums and heritage attractions are turning to Living History associations to help add value to the experience of their visitors.

This illustrates how what was once seen as a fringe hobby has grown, organised and manifested itself into a mainstream, professional and well-respected body of historical specialists. Well-led and self-regulating re-enacting groups have become trusted partners of organisations such as the Tank Museum. With high standards of professional conduct and historical accuracy, they are intolerant of those who are insensitive or irresponsible in their portrayals. Within this lies the synergy with modern heritage organisations, which cannot afford to associate with anyone who would advocate anything less.

At Tankfest, a major annual event, re-enactors representing a variety of nations at various points during the twentieth century create realistic encampments showing how soldiers of the past lived and fought. Living history re-enactment is a hobby, but with a strong public service element, as most re-enactors consider sharing their knowledge and passion with the general public an integral part of the activity. Nik comments:

They actively engage with our visitors and interpret the scenarios they depict. These interactive presentations give observers a sense that they are stepping back in time and actually meeting the protagonists of past conflicts. Seeing weapons, uniforms and equipment in a case at a museum is great, but it is difficult not to agree and appreciate that seeing these items worn and used, makes the capacity for understanding that much greater. Yet, importantly,

re-enactment is not just a case of 'playing soldiers'. Re-enactors care a great deal about the heritage they represent. In collecting and preserving artefacts and objects, they are helping to ensure the continuance of traditions, skills and activities that may otherwise be lost to history.

They are perhaps most well-known for their participation in explosive mock battles, a great spectacle, but with an important point behind them. Re-enactors admit that these can only ever be a pastiche of the 'real' thing. But for the spectator these are illustrative of conflict, as they attempt to convey the sights, sounds and smells of combat. The Tank Museum has yet to witness a battle re-enactment that did not conclude without the participants standing in silence in memory of those who were not able to get up and walk away when the shooting stopped. After the cathartic excitement of 'battle', this is an appropriate mark of respect in which the 'performers' lead the audience in a few moments of reflection.

On Remembrance Sunday every year, the Tank Museum hosts Bovington Garrison's remembrance service. Several hundred soldiers and visitors fill the Tamiya Hall to mark the two minutes' silence. To these soldiers remembering those who have given their lives is no abstract concept. In fact it has far more resonance and immediacy for them than it does for most civilians of a similar age. Some will have lost friends in Iraq or Afghanistan, others know that they too will soon be in the combat zone. Nik adds:

It is a reminder to us all that we remain a nation at war and, by extension of our remit, we are able to educate the public to enable them to understand the work our soldiers have done and continue to do for the nation they serve. In linking the present and the past, military museums make their contribution in communicating to their visitors the continued relevance of the act of remembrance. In their faithful portrayals of the soldiers of the past, living historians play their part too.

Albeit in diminishing numbers, there are still those attending remembrance services and military museum events who can well remember the great historical events that are often the subject of museum displays and living history. Men who survived Dunkirk, El Alamein, Sicily and D-Day, for example, and the war in Europe and the

American infantrymen practise on the rifle range. Reproduced courtesy of Tank Museum.

Pacific can remember the events of their youth without the romantic haze of nostalgia that is human nature to apply long after the event.

Good museums and good living historians will go to great lengths to ensure that veterans and soldiers approve of the way in which their activities are presented. Museum staff take great care in faithfully and respectfully interpreting the stories of previous generations at war, so too the amateur living historian remembers that their activities must do the same. The uniforms and equipment they wear are representative of conflict and are clearly symbolic of human tragedies and triumphs, which for some are still within living memory.

Respect for the subject matter is essential to ensure that those whose heritage we communicate is honest and appropriate and does justice to those men and women whose stories we tell. At the same time we must also inspire the audience, to both educate and instil a genuine reverence for those previous generations who have found themselves at war, something, mercifully, few of us have ever had to endure.

As the years pass, the nation as a whole is becoming further removed from its recent military heritage. In closing, Nik offers this salute to re-enacting:

Together, museums and living historians have a role to play in ensuring that the spirit of remembrance and understanding is kept alive for generations to come.

NOTES FROM A WARTIME DIARY

'Bill' Billington had a reserved occupation during the war. He was a baker, but he also served as a member of the Home Guard.

One of the lesser known, yet vitally important, reserved occupations was that of a baker for they were tasked with not only supplying the military, but, in many communities, with turning their premises over for use as emergency feeding stations. Referring to anecdotes of life on the Home Front, whether they are told in person or are taken from diaries, is an essential part of 'understanding and researching the role' that individual re-enactors choose to portray. In this chapter we review the wartime diary of 'Bill' Billington, the baker.

Bill recorded:

In March 1940, a few months the year after the Second World War broke out, Alan, our third son was born. When he was still only a small baby he had to go into hospital for an operation. He had a condition that is not uncommon, but which was very distressing. The muscle at the bottom of his stomach was too tight, too restricting, which meant that a short while after he'd been fed the whole feed would come back, described as projectile vomiting. Luckily however, he came on like a house on fire after the operation.

In 1939, almost everybody knew that Hitler would ignore treaties. Churchill was called a 'War Monger', when he said in Parliament that we should be re-arming, in contrast, Russia was said to have a 'Guns before Butter' policy. The whole world was against Russia because of the secrecy surrounding its armourment [sic] programme. In Russia the Church and the Monarchy no longer had power, previous to this both organisations had kept the people down as peasants and before the Revolutions, they even had to seek permission to collect fallen branches for firewood.

When war was declared, Britain was not fully armed and was ill prepared, so Churchill had been right all along! There was a mass undertaking then to produce aircraft, tanks, guns and bullets however, if Hitler had bombed the country from the outset, we would have been sitting ducks and we wouldn't have stood a chance!

The Germans were only limited, with regard to building their battleships, by the Armistice that followed the First World War. Their ships and their naval fleet were not as big as ours, but they did have the latest equipment. To begin with we had to make do with used American equipment and out-dated equipment from our own resources.

I passed the medical for the Army, but because I was the only able-bodied person left of call-up age at the bake house, I became exempt from military service. I had a helper later on, a Bob Jones, he had been working at Scotts in Dunnings Bridge Road, previous to that he worked at Costigans, Stanley Road, Bootle, but when he went to work one night the place was not there, it had been bombed. He said jokingly that Hitler sacked him!

Bob was a real gentleman at 70 years of age, sadly he didn't even know his parents because he had been fostered as a child and an Irish family had bought him up. Incidentally, the ingredients for baking changed during the war, for example there were no frozen egg from China and dried fruit was only a percentage of what you usually got. We had to have a hundred sacks of flour always on stock, each weighing 140lb. Dried eggs changed your method of mixing and the sugar shortage was another problem, you would mix flour and diastetic malt, then pour hot water on and mix, left in a warm place the malt worked on the starch and you had maltose sugars, it worked well in fermented goods.

The war certainly changed your lifestyle, you had no time for frivolity for example if you were doing fire watching with the Home Guard because this entailed night duty. As well as working days at the bake house, I worked every Friday night from 8pm till 6am Saturday, baking for the weekend. When my

work-mate went off to join the Royal Navy, I also worked on Sundays for a couple of hours and this entailed lighting the furnace and going back at night to bank it up so as to be ready for baking on Monday. There was no electric time clock to light the gas, no gas even, only coke. That is why we were registered as an 'Emergency Feeding Establishment.'

The only days I didn't go to work were the Sundays before Bank Holidays. The local Home Guard Unit asked me to help out on some occasions, the worst week was when I did two nights' shore patrol and Friday night at work and then the Sergeant said that I was on 'guard' that night! But I said, 'No!' he had to get some of the 'backsliders' to do their bit and that I had already been on duty three nights that week! Every Saturday when I came home and the tide was right I would go on the shore to look for driftwood because coal was rationed and we needed a fire for hot water. Then on Sunday after Home Guard Parade it was a sawing session and then to the bake house to light the furnace, then after tea back again to bank it up. I did not get paid by the hour, only by the week, what I mean is that whatever I did, I only got paid the same weekly wage.

I had told my dad that he should go to the lectures on gas proofing your home; he went and was immediately taken on as an Air Raid Warden for the Peel Road area of Bootle. Bootle was not mentioned in the news, because it would let the Germans know how badly the place had suffered from bombing. It was thought this would suggest that the enemy was winning and that would not be good for morale. The Waterloo Grammar School playing field had a deep ditch dug and on Brook Vale Bridge a machine gun post had been built so this meant a longer route round to get to the allotment. The first land mines dropped by the enemy I recall fell in a line from Crosby Road to the allotments. One bomb failed to explode so the Royal Navy Bomb Disposal lads dug it out and apparently this was the first intact one that they had had to work on. One night during a raid, 'Jerry' had dropped magnesium flares with a parachute and the sky lit up and you could see the houses in New Brighton clearly. We were patrolling the shore and you could hear the 'plop' of shrapnel hitting the sand, when a fuse-cap from an 'Ack-Ack' shell came whistling down and we heard the 'crunch' as it hit someone's roof. Someone said that, 'some poor sod will have a hole in his roof!'

It was years after when I thought that any one of us could have been hit by the falling shrapnel. Another night at nearly the same spot we were patrolling after a few drinks in the canteen to celebrate someone's birthday when a car came down Holden Road, the headlights seemed rather bright. There was a raid on so we went at the double to see what it was. There were two men in

The man from the ministry kept a watchful eye on every aspect of food production. Reproduced courtesy of B.J. Wilson.

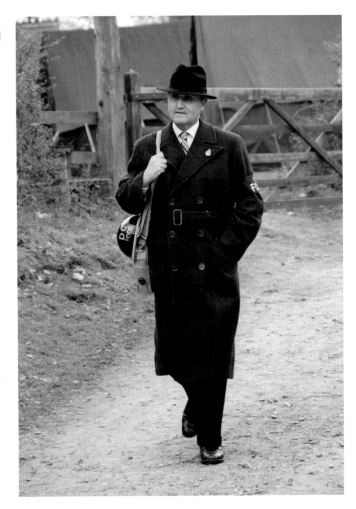

the car, when asked for their ID card one was from the Irish Republic, from Newry and the other chap said they had only moved in that day, so one of our lads reported the matter to the police when we got back to 'Ramleh', Burbo Bank Road which was our Headquarters.

We were trained in the use of Sten Guns and Remingtons from the First World War and the Remington automatic, this was a good weapon.[4] It fired

4 Incidentally Noel Coward's 1943 song about the early days of the Home Guard parodied the shortage of equipment given to the defenders. 'With the Vicar's stirrup pump, a pitchfork and a stave, It's rather hard to guard an aerodrome, So if you can't oblige us with a Bren gun, The Home Guard might as well go home.'

single or automatic, by just switching over. One night on the small rifle range on the golf course I was one of the two best shots, the prize was half a magazine to shoot automatic. We had some characters in our Home Guard Platoon, two of them had been in the first war. I remember that there was an army unit billeted in a big house further up the road, they had a cookhouse and a big pile of coal so when our allowance of coal had been used we had a quick raid on their pile. The man who was sleeping in the house was a man of habit; he went to the Blundellsands Hotel before he went to bed. The cooks riddled the 'slack' out of the coal in one of the garages. I had two sacks of the slack when they vacated the house later on in the war.

The first Anti-Aircraft rockets were positioned on the way to Bootle Stadium. Some of our company were sent there to man the site and I heard one of our lads caused some amusement when the sergeant was trying to get him to do it properly. One chap said to me that 'he can do it, but in his own pace.' No, you can't do things at your own pace in war, the enemy doesn't wait for you! We had a weapon called the Northover Projector, it was like a 6ft length of down spout with the firing mechanism at one end and mounted on three legs. It would throw a hand grenade or phosphorus bottle about 250 yards. These sticky grenades were filled with blasting powder. The bottles that the Northover Projector used were just like the small mineral water bottles and you could see the ingredients in layers, petrol, rubber solution and then the phosphorus. You could not stop it burning as the phosphorus ignites the rubber solution as it sticks to the object that it had been aimed at, for example, the rubber tracks on personnel carriers or light tanks, the cabs of Lorries and pill boxes or anything else that will burn. The Home Guard had lectures and demonstrations on landmines and anti-tank mines although we had none of these devices for our own use. We had a Red Cross man that went on the ambulance service at night. He said that after the land mines were dropped the 'all clear' wasn't sounded until they had cleared the 'bits and pieces' up, because it would frighten a lot of people. The first bit of human remains was an old man's head stuck on the barbed wire by the Ack-Ack battery by Potter's Barn. During lying in guard we had some good talks on various subjects, like what the chaps did in their jobs or businesses. One chap was an African trader, the African merchants told him what they wanted and he knew where to get it. One thing he arranged for example was wind dried fish from Norway. He hired a train to bring the fish from Hull to the docks in Bootle. He said you could tell by the smell what the train carried!

Another chap said his wife once worked at Hartley's Jam Works. When a batch of strawberry jam was ready for boiling they had to go to the office for the little packet with the special white powder, 'a secret ingredient'. One woman tasted it one day and it was bi-carbonate of soda, it saved the firm hundredweights of sugar, this was because the bicarb neutralised the acid in the strawberries and the jam wouldn't taste 'tarty' with less sugar. Another chap was a manufacturing chemist and his premises had been broken into, he said it had most likely been kids. He said the only thing that had been stolen was a quantity of chocolate laxative containing croton oil which had been left to cool overnight in moulds ready to be put into packets the next day. He said the thieves would have their own punishment! Then there was an old chap who lived in Rosset Road who had been a wine steward on the liners sailing out of Liverpool. He used to go to meet chaps he had worked with and when he came back he gave pears and apples he had received from these friends. When I first volunteered for Home Guard service, one officer was just like a small German officer in the First World War films, small with pince-nez spectacles and when marching during route marches on the roads he would walk on the pavement. You can imagine what he looked like with his cane under his arm! We had some young chaps, but not for long, as they were called up.

One Friday afternoon I was on the shore looking for firewood when I came across the Beach Inspector slicing the outer wet layers of what I thought was a bale of peat. I asked if it was peat, he said, 'no, tobacco.' So I said, 'I will have a sack full of that.' I got my sack full and on the Saturday some 'dolls' of Havana cigar tobacco were washed up, so I rinsed the salt off and dried them. That was the start of the blend 'Seadrift' mixture, which I cut it up with scissors. 'Jacko,' was our training sergeant and he christened it because the smell was like cigars. Anyway some joker remarked that it, 'smells like there are some war profiteers in the canteen tonight!' 'Jacko' Jackson went on to become The Lord Mayor of Crosby!

One time at the bake house, the furnace door had a broken hinge pin so on the Saturday I arranged for the van driver to take it to the blacksmith's and have a new one put in and I also asked him to get a bucket of black mortar plus 7lb of fire clay. That was another of my contributions to the war effort, an unpaid job as a bricklayer because a professional bricklayer did not want such a small job. Another time the galvanised flue pipe had rusted and the boss had one made. But again no one wanted to do a small job such as fixing the flue pipe, so yours truly gave up his Sunday morning to keep the oven in use. My wife used to say to me, 'If you are never off you are never missed!'

Bill's recollections were very much about the day-to-day challenges and some of the many incidents that happened in his busy days at work and as a member of the Home Guard. He tried his hand at many things, including fishing:

In the winter, when it was frosty you could put lay lines out at low water and pick up shrimps at the next low water. I had a bash at it, digging for lugworms and laying the lines out on Friday afternoon and then a nap before going to work at 8.00pm. It was not always successful I am afraid, but mind you, the best catch I ever had was ninety-five whiting and small cod. I put them in an enamel washing up bowl in the yard, covered up tightly to keep the cats off. Some nights, when it was starting to get dark and as I was laying out the lines on the shore, I could hear the sound of the diesel generators on the ships lying out in the river ready to form up in convoy. You could hear voices too shouting from ship to ship. I was on the shore at low water one Saturday afternoon when the fog came down very heavy, but luckily I had Peggy, a Jack Russell and also a Foxhound which always came on the shore with me when I was laying my lines. I kept calling the dogs and they took me to a break in the barbed wire. I was told when I got home, 'You will be found dead on that shore!' but I said I would be doing what I wanted to do.

John, the youngest of our four lads, was born the night of an air raid. The other children had to be taken from their beds and put in the shelter because of the raid. We knew that something big had been hit because of the flash of light. It was October 20th 1941. Later we found out that the Bootle Gasometer had been hit and had gone up in a fireball.

When it was high tide and we were on shore patrol we just sat on a bench with a view of the shoreline. I can remember one winter's night, there was snow on the ground and as this was the only location we had to stay at for our night's duty. I got down and stretched out under the bench with my rifle between my knees and had a nap. The other members of the patrol asked 'how can you sleep like that?' I told them, 'If you worked like me, you would sleep! The office types were excused going into work till 10am when they were on night duty, there were no concessions like this for me. One bright spot was when we had a hot-pot supper with singers, one young woman sang 'Bless This House'. She was a mezzo soprano, she had a really beautiful voice, and I still remember her name, Madge Evans. The song was very appropriate, as there was an air raid on!

During another air-raid on another evening when we were living over the shop in College Road, a plane came down low and a mobile 'Bofor' ack-ack

gun let fly a salvo and it must have been a bit too close for comfort. You could hear the noise of the plane diving down as it jettisoned its bomb. The bomb hit the gardens in Tudor Avenue right where four gardens met. A chap in Woodvale Avenue got up from bed and as he got to the bottom of the stairs, there was a thud upstairs, he went up and a large lump of clay was on his bed. Next day I went to have a look at the crater, 30ft deep and at the bottom an old fashioned clothes mangle from out of a garage which had been shattered.

At work we had some bacon from America, fatty and dry-cured to eke out the meat for pies and sausage rolls, mixed with the flavoured rusk, it was very tasty. I was telling my son, John recently about the scalded flour and diastetic malt, he said his firm uses something like that! I'm no chemist, but have only an elementary knowledge of chemicals, like how to neutralise acid if you get any on your skin, bi-soda, lime, and chalk will all stop the acid burning into the skin as they are all alkaline and wash off with plenty of cold water.

Before the invasion of Europe the place was over-run with GIs, lorry loads of black GIs who came to the shore for sand to fill sand bags, they were stationed in Maghull. They would stop at Satterthwaite's in Coronation Road, Crosby which is where I worked, for teacakes and currant buns, they would all be sitting on top of the load of sand. One Saturday afternoon I was on the allotment sitting in my shed with Arthur Gibbons having a cup of tea when a shadow passed the greenhouse, the door flew open and a GI complete with fixed bayonet charged in. I asked what was up. He said, 'Some guys have jumped the brig, got out jail, and we are looking for them!' Arthur and I went outside and there was a line of GIs fanned out across the allotments. After 'D Day', the guards on the shore petered out and the air-raids were less frequent. We didn't have as many GIs around Waterloo as the main camp and airfield was at Burtonwood and the black troops were on the Red Ball Express supply line in Europe.

Going down College Road outside The Edinburgh Inn, known locally as 'The Bug,' was Eddie Dewsbury. He had worked in the bakehouse before the war and was home on leave from the army. I did another lap of honour or my version of a victory roll on my bike and went on my way! I had been sent an aerograph from Eddie, from Tobruk. I had kept it for years and only fairly recently sent it to Eddie's son on hearing of Eddie's death. I thought that his family might like to have it. These aerographs were messages the troops sent home, the sender wrote them on a form, they were then photographed, put on microfilm and brought to England at night by fighter plane where they were developed and sent to the recipient in a window envelope.

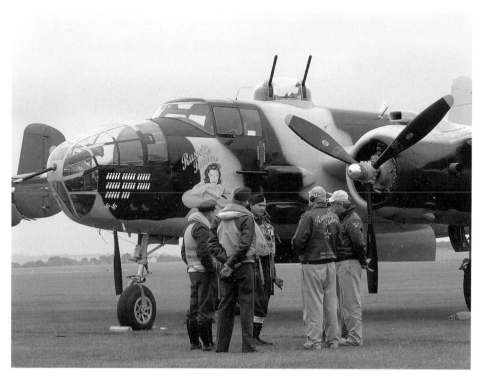

Always time for a chat, RAF meet USAAF. Reproduced courtesy of Brian A. Marshall.

The blackouts had already been taken down following V.E. Day. Supplies were tight for a long time because shipping had suffered great losses. I would say that the Second World War changed the manner in which cargo was shipped. Eventually goods started arriving in containers and there was less work for Dockers, meaning fewer jobs. There was one timber yard after another along the Dock Road at one time but because timber began arriving already cut after the war the number of Sawyers was drastically reduced. There were many jobs going for a while and then things began to fold as a lot of men had been killed and their skills with them. There were plenty of engineers because they had been kept out of the war mostly. There wasn't the same hardship as after the First World War though, because of the Welfare State.

There was a shortage of housing, but again not the same as after the First World War when I lived in Bootle and can remember how bad the housing was there. The dole money for a man, woman and child, and this was all you got, no benefits on top, was 27 shillings and 6 pence. A man's working wage, a labourer, would, not have been much more about 35 shillings. (The *Liverpool*

Echo was Id then)! There were plenty of barefoot kids knocking around, some even came to school barefoot. Bootle was teeming with people then, you pass through now and it is comparatively deserted!

We had 2 girls after the war, Hazel first in 1947, named after her mum and twenty months later the youngest of the family, Barbara. With six children, thirteen grandchildren and the twentieth great-grandchild on the way you could say that as I approach my ninetieth birthday, in April 2003, I have lived to see more life and changes than many others, both civilians and those serving in the forces. I was 26 when war broke out and 32 when it was all over. As I said at the beginning, the war changed your lifestyle, you had no time for frivolity. Leisure was not a word that was in everyone's vocabulary!

Bill died in 2009, a short time before his ninety-sixth birthday. He was a father to six, a grandfather to thirteen and a great-grandfather at that time to twenty-six great-grandchildren. It is the lives of people like Bill that inspire Home Front re-enactors and through his diaries we can gain a greater understanding of life during the war that deepens and enriches the re-enactor's portrayal.

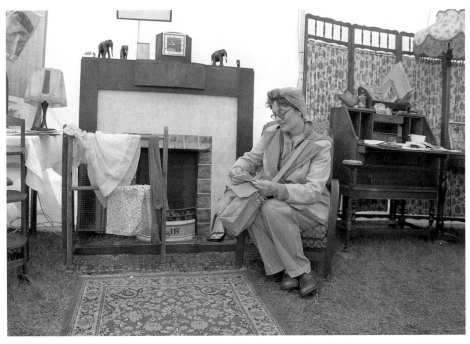

A room layout that would have been familiar to families like Bill's. Reproduced courtesy of B.J. Wilson.

10

'SOLDIERS IN TEARS'

Living history is more than a hobby. It's an act of remembrance.

With the possible exception of Armed Forces veterans, re-enactors do more than anyone else to keep alive the memories of those who sacrificed their lives in past conflicts. That is one reason why they form such an important feature of the War and Peace Show.
Rex Cadman, whose name is synonymous with the internationally famous War and Peace Show, the largest annual re-enacting event of its type in the world

These are the words of probably the best known of all event organisers, a man who is well qualified to give such a powerful endorsement of living history. In common with all pastimes, hobbies, sports and leisure-time interests, the Second World War re-enacting community has one show that is the highlight of the year and that's why tens of thousands of people from across the United Kingdom and from countries around the world, descend upon the tiny hamlet of Beltring in Kent to celebrate and commemorate. This event is a true reflection of the continued growth of and interest in Second World War re-enactment.
Rex says:

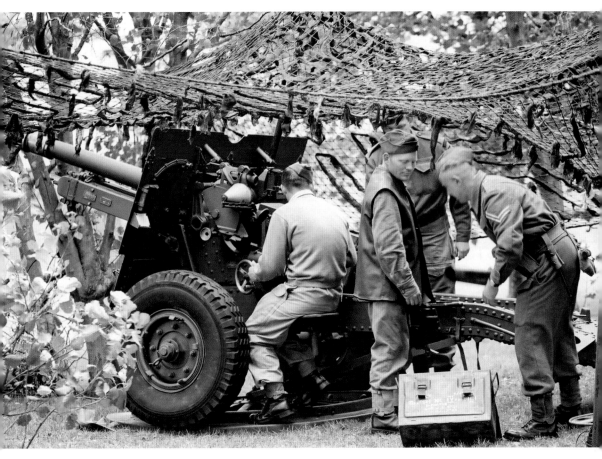

Members of The Garrison train on a field gun. Reproduced courtesy of Aldershot Military Museum.

In a sense, re-enactment has been a part of the show, almost since it started thirty years ago. In those days it was the annual display of the Invicta Military Vehicle Preservation Society, or IMPS as many know it. At one of the earliest shows, a steam crane was used to load military vehicles onto railway trucks which were hauled by a camouflaged steam locomotive. To complete the 'display', men in authentic Second World War army uniforms, guarded the train. It was a scene that could so easily have been taken from a 1940s newsreel. In recent years Living History has taken on a new dimension at the War and Peace Show. Our special schools days have been introduced to show children, in a very realistic way, how the armed services operated during the Second World War. Re-enactors have, of course, played a key role in this, for example, enthusiasts from the Royal Logistic Corps Museum at Deepcut, Surrey have set up and operated a field kitchen. Other re-enactors from The Garrison

artillery group demonstrate the loading and firing of an Anti-Aircraft gun whilst other re-enactors have even created a realistic regimental aid post to deal with casualties.

Children are encouraged to tour the Living History Field to see how soldiers from many different countries lived from day-to-day, the weapons with which they fought and the vehicles that transported them to war.

It was in about 2000 that we felt that the Living History component of the War and Peace Show had grown to such an extent that we needed a dedicated co-ordinator to organise and present it to our visitors. Greg Cottee was an ideal choice for the role because as a key member of the Normandy '44 Re-enactment Association, he is a very passionate re-enactor.

'Living History has a total fascination for me,' says Greg:

Being part of a group helps the individual to understand the sacrifices that service men and women made during the Second World War. I believe strongly that if you are going to be involved in Living History you have to make a commitment to take it seriously, both out of respect for those who died during the wars and the veterans who survived to tell their first-hand accounts of their experiences.

Like many re-enactors, Greg is an ex-serviceman; in his case he spent seven years with the Royal Air Force. By joining a group, many ex-services personnel rediscover the camaraderie they found in the forces, something that is special to both re-enacting and the armed forces.

There is help, support and every encouragement for re-enactment groups at the War and Peace Show as they strive for authenticity. On the one hand they know that if they get their presentations wrong, they are likely to be told about it by members of the large 'army' of veterans that visit the show every year. Conversely, however, almost all groups welcome such valuable advice, for who better is there to offer advice and information on the Second World War than the men and women who were actually there? For the veterans, of course, it's not only a welcome opportunity to wear their uniform and their medals, but the show also provides the chance to see again the weapons, vehicles and machinery with which they took on the Axis armies all those decades ago.

'Veterans are particularly appreciative of what we do,' says Greg:

I have seen former soldiers in tears because of the nostalgia our displays generate for them. They are seeing things they haven't set eyes on for perhaps sixty or seventy years. Even serving soldiers show their appreciation, for example I know of a Royal Marine who has seen action in Afghanistan and who takes part in a re-enactment each year and a sergeant in the Royal Tank Regiment, who on observing a group of re-enactors taking on the role of a modern army patrol, was heard to remark, 'Crikey they're better than we are'. He had returned from Afghanistan just a few months before apparently.

Of course it makes sense for military vehicle groups and living history groups to co-exist at a show such as War and Peace. After all, you can't stage a convincing re-enactment without the right vehicles. And if you have military vehicles it makes sense to have people in authentic uniforms to operate them in the right way. So they are all part of the same presentation and for re-enactors seeking genuine authenticity there is the benefit of the show's extensive stall market, where they can pick up just about anything they need, from a regimental cap badge to a full uniform, not to mention weapons and all kinds of ancillary equipment.

Greg continues:

By the way, re-enactment is by no means exclusively for men. Women are just as keen to take a trip back in time, especially when it means dressing in the fashions of the 1940s. These enduring fashions, which despite wartime shortages achieved a high degree of glamour, continue to be revised and updated for the twenty-first century fashion conscious women. This all came about when designer Annette Leeman visited the show in 2000 and was disappointed to find that most of the women were dressed in drab jeans and trainers. She set about re-creating the colourful and shapely wartime designs, to parade on a catwalk in what was then known as the Miller Marquee. Annette commented, 'I think it's the cut of the clothes that makes them so attractive. They're very smart and well tailored. Of course the undergarments made a difference. Bras were very structured and many girls wore corsets.'

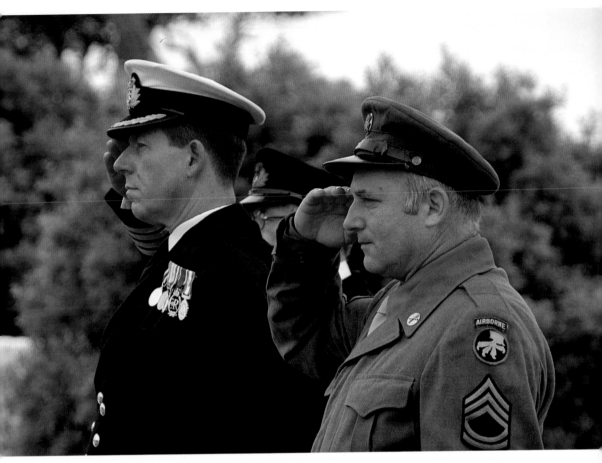

Two re-enactors take a formal salute with a serving Royal Navy officer. Reproduced courtesy of Andrew Wilkinson.

The Home Front frequently forms the basis for re-enactments and presentations, for example, in 2003, a wartime fete was held at the show to replicate an event held in 1943 to help raise money to buy a Spitfire via the local community Spitfire fund. The event was organised by a Land Army re-enactment group, the 'Soil Cinderellas'; they staged three-legged races, bottle stalls, sack races, a guess the weight of the cake competition and a host of other summer fete favourites. There was even a tea dance to make the experience as close to authentic as possible.

The Soil Cinderellas were formed specifically to make sure the work of the Land Army girls would never be forgotten. 'Everything we do and wear is authentic,' said founder Nicky Reynolds. 'All of our members must be able to drive a Fordson tractor, milk a cow by hand and shear a sheep,' she said by way of reinforcing the fact that re-enactors dedicate themselves to authenticity in their portrayals.

Another notable example of such dedication is demonstrated by the men of the Red Ball Express who are amongst the loyal regulars of the War and Peace Show. The group represents the truck drivers who kept American troops supplied with fuel. They needed 800,000 gallons a day in the weeks and months after D-Day and the original Red Ball also transported medical supplies, ammunition and food, and provided film shows for battle-weary troops. Without them the drive to Berlin would have come to a halt. 'We run our display like a depot, with around fifteen trucks, mostly GMCs,' said Mick Wilson who heads the group. 'We also have a half track that tows a Bofors AA gun, a Dodge ambulance and a mobile canteen as well as a mobile cinema.'

One of the fascinations of living history is that you never really know what you might see at a show like War and Peace until it opens. 'To Hell and Back', led by veteran re-enactor Danny Butler, is always full of surprises. To the consternation of his neighbours, his team once put together a replica V1 rocket in his back garden as the centrepiece of the group's display. For other shows at Beltring they have created bombed-out French farmhouses and churches, and they once hung a dead para-trooper from a telegraph pole. Not a real one of course! Their continuing theme is that of the American infantry which struggled ashore on Omaha beach and how they made the best of the conditions. 'We make sure we live like they did,' says Danny. 'We sleep in holes in the ground, we don't wash or shave, there's nothing half-hearted about what we do.'

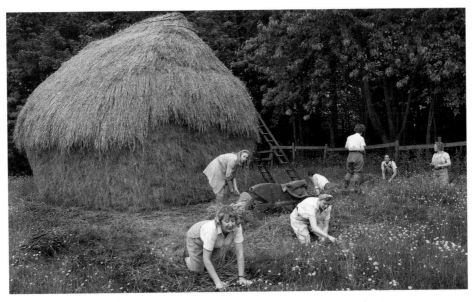

Helping to feed the nation, members of the Women's Land Army. Reproduced courtesy of Nick Halling.

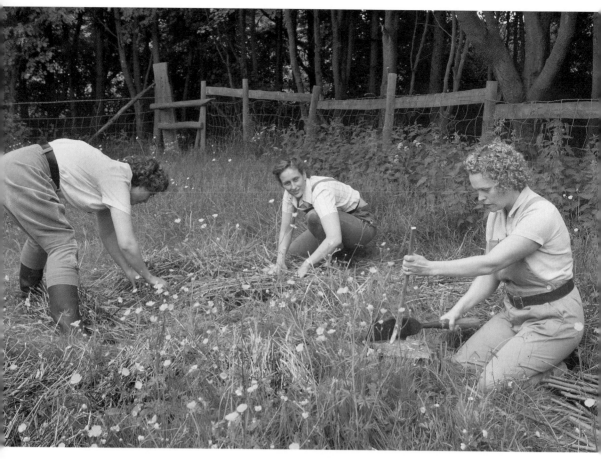

The Women's Land Army is one of the most popular re-enacting portrayals. Reproduced courtesy of Nick Halling.

Each year, living history displays get bigger and more spectacular. Perhaps the most exciting seen so far is the battle staged by the Kelly's Heroes group, 2nd Armoured 502 MP Company. Under the direction of its leader Malcolm Dunlop the group took on crack German troops in a re-enactment of the Battle of Foy, which took place during the Battle of the Bulge during the Second World War.

To add authenticity, the display made use of four snow machines, bought on an auction website, which turned the display area white under the July sun. Tanks, Jeeps, trucks and other vehicles worth a total of more than £1 million fought the battle. Malcolm said afterwards: 'We like to make our displays entertaining for the public as well as realistic.' It was certainly that.

The winter months are a time for the minds and imaginations of re-enactment groups to get to work, dreaming up ever more ambitious displays for the next show.

Improvisation was a byword for invention. Reproduced courtesy of Robert Baker.

The 2012 show will mark the thirtieth anniversary of War and Peace, so it will be exciting to see what new displays and demonstrations have been devised by the ever-expanding army of living history enthusiasts. They are bound to be imaginative, impressive and amazing.

A visitor's view of the show comes from Paul Talores, who has been a loyal follower for about five years:

> I make the trip over to the venue in Kent from my home in Seattle. My vacation is spent amongst the displays and the people. The atmosphere of what is probably one of the most informative events I attend every year is unrivalled. I never cease to be amazed at the accuracy of the many exhibits, the attention to detail that the re-enactors focus on, their dedication and commitment.

To this Andy Johnson from South Africa adds:

A veteran shares his story with a re-enactor. Reproduced courtesy of Ade Pitman.

It's a great occasion, but the guys there never lose sight of the fact that the veterans are the stars of the show. You know these old soldiers are just so unassuming and they seem overwhelmed by the attention they receive. It's good that the re-enactors have a great empathy with the 'Vets'.

Yes, I know the show is a huge commercial undertaking, but it's a great advertisement for re-enacting and the way these guys respect their veteran soldiers is really impressive.

Paula Tilling, who works in Hong Kong, said, after visiting the show for the first time:

As an historian and researcher in Modern History, I have never visited any other show which better reflects the reality of Second World War re-enacting.

The last words on the subject are those of a veteran, Bob Conway, who says that:

Like my fellow veterans, we always get a warm welcome at this event and its wonderful how all the re-enactors go to such lengths in their portrayals. I am particularly impressed by the way they treat us, they are always very kind and respectful and they tell us how grateful they are for what we did.

FRIENDS FROM ABROAD

The word 'cosmopolitan' was not one that featured in everyday conversation on the streets of Britain before the war. Come the arrival of thousands of service personnel from the Empire and from America however, there were not only new languages to understand, but new protocols too.

On Monday 26 January 1942, Private First Class Milburn Henke from Minnesota was the subject of a huge public relations exercise as he stepped off a troopship in Northern Ireland. King George VI was not able to be part of this occasion so the Duke of Abercorn stepped in as his representative. With Abercorn was the local chief of police, an admiral, a general, an air vice-marshal and the Secretary of State for Air.

Henke was at the vanguard of the invasion of millions of service personnel from the United States and it was believed he was the first GI on British soil, although in fact a whole battalion had already arrived and were en route for camp. These troops arrived at a rate of around 20,000 per week on the ships *Queen Elizabeth* and *Queen Mary*, both of which had been adapted for mass transportation. Back home, girlfriends of the servicemen, well some girlfriends, not all, joined the national 'Always in my Heart Club' for which the criteria was 'promising to be faithful to G.I.'s overseas'. By coincidence or otherwise, the girlfriend of PFC Henke was made president of this club.

Although Americans and Brits spoke the same language, they were blissfully unaware of the gulf that lay between them in terms of each other's sayings, customs and way of life so, as was by now the custom, all sorts of advice was dispensed to

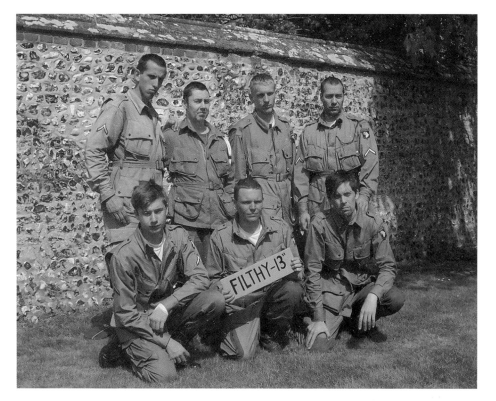

The Filthy Thirteen portrayal based on a real wartime unit that spent time in Britain. Reproduced courtesy of Canda Images.

the public. Troops of each nation were also presented with a booklet explaining the dos and don'ts when in each other's company: 'No time to fight old wars', 'Don't be a Show Off', 'The British Like Sports' and 'British Women at War' were some of the subjects addressed in 'Welcome to Britain', which was issued to the American Expeditionary Force.

Some schools added a condensed American history lesson to the weekly time-table, yet the country was not just welcoming Americans, but Poles, Dutch, Free French, Czechs, South Africans, Canadians, Indians and many other nationalities. The press was not slow in promoting London as one of the most cosmopolitan cities in the world. The smart uniforms worn by our friends from America, the large trucks they drove, the way they presented themselves, calling men and women 'sir' and 'ma'am', the less regimented and happy-go-lucky attitude won over vast swathes of the population.

Little has changed for those re-enactors who choose to portray members of the American armed forces! It is arguably one of the most popular 'sectors' of living history in Britain today, not least because original and reproduction kit is easy to

It was on this site that services were held in the days leading up to the D-Day embarkation of Canadian troops. From the author's collection.

obtain, the smart Class A walking-out uniform still exudes style and charisma, and the essential mode of transport, the Jeep, remains an iconic machine that, like the Spitfire, is about as close as you can get today to 'touching wartime history':

Many years ago I found myself talking to 101st veterans when on a trip to Normandy, even though I was happy with the little knowledge I had of the D-Day invasion, I suddenly realised that I had not even scratched the surface of what went on even in the small town of St Mere Eglise. My quest had begun.

My passion was motorcycling, that is until I purchased a WW2 jeep for 'a little fun'. Within eighteen months I was at the head of what has to become one of the most respected and authentic re-enactment groups in the country, the Screaming Eagles Living History Group.

Hard work and dedication is the key, research into the finest detail and a strict set of regulations and protocols help to keep the group focused, motivated and working professionally in the right direction. Good leadership from the captain and the two 1st sergeants are most important. The group is run on a military formula at events and very informally at other times, the group is also run democratically with a committee.

The greatest drive within the group is to educate the public about the WW2 veterans, to make sure that they are not forgotten, to give a glimpse of what it was like for those boys of the 101st. Our greatest accolade is the

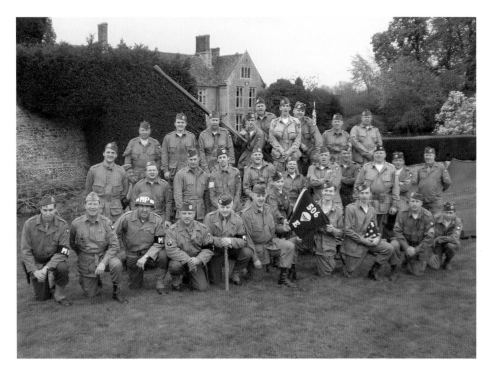

Members of the Screaming Eagles re-enactment group, playing the part of the 101st Airborne (Band of Brothers). Reproduced courtesy of Canda Images.

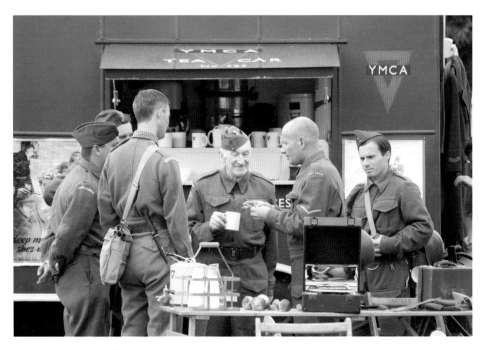

The YMCA provided hot drinks to civilians and the services alike. Many catering vans were donated by Canada and the USA. Reproduced courtesy of B.J. Wilson.

blessing and support from surviving soldiers. Veterans of the legendary 'Easy Company' are in constant touch through letter and email, they get updates of what the group is doing and we ask advice on many subjects, they appreciate what we do and that is why we do it. We all recognise the service they gave under extreme circumstances.

Dave Allaway (Captain), 101st Airborne (Screaming Eagles Living History Group)

Members of the wartime Women's Army Corps (WACs), the American Red Cross and the Women's Auxiliary Service Pilots (WASPs) are portrayed in growing numbers in the United Kingdom, where a whole industry has grown up around the need for reproduction items, especially badges and insignia, personal items and parts of uniform.

For many the GI 'friendly invasion' changed their lives forever:

My dad was a US Army medic and he was a veteran of Omaha. As a child of about nine or ten years of age, I remember going into a local telephone box and opening the big heavy door and getting the book down to see if this man, Paul Natividad, was in the Southampton phone book. I had been told about my dad in the early 1950s although to me at that age, whether he was an American or not, he was my dad and I thought I could find him locally. I thought everyone in the world was in that book.

I was searching for Paul Natividad as my father was known to my mum and after years of searching I discovered that Paul was his nickname, his real Christian name was Pilar. Once I had the correct name everything came to a quick conclusion after that. I had a hunch about three names I subsequently came across although after 'phoning one of the three guys, having discounted the others, I realised I was talking to a half-brother I never knew I had or who knew about me! He gave me the phone number for my dad. At almost forty years of age I traced the dad I had never known. When I contacted him it was a big shock for him, a tearful but so happy experience for me. He had known about me and was delighted I had found him.

The very next day my work colleagues at the time had a collection for my air ticket and I was able to go to America for that Christmas. In less than a month of first speaking to my dad, I was on my way to meet him. It was a wonderful reunion that still makes me cry thinking about it now. I was totally

accepted by him and the rest of the family and I have been going back and forth ever since. It's truly the best thing that ever happened to me.

It's made me whole, it's good.

Pauline Natividad

★★★★

I bumped into a friend in the street one day and we got talking about my dad. I had known about him for some time and was keen to trace him. Anyway, the friend suggested I went to visit her aunt who was able to give me an address in the States through which one could get information about former service-men in England during the war. I wrote off to them and a couple of weeks later I received a reply.

It said something like, we have two men on the records, one is in New York and one is in Detroit and we think the man in Detroit is the man you are look-ing for. I then phoned the telephone number given and I spoke to the man. It was my dad. I was invited on to national TV to talk about my search for my dad and to my surprise the TV company gave me a ticket to America. When I arrived there, I spotted the man who was my father. I could tell straight away, a big tall man. The first cuddle is what I wanted. It was though he had just been living down the street. He remembered everything, the town hall in Eastleigh where he met my mum. He remembered my grandparents because they used to invite him home to tea.

My father's family were the first negroes [sic] to buy land in the area where they lived and it's still there. I am very proud of them all.

Rita Lange

★★★★

Apparently he wrote to his parents and said 'I have met the girl I am going to marry'.

It took about two years and during that time my parents changed their mind about the relationship. They really didn't think he was right for me. He was older than me and they thought that was 'iffy'. Anyway, they finally gave in when I was nineteen years old and then I married him. It must have been right because it lasted a long time and we had four beautiful children.

Edna Simmons, who immigrated to America with her GI husband

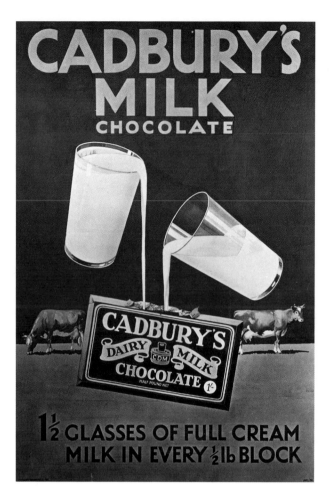

During wartime cocoa was reduced in price but chocolate was scarce. From the author's collection.

Whilst there is no doubt in the minds of many of those who came into contact with the Americans that they were courteous, generous and here to help, there were occasions when the lifestyle of the American forces caused some disquiet amongst the population. In particular, it was difficult for the British people on rations to understand how the Americans were able to enjoy luxuries, including chocolate and fruit. It was even more difficult to understand why the British troops were unable to benefit from better rations on a par with the Americans:

> The awful thing is if you went to our camps to sing, there was never much to eat for us or the servicemen and women. They did not have very good rations. But when we went to the American camps, the food was fantastic and it made us angry to see our boys with rations and the Americans with 'luxury' food.

When the first American troops arrived, there were no organisations set up for them by the US authorities and it was the Women's Voluntary Service (later the WRVS) which was called upon to welcome and feed the men at the docks. Local WVS members opened up their homes and offered hospitality as best they could. Because troop movements were surrounded by secrecy, it was impossible to give adequate notice of the arrival of men and so the WVS had to prepare themselves for improvised welfare and hospitality arrangements.

The late Betty Driver, Actress

All the WVS canteens were opened up to the Americans and the Allies, and they soon realised and appreciated that the women would help darn socks, change shoulder flashes on uniforms and provide information on fetes, dances and events at which the 'yanks' could 'meet the locals'. Given that some difficulties arose from what was called the private hospitality scheme, introduced to help the Americans acclimatise and to meet British people, the WVS conceived the British Welcome Clubs which helped to integrate the US servicemen with local communities. Some members of the gentry were encouraged to open up their country estates for visits by and afternoon tea for the GIs, while sightseeing tours gave the American visitors the opportunity to see areas of the UK that were relatively devoid of bombed-out buildings and rescue squads clearing up the damage. In London, what became the 'famous' Rainbow Club for 'the boys from overseas' was attracting attention for all

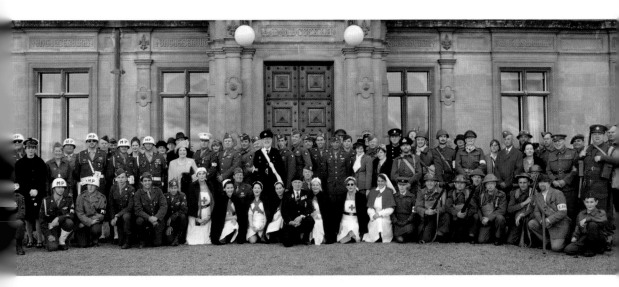

The Americans soon got to know the Brits. Reproduced courtesy of Canda Images.

Making friends with the locals helped the US armed services to integrate. Reproduced courtesy of Manor Farm.

the wrong reasons, not least the ease with which prostitutes could ply their trade. Elsewhere in Ringwood, Hampshire, for example, forty pilots based at RAF Hurn were invited to a party to meet families in the neighbourhood and visit their homes. It was a great success, witnessed by British and American welfare officers and the pilots were very loud in their appreciation of their hosts. Subsequently, a list of local families who would welcome enlisted men was given to the authorities and new friendships were forged and maintained, in some cases, long after D-Day.

Many thousands of members of the Women's Voluntary Service took part in offering support for Allied services hospitals in Britain and they undertook simple but beneficial jobs such as providing flowers and organising a library service, or taking convalescents for walks and staffing kitchens during temporary emergencies. The service given to the Americans in particular by the WVS was far from one sided and this can be illustrated by the events at WVS hostels at Christmas. A number of Father Christmases arrived in Jeeps, trucks and even tanks to the delight of the little children, all of whom were given presents, sweets and attention probably beyond their expectations:

By 1943 the American Forces were streaming into the country by the tens of thousands and the demands upon our concert party were increasing by the day. They just loved child entertainers, so my daughter Gloria and little friend Jill, both then about four or five years old, came into their own. They often accompanied our concert party when appropriate, but mainly they were in demand for children's Christmas parties and suchlike. Their little tutus made them look very cute and when they dressed as fairies they both helped Santa hand out presents. Of course, they were amply rewarded by the Americans who gave both girls some wonderful presents of their own.

Betty Hockey

Few things have contributed more to the memory of the Anglo-American relationship during the Second World War than the enthusiasm with which the American airmen and soldiers entertained the children and gave away their candy and gum to the delight of the British children:

Looking back it was like having all your birthdays on one day. The Americans were always kind to the children. Many of them of course had their own families and must have missed them so much. They adopted us I suppose and treated us very well. I know some of the adults had a few moans and groans but as a child you didn't understand them. You just enjoyed the parties, the little gifts, simple things like the carving one man made from a piece of wood and gave to me before he left. We were all skinny little kids in hand me down clothes but we were happy and the Americans gave us some good times. None of us knew of course that these men faced an uncertain future. We just did not understand. You look back now and wonder what happened to those people who did after all have a great impact at a time in your life when you were very impressionable. For that moment in time, I will never forget the Americans.

Susan Cooper, who was nine years of age when the 'Yanks' arrived at
Aldermaston airfield[5]

5 Aldermaston was variously a base for RAF Bomber Command and the Eighth and the Ninth USAAF. Some Spitfires were built at this site and Aldermaston was also a base for glider operations. It is now an atomic weapons research establishment.

An American Second World War veteran meets members of a group that re-enact his old unit. Many groups have close associations with veterans. Reproduced courtesy of Canda Images.

The Americans in particular amongst all our Allies left a lasting legacy, not just their 'gum', their expressions and their rather carefree attitude, but through their offspring as well. The GI war babies have their own organisation and many children have been united with their fathers and welcomed by their extended families in the United States.

It is understandable why GIs continue to be held in such affection today and their important contribution to the British Home Front is remembered by re-enactors today. However, the re-enactment community also reflects the many other Allies who were stationed in the UK during the war and whose service alongside our own armed forces will never be forgotten.

12

THE CHANGING FACE
OF RE-ENACTMENT

I'm rapidly approaching the age when it's become slightly embarrassing, although I am just a little too proud to admit that I've been 'fighting' World War Two for nearly four times longer than it lasted.

Guy Channing, re-enactor

Reasons for becoming a re-enactor are many and varied, yet for those who are interested in stories about wartime Britain, it can be a fairly easy transition from thinking about the subject to playing out a role. Guy Channing hopes his story will inspire others:

I grew up in the heady days of the 1960s, yet my childhood memories are dominated by endless games of soldiers and Saturday evenings in front of the TV watching a succession of huge budget war movies. As I grew older I shared precious hours with my dad, berating him somewhat unfairly to recount his wartime memories. He was an infantryman through the worst of the Normandy campaign and also during the drive into Northern Germany. Granddad too was a soldier; he was in the Great War.

They were my heroes alongside the big name Hollywood stars, those who on film sneered at adversity and went to their deaths in the best traditions of their craft. I had hundreds of toy soldiers, Action Men, the lot. I spent my play

times clutching imaginary machine guns as I mowed down the equally imaginary enemy. Later, my interest turned from play to reading. History, fiction, comics you name it, my veracious appetite for books only fulfilled a greater appetite for the War. That appetite is still there, although it is tempered now by age and experience and replaced by a yearning to understand what drives men to war and what sustains them through the ensuing horrors.

'When I left school,' Guy tells me:

I considered joining the Junior Leaders Regiment of the British Army, but then I floundered through several jobs before I discovered a love of photography which, fortunately, turned rapidly from a hobby into a job. I've been a professional photographer now for about 25 years and it was this work that first brought me into contact with World War Two re-enacting. The 43rd Wessex Recce Regiment to be exact, a small band of infantry re-enactors which were organised around a couple of friends from East Devon with their erstwhile foe based around an eccentric bunch of 'Jerries' from Tavistock.

A commission from a local paper sent me off to the site of an old tin mine where during a damp and miserably cold autumn afternoon, I met and embraced Second World War Living History thanks to those re-enactors! It took me a month to get all my kit together with my first set of original battledress trousers setting me back all of £6. The local surplus shop had bundle after bundle of battledress. Local events then followed and I vividly recall a somewhat embarrassing afternoon running round a football field at a summer fete, sweating profusely in full kit as we tried to make 200 rounds of blank ammunition sound like the Battle of the Bulge. It was at a decent winter battle weekend however, when I began to realise that it wasn't all about shooting guns and doing an over exaggerated John Wayne 'stagger, stagger, death'.

At this bigger and slightly better organised event came the 'piece de resistance' in my little inexperienced re-enactment world, a visit from the British Re-enacting Association. The BRA were the 'big boys' back then, they had Sten guns, Brens, MP40s, Thompsons, they had the lot and more ammo than you could shake the proverbial big stick at. Yes, I was hooked! The 43rd Wessex Recce went through a metamorphosis into a section of South Staffs, don't ask why because I cannot for the life of me remember, before joining the BRA as a semi-independent section within one of its existing units, After a while we

almost became *the* Recce Squadron turning out more troops from the South West than the other two sections could muster between them. I had a fantastic time taking part in dozens of public shows throughout the country where I'd arrive in a car groaning under the weight of kit. What we couldn't buy, we made! Drop baskets, ration boxes, parachute containers and, at one stage, a Welbike. The individual commitment was staggering and the final arrival of three airborne jeeps put the icing on the cake, well, that and the original Vickers 'K' gun to adorn the lead vehicle.

They were halcyon days of countless public shows and a succession of crazy nights of singing and 'being Airborne'. The events we attended included many of the better events across the country, as well as my most memorable event as an airborne re-enactor, the fiftieth anniversary of the Battle of Arnhem where we were officially included in the public event for the first time. It was truly memorable and very humbling to lead the march from the drop zone [DZ] on Ginkel Heath[6] to the bridge and to be applauded by the very men we were there to emulate.

We met veterans by the score and experienced a welcome, in my opinion, which could never be bettered. We even provided impromptu transport to a group of veterans stranded in the Oosterbeek cemetery after their coach broke down. Delivering them in time for their commemorative medal ceremony was an added bonus on a trip that was filled to the brim with experiences that are worth a story all of their own. Our increased popularity led to an influx of new recruits and as the numbers grew so, unfortunately, did the internal politics. It's a sad fact of re-enacting, but it's the same in all organisations, someone can always do it better. Over the next few months things began to change as people came and went and the general feel of the unit changed subtly. The new faces and new ideas only seemed to add to the general undercurrent of unease. Something had to give, but what?

My own personal 'epiphany' came during an event in Mereworth. The infighting reduced my enjoyment, that and the loud and unfair criticism of a visiting group. Far from seeing red I saw no more point to it at all, the nagging doubts congealed into a conscious thought that somehow I'd outgrown what I was doing. I decided that I'd put my civvies back on and sit the rest out the rest of the event.

6 British and Polish paratroopers landed here during Operation Market Garden, 1944.

Sadly, I only lasted another event before I went fully off the boil and left the BRA entirely. I did however get the chance to see the change of management when an unfamiliar officer was asked who he was, only to be told quite bluntly he was the new unit commander. I obviously wasn't the only one who'd noticed things were not all they seemed. That said, credit where it's due, my old unit went through a massive period of growth and not only outgrew, but outshone the 'old' Recce by their sheer presence. It wasn't for me however. After twelve years something was tarnished and although I loved being an airborne trooper, doubts about my age and commitment kept me away from the hobby for about a year. I wasn't alone in seeking new horizons a little more in line with my growing maturity as a re-enactor.

The idea to create an Infantry Section and limit our activities to the South West of England seemed the answer to many questions, so in 2000 the 2nd Devons were formed from a few ex-BRA members and a couple of new recruits. One of the recruits lived in Salisbury and we timed a visit to meet him with a visit to a Living History event at Old Sarum, it was to say hello to our old friends of the BRA. This resulted in the Devons getting co-opted back into the ranks of what had by then become the WW2 Living History Association. We re-joined with eight troops, this number grew to something approaching twenty on paper at least and has settled into a regular membership of around a dozen. I was in nominal command until 2006 when family and work commitments meant I could no longer attend as many events, so command passed to Tony Crofts who was one of the original 43rd Wessex lads from all those years ago. Recently I have become self-employed and I started my own photographic business in 2010. This now operates in tandem with my Living History site.

I still attend events and I divide my time between the photography and my active, but less arduous role in the Devons in my portrayal as their Medic. It gives me every opportunity to combine my two major passions, photography and re-enactment. This role has opened up an interesting part of the hobby, often overlooked and which we try to portray it as honestly as possible. Within the structure of the 2nd Devons there is an attached Royal Army Medical Corp group including a Medic, medical Jeep and a driver. It also makes our display a little more 'rounded' as the 'atmosphere' of a headquarters takes shape. As a 50th Division unit they sit comfortably alongside our comrades in the Hampshire Regiment, which is in fact, another main British infantry unit within the LHA.

Asked if he still considers re-enacting to be rewarding, Guy says simply:

Yes, of course I do. I temper that with the huge amount of experience I have gained in the twenty-four years I've been a re-enactor. In that time I've seen a lot of changes. Good people come and go, some lesser individuals grow into highly competent and highly regarded re-enactors. Big units became smaller and small units grew into some of the very best portrayals I've seen.

In the last ten years or so in the United Kingdom, re-enacting has increased significantly. The Second World War element of that is, frankly, phenomenal and just visiting the larger events throughout the country throws up so many well thought-out and well-researched portrayals that even the most ordinary of heroes, the infantry, are finally becoming well represented.

Personally, I find the number of British infantry units on the scene incredibly rewarding because beyond the 'shiny kit' syndrome portrayal of elite forces, it really was the infantry that bore the brunt of the fighting during the war. It is a fitting tribute to the ordinary 'Tommy Atkins' of the largely forgotten county regiments that so many dedicated souls now choose to recreate them in this way.

I don't know how many years I have left as a Second World War re-enactor because there is only so much grey hair and waistline any period can support! What I do know is that Second World War re-enactment has reached an unprecedented popularity and quality.

In my opinion, we can thank filmmakers Stephen Spielberg and Tom Hanks for some of that popularity plus, and very sad to say, the highlighted awareness created by the on-going conflicts this country is engaged in.

At a recent event, I stood next to the owner of a very well-known 'kit' specialist as a very large contingent of Jeep-mounted British airborne troops sped by. I could only marvel at his restraint as he watched them speed off to the battle display. Nearly every one of them was equipped head to toe in his uniforms, smocks and equipment. If I didn't know that 'It's not all about the profit', I would have expected a lot more reaction than the pleased, but slightly wry smile, that played across his lips. We also need to recognise the commitment and effort put in by every individual member of the re-enactment groups and societies that make up the ever increasing patchwork of domestic living history.

I now consider myself to be a 'veteran' re-enactor and after all these years I believe I have a right to the opinions I hold about this most fascinating of

What mischief have these lads been up to? Reproduced courtesy of Nick Halling.

pastimes. It is so rewarding to enjoy events now in what may well be my personal twilight as a re-enactor with the knowledge that as a hobby, the Second World War will be recreated well into the future by committed individuals, just as previous generations have done in the past. Remembrance is one of the foundations of the hobby, that and a genuine love of history. As hobbies go it's as good a foundation as you can get. When I finally hang up my boots it will be comforting to know the hobby will be left in such highly committed hands.

13

'RUN RABBIT, RUN'

The future of re-enacting will, in due time, pass to the younger generation and it is encouraging therefore that more children of school age are taking an interest in and becoming involved with living history.

The portrayal of 1940s evacuees and schoolchildren is as much a part of Home Front re-enacting as is the Home Guard and Women's Land Army. Many children learn, via the curriculum, how their counterparts lived during the war and how they dealt with the daily challenges of rationing, air raids and destruction. However, oral history and anecdotal evidence presented by 'those that were there' have proved to be a good way of ensuring that the audience retains a higher percentage of the information.

Walter Penketh was born in July 1932 and has such a story to tell regarding the Liverpool Blitz:

Of course when war came I was just seven years old and was living with my mother my father and my elder brother and one of the first experiences I remember was when we all slept for a period of about six weeks in our garden 'Anderson Shelter'. On one occasion my mother and I put out an incendiary bomb which landed some 12ft away from our shelter. The other slightly more interesting tale is when a landmine came down about 250 yards away and fortunately it failed to explode.

Because of the landmine, we were requested by the officials to evacuate our home. There was a problem, however, well apart from the unexploded

A constant companion for most children, a favourite doll or toy bear. Reproduced courtesy of Nick Halling.

bomb we had two hens in our garden which were housed in an enclosed 'pen'. None of us knew when we would return home so my Dad released the hens to roam freely so they could spread corn within the garden area. Upon our return several days later and much to our surprise, the hens were still in our garden. However, their reward for this loyalty was when the next door neighbour strangled them in December for our Christmas dinner. My grandchildren were horrified when I related this story, many years later.

When we were evacuated from home, we were notified by the A.R.P. that we were to make our way to the local Salvation Army hall where we were subsequently looked after. There were over one hundred of us being temporarily housed there, sharing just two toilets I remember. There were no worries for me though, by then I was aged nine years and it was all something of an adventure. My debt to the Salvation Army has been paid many times over since those far off years, for not only do I make an annual donation, but I always, when making a donation to a collector in the street, recall the event of that May evening in 1941.

It is important to remember what we all went through and the kindness of friends and strangers alike.

Walter Penketh, Cheshire

The war years of 1939 to 1945 are still 'within living memory' and nowhere is this more apparent than in the anecdotes of children of the war. For many it was a great adventure and an exciting time, for others it was bewildering, frightening and heartbreaking. For those who survived, whether as orphans or as members of an intact family, few can erase the memories:

My name is John Dickson and this is my story of the first ten years of my life; it is dedicated to all those who did not go to war, instead the war came to us.

I was born on 1 December 1936 at a nursing home at 87 Fordwych Street, in Camden, a part of the London Borough of Hampstead in NW1. Why I came to be born there is a mystery, the key to which was only known to my late parents Bill and Ivy Dickson. They actually lived in Wembley, several miles away from, and a place which was well equipped with suitable nursing homes. As Hampstead today is an area of quiet opulence I am quite happy to have been associated with the area – even if it was only for the first few days of my life. Had I been famous they would have erected a blue plaque on a wall there – but I am not!

My first three years on this earth were uneventful. At least they must have been as I have no memories of that time. My real life experience began in 1940 when, at the ripe old age of 4, the world changed dramatically for me and the rest of those of us living in London. Almost to the day that I started going to school the Germans announced their arrival over London with a lot of noise!

The arrival of the Luftwaffe over London in August and September of 1940 coincided with my arrival at White Gates School which was a sort of kindergarten in Willsmere Drive in Stanmore. We were by then living in Stanmore because our house in Kinch Grove in Wembley was unfortunately in the way of a large German bomb. However, thankfully, no-one was at home at the time when it dropped in. Anyway, that's why my parents then bought 'The Cottage' on Clamp Hill in Stanmore. This was and still is today, a lovely double storey desirable residence, but it did have its drawbacks. If you chose to live over the road from the Headquarters of RAF Fighter Command, Bentley Priory at a time when there is the world's greatest aerial battle being fought above your heads, there can, I am afraid, be problems! Hitler had decided that the RAF were to be wiped out of the skies, but fortunately he seemed to have some shortcomings in his intelligence as he only 'discovered' Bentley Priory later in the war when it was too late for him to make a real impression.

The Blitz was an experience that many, more qualified than I, have written about and described in minute detail as it unfolded day by day. Thousands of German aircraft came over south east England and bombed London every day and every night for several months without a break. In North London we still had our share although we lived some 11 miles from the Docklands in the East End where the real action took place. Fortunately our bad experiences were minimal compared with the unfortunate folk living near the River Thames and the docks. Often I stood at the upstairs bedroom window and I could see the red glow of the massive fires which were slowly destroying London. In addition the German bombers dropped flares so that they could see their targets better. These lit up the city as wave after wave of bombers arrived to try and fulfill Hitler's aim of subjugating the damn English.

We did actually manage to attract some attention from the German bombers. We did wonder whether our close proximity to the HQ of Fighter Command may have had something to do with it. During my first few weeks going to school my mother and I were walking down Elms Road and, near the corner of Willsmere Road, there was a huge hole in the road. A big bomb had landed on the road overnight tearing the fronts off the houses on either side

This Bren gunner is ready for action against incoming raiders. Reproduced courtesy of B.J. Wilson.

of the road. The unfortunate occupants did not survive and were still laid out covered on the pavement awaiting collection. The bomb may have come from the tail end of the bombing raid on the Harrow School which was hit by some three hundred incendiary bombs in one single night. The bombs fell amongst the buildings, on the grounds as well as in the surrounding areas of Harrow and Stanmore.

Holes in the street are one thing, but there were many other aspects of living in a war zone that made things almost fun for a five to six year old. For protection from the bombs we were offered a Morrison shelter. A Morrison shelter was like a large table approximately 6ft long and 4ft wide and about 3ft high. It had a solid steel top and the sides had wire mesh. You had to lift one side off to get inside. These shelters were usually kept in the lounge and the family, especially the children, slept in them almost every night. We did not have this type of shelter as my father decided to reinforce our kitchen ceiling with quarter inch thick corrugated steel supported by 3 inch diameter poles. I slept for five years under the kitchen table, on a Lilo mattress, protected by this steel structure. It was fun until I grew taller and made a habit of bumping my head on the underside of the table.

The philosophy in those days was that 'if it had your number on it then you had had it'. A direct hit by a German bomb on a house, or even in the garden or in the road outside, almost certainly ensured the demise of the occupants of the house and even their closest neighbours. During a raid we often opened all the windows in the house, even in winter, because this ensured that bombs that landed within a mile or so would not blow out our windows with the blast. Nevertheless we lost our windows three times during the war. During one particular raid, a bomb dropped on the garage near the corner of Uxbridge Road and Clamp Hill. A large piece of the garage driveway found its way through the roof of our house and the blast knocked many ornaments off the mantle-piece simultaneously dislodging my mother from a chair on which she was standing whilst dusting the said ornaments. Other than my own stay in hospital a year or two later, mother's broken arm was the only serious damage 'Jerry' inflicted on my family during the war.

I have often been asked what an air raid was like and what we did when the siren sounded. For the first few years of the war I remember my mother and the teachers at school hurrying us into shelters where we sat and waited for the whine of the all clear siren. Unfortunately air raids became very regular and were something of a distraction so after the first year or so of the war we just carried on with whatever we were doing. If you were on the streets

then the ARP (Air Raid Patrol) man in his white helmet chased you into a shelter. It was against the law not to have your gas mask with you as well. At home we just stood still and listened to hear if the bombs were dropping in our area. If all was quiet we just carried on playing. We were told never to pick anything up outside that looked like a pen or a metal butterfly as it could explode. That was hard for curious children. I think we looked all the harder for these mysterious objects and also collected little pieces of silver paper which the Germans had dropped to confuse the radar. Boys would come to school, at Quainton Hall in Hyndes Road, with chunks of shrapnel that they would proudly show off to the other children. I had the front part of a shell which had penetrated the shoulder of a Polish airman that was billeted on us for a few months. It was a kind of status symbol to have a large piece of shrapnel.

The fortitude and humour of the people of the Blitz is well illustrated by the experience of our very close family friends, the Fodens, who lived in Wembley. Auntie Laura was bathing George, her son of five, in a tin bath in the kitchen during a raid. A bomb landed in a street nearby and the blast blew both of them, together with the bath, out of the kitchen door and onto the lawn outside. Auntie Laura and George were fortunately unharmed and she merely picked up him, and the bath, and walked back inside to complete the bathing. Whilst always a perfect lady she was heard to mutter some strong words about Hitler's heritage!!

It has been said that the children of the war in Europe were to become the healthiest generation in future years thanks to the very limited, but apparently very healthy, diet that we had during the war. Food rationing was in force in Britain throughout the war and even continued for almost as many years after the war.

During and after the Blitz our *weekly* rations per person amounted to the following:

Meat:	approx. 150g (not always 'traditional' meat and often horsemeat or whale meat)
Eggs:	1
Fats:	(butter, margarine and lard) 100g
Cheese:	100g
Bacon:	50g, but increased later to 100g
Sugar:	200g although initially 300g
Tea:	50g

Young children and expectant mothers were allowed extra rations, including orange juice and cod liver oil to ensure that they received the correct vitamins. My allergy to orange juice ensured that others got more juice but I remained healthy despite having to take the cod liver oil neat! The foods which were not rationed were nonetheless in very short supply such as tinned meat, fish and fruit, condensed milk, rice and breakfast cereal. In late 1941 a coupon scheme was introduced to control the sale of other types of food. This was to ensure that everyone had the chance to buy the food when it was in stock, and to stop people buying a lot at once and filling up their cupboards when others had none. SPAM which is similar to corned beef, was almost always available and became the main meat for many families and clever and ingenious recipes were invented to use it. Vegetables were not rationed although popular types were sometimes hard to find, and certain types such as swedes became the bane of my life. Onions were hard to find. We were also encouraged to turn lawns and the rest of the garden into 'victory gardens' and for us to be self-sufficient in vegetables. Throughout Britain public parks and gardens were dug up and vegetables were planted. As with many families we also kept six rabbits and six Rhode Island Red chickens. Once their numbers exceeded six then we had a special meal. Naturally there were eggs from the hens as well.

Bread was not rationed during the war, although white flour was in short supply, so wartime bread was mainly sort of whole-wheat. Milk was not rationed although the amount available varied. During the school holidays I often joined the milkman from the Express Dairies and rode on his horse drawn cart up and down Clamp Hill helping him with his deliveries. I can never recall being really hungry during the war. I realised that my mother concocted some amazing meals using the food available so as to supplement our diet. Tea was often sweetened with honey or jam. The bread was a greyish colour, it was heavy in consistency but we ate it. Grated carrots replaced fruit in birthday and Christmas cakes. And then there was the horse meat shop which, in peace time only sold it products to pet lovers now declared its product was 'fit for human consumption'. Horse meat was not rationed but had a sweet taste which we could not eat on a regular basis. It needed to be cooked for a very long time as was the case with whale meat. Yes whale meat found its way onto our table eventually. It had to be soaked overnight, steam cooked and then soaked again. Blanketed in a sauce it still tasted exactly what it sounds like – very tough meat with a distinctly fishy flavour. Unfortunately fishing was a very dangerous occupation as most of the British coastline was mined so we had little real fish during the war.

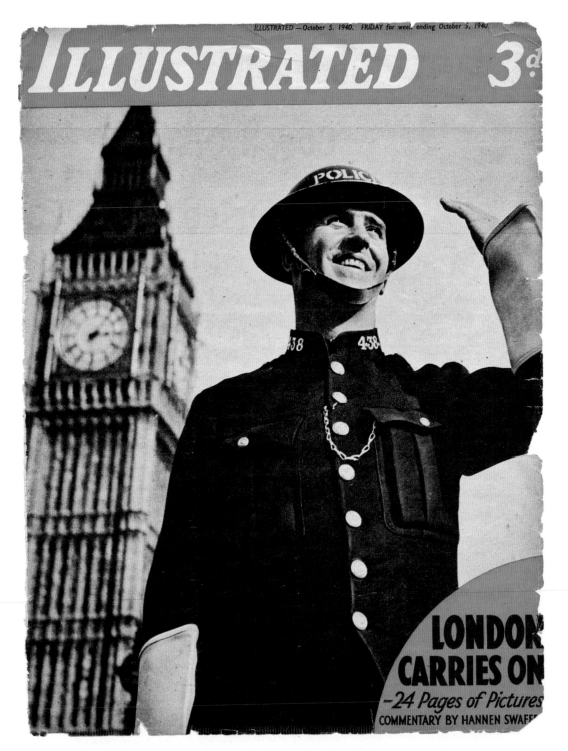

Newspapers and magazines regularly carried such cheerful images of 'Blitz spirit', as seen here on the front page of *London Illustrated*, 5 October 1940. From the author's collection.

I remember our gas masks and the first time that I tried mine on it smelled of rubber. It was packed into a small brown cardboard box with a string attached so you could hang it around your neck. It was the law that we carried our gas masks whenever we went outside the house. The adults had a larger one in a sort of canvas bag. Fortunately my gas mask survived the entire war unused and I can honestly say that I never took it out of its box for the five years I had it around my neck.

Whilst the Blitz of 1940 was aimed mainly at the docks in the East End of London, the introduction of the V1 doodlebug in 1944 brought a whole new dimension to the war and exposed the whole of London to attack. These awesome flying bombs were launched from fixed sites in German occupied Europe. The ones we saw almost every day came directly over the church spire which was about half a mile from the end of our garden. We kids used to sit in the back garden and watch them come over. The very significant droning noise of the jet engine could be heard for miles around. When the pulsating motor stopped the bomb angled down and hit the ground and exploded. We always estimated that if the motor shut down over the church that would be the one for us. It never did, but one or two did stop directly over our house and appear to have landed fairly close in the fields of Bentley Priory over the road. Whilst I was going to the bus stop in Harrow, I was unfortunately hit in the face with some flying metal. I was bandaged up and put on the No.114 bus and sent home. On arrival at home my father, who was home from his war work in Scotland, took me immediately to the hospital where I was to spend several months and six operations to try and save the sight in my right eye. We lost the fight and I lost the eye!

There was little point in running for the shelters when these bombs came over as there was little or no warning from the air raid sirens that they were coming. I am told that nearly 60,000 civilians lost their lives in the raids on London of which some 12,000 were children. Even worse was the arrival in late 1944 of the V2. In today's terminology, that's a long range ballistic missile. These flew at supersonic speeds and were launched from anywhere the Germans chose to do so. Over 2,000 of these one ton warhead bombs hit London, just coming out of the blue and destroying many houses and many people each time they landed. In late 1944 I went to an ocularist (as they are now called), a Mr Clarkson who had his rooms in Wigmore Street. He made my first plastic eye. I had the distinction, according to Mr Clarkson, of being the first civilian in the world to have an eye made of acrylic plastic. My time in hospital is best forgotten. We had sulphur drugs, no penicillin and the

operations were done under ether. A far cry from today! You may wonder why I did not get to Moorfield's Eye Hospital, well during the war the hospital opened its doors to general surgical cases and most of the ophthalmic patients were evacuated out of London. In 1944 Moorfields received a direct hit from a VI 'doodlebug' and was extensively damaged. It was so bad that the hospital was nearly pulled down. I have read that it was rebuilt in 1946.

When people complained about things, others used to say to them, 'Remember there's a war on' and the children would say that too. We knew that all the spare metal pots and other scrap had gone to be made into air-planes to fight the Germans, yet somehow we had no conception of peace. When the war in Europe was finally over, my mother was waiting for me at the front door when I came home from school. With a big smile on her face she said 'Guess what, the war is over, we have peace'. 'What is peace' I asked.

Memory plays some strange tricks on us and in time it blurs the edges of the sad, unpleasant, or uncomfortable happenings in our lives. It is even difficult now to remember that going without all the good things in life was not really fun, we just made the best of it as it was pointless to grumble. Therefore today we look back and smile and even laugh at what we endured. There will always be those flashbacks. Over the years a sudden, very loud noise close to me has resulted in my diving under a table or just freezing. Very embarrassing and yes the occa-sional bad dream still haunts me. Unfortunately in those far off days there was no such thing as counselling. Recent visits to the places significant in my war-time childhood have still affected me and still bring back strong memories.

The first ten years of my life were all really quite exciting though and as it was the only childhood I had known, I thought it was all very normal. I honestly did not know what was really going on. I understood in a way what was happening as I often listened with my parents to the BBC news on the wireless, in particular I remember very clearly that the news reader was Alvar Liddell. We heard Big Ben, as well as Winston Churchill and we heard how many ships had been sunk and how many enemy aircraft had been shot down. We even laughed at Tommy Handley in the ITMA comedy show. I even remember that ITMA meant 'It's That Man Again'. We heard songs like 'Run Rabbit, Run'. But, above all, I never really understood that this was not the normal way of living.

This short summary of my war is dedicated to the mothers, the aunts and grandparents who did not have to go to war, the war came to them and to us. They fed us, often going without food themselves, they bathed us and clothed us, they did the best they could for us under conditions that were sometimes

The demand on nurses was intense, particularly after air raids. Reproduced courtesy of Canda Images.

frightening, uncomfortable, restrictive, and often very dangerous. They did this unselfishly and always with a smile. In the end I have to say that 'There will always be an England' as my tribute to those adults who, during the dark days of the Blitz, worked so hard to keep and protect those of us kids who stayed in London and were not evacuated to the safety of the countryside.

My very final tribute goes to Dr Chou and the nurses who looked after me for many months I spent in the Roxbourgh Nursing Home, an annex to the Middlesex Hospital, and the amazing airmen of the RAF with whom I shared a ward. When my bandages were removed and I could see again I became the unofficial ward orderly and was privileged to be able to carry their tea to them.

Who will ever forget 'The Few'?

We, the children of the Blitz, have been able to live a full life thanks to them.

John Dickson, London

For re-enactors such stories as John's are inspiring and for many are the reason why they continue to keep the spirit of that era alive, in memory of all those who lived through such extraordinary times with grace and fortitude. Re-enactment is always keen to welcome in the younger generation and to encourage them to understand what children like John went through, so that they might reflect on how the differences between a wartime childhood and their own experiences.

14

THE BEGINNING OF THE END

The Second World War had lumbered by slow and painful stages for almost five years, when on the gale-swept evening of 4 June 1944, the Supreme Commander of the Allied Forces, General Dwight D. Eisenhower entered Southwick House.

Southwick House, a mansion near Portsmouth, Hampshire, had been requisitioned in 1940 for use as a naval establishment, accommodating pupils from the nearby Royal Navy School of Navigation on HMS *Dryad*, Portsmouth Naval Dockyard. Its role had gained prominence in April 1944 when Admiral Ramsay, the Allied naval commander-in-chief for Operation Neptune – the naval assault phase of Operation Overlord (the D-Day landings) – moved his headquarters to Southwick House. From here the plans for D-Day were devised, amended and dispatched to the units waiting along the south coast.

Steve Day, an instructor at the Tri-Services College in Southwick, Hampshire, is very knowledgeable about the history of base and he took time out to talk to me about the occasions when re-enactors are invited to support onsite activities organised for the benefit of both internal and external organisations:

Eisenhower had to make the monumental decision of whether to launch the greatest invasion in history or to delay and await a more favourable weather and tidal situation. Over 5,400 assault craft with 156,000 men had already been at sea for over 24 hours because of enforced delays caused by the worsening weather. Members of the Allied Command understood that the current high seas meant potential disaster for the beach landings along the coast of Normandy, but they also knew that a further postponement meant a return to port and refuelling for most of the ships. The next suitable date when tide and moon conditions would be right was the 19th June. The members of the Command waiting for Gen. Eisenhower were, Air Chief Marshal Sir Arthur Tedder Deputy Commander, Admiral Sir Bertram Ramsey Naval Commander, General Sir Bernard Montgomery Ground Force Commander, Air Vice Marshal Sir Trafford Leigh-Mallory Air Forces Commander, Lt. General Bradley, and Eisenhower's chief of staff, Major General Walter Bedell Smith.

Eisenhower asked each man his opinion. Leigh-Mallory urged a delay until 19 June, Tedder thought it 'chancy', Ramsey resolutely opposed it. Smith in contrast said that it was a gamble, but a good gamble. Eisenhower turned to Montgomery, 'Do you see any reason for not going Tuesday'. Monty looked Ike squarely in the eye and gave his answer: 'I would say go.' At 21.45 Hours, the Supreme Commander made a preliminary decision: 'I am quite positive that the order must be given.' But it could still be rescinded and the ships returned to safe harbour. Final approval would come after the 04.00 Hours, weather briefing.

So it was that at 04.00 Hours on 5 June 1944, the members of the Command gathered in the library and awaited the weather briefing that subsequently would change the course of history. That forecast was given by meteorologist Group Captain Stagg who had discovered during his observations that between the bad weather of the 5th and the next impeding low there was a small lull in the weather which would be enough to allow the invasion to proceed as planned. After a few minutes Eisenhower, who had been looking out of the window towards Portsdown Hill, turned to his staff and quietly, but firmly said 'OK let's go'.[7]

In a short while the map room become a hive of activity, this scene is depicted in a pen and ink drawing by Barnett Freedman which is displayed in the room.

7 Jerome M. O'Connor, MEMBER: American Society of Journalists and Authors.

One wall of the D-Day map room is dominated by a hand-painted plywood map of the coastline of southern England, the Channel and the coast of northern France stretching from Calais in the east to Brest in the west. It was created by the toy firm Chad Valley, which was commissioned to produce a map of the entire European coast-line from Norway to the Pyrenees. When the map was completed, it was transported to Southwick House; however, only the Normandy section was installed on the wall and the rest of the plywood map was burnt. To keep the location of the invasion secret and much to their surprise, the two carpenters and the escorting naval lieutenant were then promptly detained in the house until after the invasion had taken place.

Steve Day again:

In September 1944, Admiral Ramsay moved his headquarters to France, so not long after the invasion began the operations room and Southwick House were abandoned by the Allied Naval Command and the chairs, tables and charts just lay where they had been left. Little could be done to the exposed wall map and the ravages of time soon became apparent. Fortunately the historical importance of the Wall Map was recognised by the then Captain of HMS Dryad, Captain C.F.W. Norris. He, together with a small commit-tee and experts from the Portsmouth Naval Dockyard, set about erecting a glass case and internal lighting to preserve the map. It was decided that the most appropriate settings for all the icons and other markers representing the invasion forces should recreate the moment when the landings began on the British and Canadian beaches on D-Day. That was H-Hour on 6 June 1944. The restored wall map was unveiled on 7 August 1946 by Admiral Sir George Creasy in front of senior officers representing many of the services that took part in the invasion. The map remains like that to this day.

Today, when visitors come to Southwick House to view the map and the contents of the room, they are greeted either by a member of staff or a pre-recorded talk by Richard Baker. Our visitor groups are always small and this makes the presentation or commentary more intimate to the listener and they are able to quietly reflect on the monumental decisions that were made in the very room where they are gathered. This seems in keeping with and most appropriate for the intimate setting of the location. We continue to welcome visitors from some of the D-Day veterans groups and they come to see where the orders were given that sent them running up the beaches of Normandy under enemy fire. This of course triggers personal memories that are in keeping with the quietness and serenity of room itself.

On D-Day the map room which was already a hive of activity, was accelerated into even more industrious labour. Signals went from desk to desk, orders, messages and 'phone calls were continuous, the room was full of movement and noise. We pondered the question would the use of re-enactors to re-create events on that day as a Living History exhibit, add or detract from the feeling of the room? On a day-to-day basis, most personnel at Southwick Park think it would somehow detract and that's why the presenting staff wear modern clothing or military uniform. However, we do call upon the skills and expertise of re-enactors on occasions when the map room is been used to give a background ambiance to a bigger event.

The first of these occasions was in June 2009 when the BBC topical programme the One Show decided to air a live outside broadcast from Southwick House to commemorate the D-Day landings. Members of the Deco in Style re-enactment group were asked to dress the area in front of the map to look like a scene from 1944. This was done with 1940s equipment and memorabilia. The idea was to give the impression of, but not to recreate, how the room might have looked in 1944. The BBC had planned that the opening sequence was to be at the front of the house and they asked Steve Day if he could find a Second World War vehicle to place next to the front door. A Military Police jeep was subsequently loaned by a member of the Solent Overlord Executive Vehicle Club and because Southwick Park is now home to the Tri-Service Military Police College, three of our students wore period military police uniforms and manned the jeep.

Members of the Deco in Style group also wore period uniforms and acted as background 'extras' within the map room during the rehearsal and live transmission of the programme. Steve Day:

The feedback we received from both the onsite TV crew and the studio was very positive. They both commented that the use of the re-enactors on this occasion had enhanced the images of the map room as the story of D-Day unfolded during the live transmission. This gave us a positive feeling that the use of re-enactors had a place at Southwick Park. The next occasion came later that month when the charity Help for Heroes asked if they could use Southwick Park as the starting point for a new fundraising venture. The venture was a sponsored cycle ride named 'The Band of Brothers Cycle Ride'. The idea was to cycle the route taken by the men portrayed in the Band of

Brothers series from the beaches of Normandy on D-Day to the Liberation of Paris. As Southwick Park was the 'starting point' for D-Day it seemed the most logical starting point for the ride.

The house played host to 250 cyclists plus all their supporters, with map room talks for 60 people every 30 mins. Once again the re-enactors dressed the room for us so having had the room dressed on two occasions the question was, did visitors feel that it enhanced the ambiance of the room during the presentation? Well most, probably had no strong views on the subject, but one person certainly did! Depicted at the front of the pen and ink drawing by Barnett Freedman is 3rd Wren Officer Alison Gregory. Aged 91 Alison returned to Southwick House for the first time since 1944 as a guest of Help for Heroes. She had come to see her grandson take part in the cycle ride, but she not surprisingly took the opportunity to visit the room she left in September 1944. The room, as her visit began, only contained the re-enactors and as 'Wren' Officer Gregory came through the doorway, she stopped for what seemed like an eternity before she moved into the room. Talking to her later she told me that seeing both the dressed room and the re-enactors in period uniform took her back to that fateful day in 1944.

Police re-enactors at Southwick House with actor Ross Kemp during a special event at the D-Day map room. Reproduced courtesy of Steve Day.

In addition to the groups already used, a further group of re-enactors were asked to attend in a very specialist role. These were the Portsdown Artillery Volunteers who were using a cannon loaned to Southwick House by the Royal Armouries at Fort Nelson. The cannon was used as the starting gun and a single round was fired to start the ride. During this particular day, three separate re-enacting groups were successfully used to enhance the event and again the feedback received from all concerned was very positive. In addition to the female 'Wren' re-enactors creating background portrayals in the map room, other areas were put to good use by the male re-enactors who were dressed as officers from all three services. They gave a convincing presentation on the first hours of the land offensive after landing and securing the Normandy Beaches.

Following the success of the BBC D-Day programme from Southwick House in 2009, ITV Meridian contacted Southwick Park to arrange to transmit a programme from the map room as part of its anniversary coverage in 2010. The station also wanted to include in the broadcast, exterior shots of the house so they thought it would be a good idea to have a number of period vehicles in the background. The producer then decided that he would like the vehicles manned, so members of Solent Overlord Group were asked to wear period uniforms and become 'extras' during the filming. This was done with a minimum of fuss as most members already had uniforms stored in their support vehicles.

This proves the flexibility and 'can do' attitude that seems inherent in most re-enactors I have worked with. Again, the feedback from the TV company was very positive especially with the period crews manning the vehicles. The latest event that brought together Southwick House and re-enactors was the Help for Heroes sponsored cycle ride, entitled 'The Big Battlefield Tour Bike Ride' as it not only followed the 'Band of Brothers' route, but stopped at a number of war grave sites in Northern France.

By this time our regular re-enactors had the dressing of the map room down to a fine art and more importantly, the trust of the map room staff. This meant that they were able to give the map room its 1940s look in a very short time with the minimum of supervision. However, lessons learned from the first cycle event meant that extra re-enactors were needed to assist with the management of large numbers of visitors and the through flow of people in Southwick House. The services of Home Front History were called upon and their team stepped into the breach and assisted the in-house security personnel.

Steve Day closes by mentioning that:

Four events have now featured Southwick House and the re-enactors have been called upon to give the impression and feel of how the house and grounds might have looked when history was made her back in 1944. We do not set out to recreate the actual events that happened here, but we do try to enhance the visitors understanding of the role that Southwick House has in events of modern history. The feedback that we have had is very positive and proves that the use of re-enactors really does help to bring events to life and makes them more real in the visitors mind.

The collaboration of re-enactors and heritage sites has been highlighted throughout this book and is one of the many rewarding experiences of re-enactment.

15

BELLS RING OUT
ACROSS THE LAND

The view from the chin gun turret of the Flying Fortress B-17G was impressive for those used to it. For its current passengers however, lying face down on the floor of the aircraft, gazing at the view below, well, it was just something else to add to the wonder of the moment. The two .50-cal guns that normally formed part of the aircraft's impressive armoury had been removed to make enough room for two people to lie down in the space normally reserved for one to sit.

The passengers though were not interested in the capabilities of the aircraft, just that it was taking them home. It was over five years since they had left England, five long years during which they had seen things no one should ever have to see or to live through. Many frightening and brutal years had passed since they had last seen those they loved and since they could feel safe. It was over now though; life was going to begin again. There would be time to remember, now was for looking forward, to spending time with those who had waited, those who had never given up hope that one day they would come back.

The soldier gazed out through the Perspex window onto the sea below, unable to believe that he was finally going home. Later that day he would once again walk along the streets of London and then up the front path to his front door. Perhaps then it might be as if the last few dramatic years had never happened.

The sun played off the water creating patterns on the gently rolling waves. The circling sea gulls soared through the air, gliding on the currents as they hunted for fish. The scene was one of such peace and tranquillity that it had

a timeless quality to it, yet it was so different from his memories of the last time that he could hardly believe it was the same place. Ted fought back the memories that suddenly threatened to overtake him and instead forced himself to concentrate on the present. Soon he would be home, back in the arms of his Mum and his brothers and he would finally be able to marry Brenda, who had waited all this time for him.

Just thinking about them all bought a smile to his lips. It was only the letters from his family and Brenda that had kept him going month after month, year after exhausting year. He had been doggedly determined not to allow the camps with their regime of brutality and sense of desolation to break him. He had determined that he would survive and that he would eventually tell his story. The world should never be allowed to forget the madness that had engulfed it because by forgetting, it could allow itself to slip into that same madness again. Ted pondered, no one should ever forget the sacrifices they had made, the sacrifices of those who would never come back.

Ted Taylor, Rifleman, Calais Force, 1940

Ironing for the neighbours: sharing the community iron – the others have gone for scrap. Reproduced courtesy of Scottish Home Front.

We're going to hang out the washing. Reproduced courtesy of Nick Halling.

The re-enactment scene is rapidly growing around the UK and there are many events at which groups can display the 'military' aspect of life during WW2, but what happened at home back in those days?

Home Front Re-enactors come to the front of the picture in this respect. These groups are also growing in number, bringing a glimpse of the 1940s to our events. They show members of the public what was happening, how people lived, they tell us of the horrors of the blitz and also show us the brighter side like the dances, the friendships made and the romances. This was a time of great change for women in particular. These re-enactors help us all to learn of life on the Home Front.

Maryrose Mantle, Organiser, Armed Forces and Veterans Weekend, Trowbridge, Wiltshire

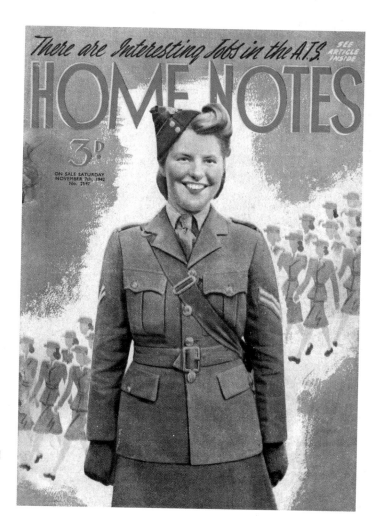

The ATS 'girls in khaki' played a significant role in keeping the Home Front protected and in supporting army logistics. From the author's collection.

Household chores were still a priority on the Home Front. Reproduced courtesy of Nick Halling.

Many women had a natural aptitude for driving, much to the surprise of the men folk. Reproduced courtesy of Nick Halling.

Victory inevitably bought challenges for individuals, families, the government, returning servicemen and women, returning POWs and for society as a whole.

The war proved that it was not bombs and guns alone that won freedom, it was also the spirit of a nation, the will of the people and the sheer patriotism and courage of every man, woman and child. A nation stood united against a foe in the belief that whatever the odds, victory would be theirs. The plight of those on the Home Front has been well documented, although many more stories have yet to emerge and many more anecdotes have still to be shared.

The war had witnessed great social change. For example, hundreds of thousands of women had been given full-time employment and with it some independence and some recognition of their skills and abilities. Traditionally relegated to the home and the kitchen, women now desired independence on a par with the men. Whereas after the end of the First World War, many female war workers simply accepted returning to their original domestic roles, post-1945 many women, who had a new-found sense of freedom, did not adapt well to returning to the old routines of keeping the home and the secondary status they had in society:

I returned from service with the ATS and I had made many friends, had a little financial independence, was quite free to come and go as I pleased within the parameters of the service life. I was restless and soon found myself work as a driver for a local company. Many women like me had gained confidence and realised how much of a contribution they could make, more than spending all day cooking, washing and keeping house. I met my future husband in 1948 when I was working. It was the best thing I did, deciding not to return home and to the old pre-war routines.

Ellen Walker, Glasgow

Men, too, found it difficult to settle back into the comparatively mundane work environments after the experiences of war and the camaraderie that forces life had shown them. Some signed up, only months after being discharged, while others went abroad to seek a new life; for the majority though it was very much a matter of 'doing the best you could' in what everyone recognised to be a new world. This was a world far removed from the pre-war years of the 1920s and 1930s, a world in which everyone would have to find their own way because they were no longer going to be given the step-by-step guidance to which they had been subjected for the previous six years. However, there was a general feeling that they were all

going to benefit from the new world. The industrial and technological advances made during the war years could now be adapted for the benefit of the masses; there was a rush to rebuild and a desire to destroy the imprint that war had left on the country.

Buildings and recreational areas that had been closed off to the public for the duration were now being restored back to the community, businesses started up at a rate of over 150 every week, old army vehicles bought from scrapyards were pressed into service once again, mobile grocery stores replaced for a time the corner shops and stores that had been destroyed during the war and there were mobile fish and chip shops and vans visiting towns and urban areas selling hot pies, faggots, peas and mash (an idea based on the WVS Pie Scheme which provided crews on remote anti-aircraft gun sites at least one cooked meal a day). Elsewhere, former RAF pilots got together, bought aircraft and operated as cargo and passenger ferries. Former wartime airfields, if the huts weren't already occupied by some of the bombed-out families from the big cities, became the base for new commercial enterprises:

> **One thing I do remember was listening to the church bells, at first they seemed very noisy, but when I realised they were playing a tune and it was a happy tune, then I knew that maybe we could once again find happiness despite all the heartbreak of war.**
>
> Joy Siddal, Staffordshire

British children, young enough to adapt but old enough to remember, now somewhat hardened by their experiences, spent hours searching for used cartridges, old tin helmets, badges, pieces of aeroplane, anything that was a relic of the war they had lived through and survived. Bomb sites, most cleared of the debris, were playgrounds and brick-built shelters became dens and secret hideouts. Car lots appeared all over London and other large cities, set up by sharp-suited gents with the 'gift of the gab'. In the immediate post-war years it wasn't possible to buy new cars as they went for export, so second-hand car lots were the only option for those who had the money to spend. Local children were often given a few pennies to wash the cars, but the kids were as quick at turning a trick as the car salesmen were. They returned when the car lot closed in the evening before tea and sprinkled the cars with brick dust, which increased their chances of earning money the next day:

When I went to visit my granddad in Walthamstow, I used to meet up with a lot of the local kids and we used to go on treasure hunts. It was quite easy to walk the length of any street and under bushes and in front gardens we used to find old cartridges and I remember finding a helmet with the letters FAP still clearly marked on it. We used to knock on the door and ask if we could take what we found, most people were happy about this and in all the time we were collecting, we amassed quite a lot of stuff. At the back of my grand-dad's house was a scrapyard which had been set up at the end of the war. It was right at the side of the railway and trains used to stop and offload tons of metal. We used to be allowed into the yard sometimes and we were allowed to take one item each, I got a really large shell casing which in later life I polished up and used as a doorstop. At the entrance to the scrapyard was a little memorial stone with an inscription to a pilot who had steered his plane away from the houses when he was shot down early in the war.

John Whitmore

The BBC, which had established itself as not only the prime source of news (albeit censored) but also as the pioneers of boosting morale and keeping the spirits of the nation high through its daily delivery of music, songs, readings, short plays and outside broadcasts such as 'Workers Playtime', now felt it could share, not just the entertainment, but also its opinions:

The most hopeful thing in the world today is the zest and eagerness with which the British people are arguing about the future. The controversies, even the squabbles, now proceeding are an astonishing tribute to the stamina of this nation in the sixth year of a grim and arduous war. The British people might be excused if they felt a trifle tired, if they had come to the conclusion that victory in itself was enough. But, not at all. Victory is now everywhere recognised as only a beginning. It is the great preliminary. It is what we manage to build following the exertions of these six long years that really matters.

M. Haley, Radio Industries Club, 1944

Meanwhile, Sid Field, actor, singer and comedian, had been singing his heart out to audiences across the nation. Known widely for his stage character of 'Slasher Green', the spiv, one of his most enduring recordings, which was also sung by stars including

Zoe Gail, was played repeatedly from the lifting of black-out regulations through until the end of the war and the victory celebrations:

I'm going to get lit-up when the lights go up in London
I'm going to get lit up as I've never been before
You will find me on the tiles
You will find me wreathed in smiles
I'm going to get so lit up I'll be visible for miles
The city will sit up when the lights go up in London
We'll all be lit up as the Strand was, only more, much more,
And before the party's played out
They will fetch the Fire Brigade out
To the lit-est up-est scene you ever saw

Also, just as there were songs of victory, so too were there recipes, most popular of which, ingredients permitting, was victory cake. There were many different types of victory cake, but this recipe doesn't use eggs or milk, and only a small amount of butter:

Ingredients:-
2 cups of seeded raisins, 3 cups flour, 1 tsp baking soda, 1 tsp baking powder, ½ tsp Salt, ½ tsp Allspice, ½ tsp cinnamon, ¼ tsp cloves, 2 cups of cold water, 3 tbsp butter, 2 cups sugar, 3 tbsp cocoa.

Instructions:-
Boil together the butter, seeded raisins, sugar, and cold water for five minutes and then put to one side to cool. Sift together all dry ingredients, then add the boiled liquid ingredients and mix together until blended. Grease and dust with flour a 10in. tin, pour the mixture into the tin and bake at 350°F/Gas Mark 4 for 1½ hours. Cover the cake with foil for the last ½ hour to prevent burning. Candied Cherries may be added, if available.

'The result is a lovely moist cake, just what you need for a Victory party and it smells lovely too!' (as per the advertising!)

Practical demonstrations and displays are very much part of the re-enactor's presentation. Reproduced courtesy of B.J. Wilson.

As soon as the news was out on V.J. Day, that it was all over, we finished what was prepared that day in the bake house, baked it and left anything else! We all went, the men that is, to 'The George' in Moor Lane, Crosby. It took them all their time to supply the demand for drinks. I was on my bike and left it in the porch unlocked, you didn't need to lock things those days. When 3 o'clock came they all lined up and watched me set off. I did a lap of honour on my bike, a victory roll and shot off home. It was good job that there wasn't much movement on the roads.

Bill Billington

★★★★

June 1946, I am just out of uniform, In the Strand I meet a friend whom I haven't seen for eight years. I shoot out my right hand to grasp his. I encounter nothing, his right arm has been shot off. I meet another man who greets me. I don't recognise his face, only his voice, he has a new nose, chin, left ear, eyelids,

and lips, given him after twenty-six operations by Archibald McIndoe the plastic surgeon. His plane 'brewed up'. It's difficult to tell, but I think he is smiling.

Alan Jenkins, London

★★★★

However, we did make some good evacuee friends who we met when they were in between destinations. They came from Hounslow and we stayed with them for the VE day celebrations in London. We saw Churchill and Montgomery at Buckingham Palace and fireworks over the River Thames.

Graham Roberts, Crewe

★★★★

The one thing that really lifted my spirits above everything else during those amazing days of celebration was the sound of church bells ringing out across the countryside and now instead of being a warning of invasion, the bells were being rung in happy, joyous times and I suppose they reflected how we all felt, free of the struggle of war and the chance now to look ahead to a better future.

Pauline Winters, Manchester

It is now nearly seventy years since VE Day was celebrated across Britain, but that wartime spirit lives on and it is from the substantial heritage of the war years that re-enactors take their inspiration to present, in the best way they can, a glimpse of those times and those people, and to carry forward that legacy. Anecdotes such as those published in this book contribute towards creating portrayals and strengthening the knowledge which re-enactors, in turn, pass on to new audiences.

Annie Andrews and her mother Jan have pooled their love and knowledge of re-enacting and are now partners of 'A Vintage Life' which is devoted to recreating 'scenes from the past'. Annie, whose portrayals include stylised pin-ups, explains:

We make it our job to consider and develop every aspect of organising and delivering shows and 1940s dances as well as television productions, to make them as realistic and as believable as possible. We strive to ensure that each and every aspect of our work, no matter how big or small, is accurate.

On a regular basis, we organise special events to help charities raise funds that will go to support veterans, ex-service men and women and those who are currently serving in the Armed Forces. Yes, we organise everything, from bunting and sandwiches to music and vehicles, we want to be sure that every detail of our wartime history on the Home Front is never forgotten. 'Make Do and Mend', 'Keep Calm and Carry On' and 'Dig for Victory', these are phrases which are as well known today as they were during the war and this is primarily due to the interest in the 1940s. Interestingly, today at a time

when our money doesn't stretch as far as it used to, we find the entire nation constantly making reference to wartime Britain. This in many ways can only be a good thing, if not for the helpful money saving ideas and recycling, then certainly for the fact that people are still aware of how our nation lived during the war and what tips and guidance we can take from that generation.

It is not just specific aspects of that time that we need to remember. The world was an entirely different place back then and it is our responsibility as re-enactors to ensure that all aspects of the Second World War are never forgotten. Without the current community of re-enactors using their knowledge and passing on valuable information, the challenging times of 1939–1945 would soon be forgotten and the valuable lessons, the knowledge and the heritage, lost forever.

Savings groups were established and encouraged by the government as a way of dealing with the austerity of wartime and the post-war period. From the author's collection.

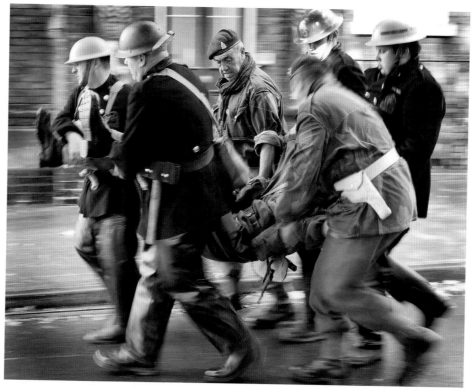

Everyone lends a hand very much as they would have done on the wartime Home Front.

Jolly decent weather for camping. Another aspect of civilian re-enacting and an example of the lengths re-enactors go to achieve authenticity. Reproduced courtesy of B.J. Wilson.

Be they in uniform or in 'civvies', be they rich or poor, be they working on the land or in the factories, be they young evacuees or young pilots, be they members of the Home Guard or members of the rescue squads, every sector and group in wartime society is being portrayed somewhere in Britain today. The opportunity to bring those portrayals to the public, and especially to the generation for whom the war years are still within living memory, will almost certainly mean being part of one of the many 1940s events in the annual calendar from Jersey to Troon, from Pickering to Detling, from Northern Ireland to Exmouth and from Barry in Wales to Headcorn. Managers at two of the country's premier venues are delighted to endorse the role of re-enactors:

Weymouth and Portland has a rich and fascinating history dating back several hundred years, this history combined with its historic buildings and back-drop makes it an ideal location for storytelling and a great opportunity for re-enactors to bring history alive. The historical structures and buildings

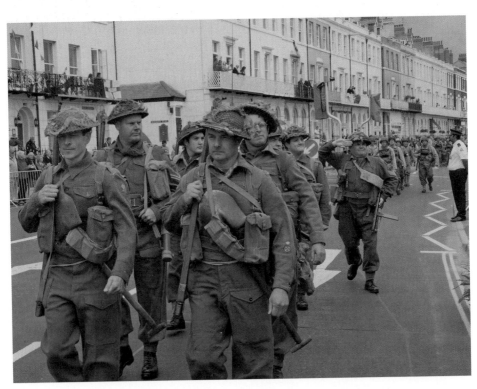

Re-enactors take part in parades across the country. This is the Veterans' Week parade in Weymouth. Reproduced courtesy of Weymouth and Portland Council.

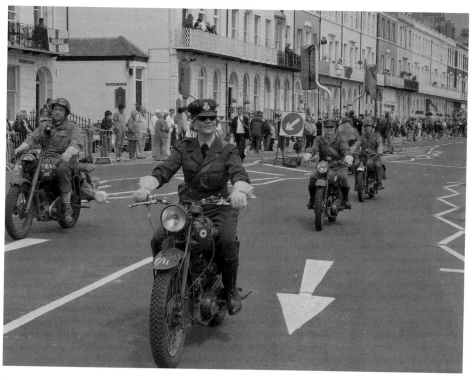

Dispatch riders representing the many men and women who served in this important role.
Reproduced courtesy of Weymouth and Portland Council.

throughout the Borough including the seventeenth-century historic harbour,
Nothe Fort, Georgian Seafront, Tudor House, churches and castles create a
wonderful backdrop for re-enactments, battles and parades. These events,
including our annual and highly successful Veterans Week, are embraced by
a wonderful enthusiastic local community and thousands of annual visitors
and make this an ideal location for re-enactment groups. The borough has
a strong association with many resident and visiting re-enactment groups
which present a colourful and fascinating opportunity to bring history alive
for the present generations.

Steve Davies, Promotions and Events, Visit Weymouth

In 2006, Chatham Historic Dockyard Trust introduced a new event at the Chatham
Historic Dockyard. Taking place in September each year, 'Salute to the '40s' has
grown to be one of the best events of its kind in the south-east and amongst the
premier 1940s events in Britain in just six years. Anthony Morse, its organiser, says:

A realistic demonstration of firefighting at Chatham Historic Dockyard which hosts many re-enacting displays during its 1940s events. Reproduced courtesy of Chatham Historic Dockyard.

The Historic Dockyard Chatham, itself much unaltered since the 1940s and almost like a film set, is brought alive by the vehicles, uniforms, music and activities of Britain at War. Military and Home Front re-enactors, wartime vehicles, music and dance recreate the historic events and activities that saw Britain through the war years. The dockyard's own air-raid shelters are open for tours and the siren sounds at regular intervals during the event adding to the 'real' atmosphere that is created.

Much of the success of Salute to the '40s is due to the way in which the organisers at the Trust engage and work with both civilian and military re-enactors to present an interesting, exciting and educational event for the public who visit to enjoy. The underlying concept and presentation for Salute to the '40s is 'Life on the Home Front'. The event does not in any way glorify war but recognises the sacrifice, commitment and sheer determination of those left at home as much as those on the frontline. Civilian re-enactors, therefore, play a very significant part in presenting the ways in which the home fires were kept burning and depicting scenes of everyday life during the

Civilian re-enacting has become more popular in recent years. Fashions of the era are reflected by these smart chaps. Reproduced courtesy of Robert Baker.

difficult and challenging wartime years. At the 2011 event a wonderful village square was set up with shops, post office, and mobile laundry, garage and even a clock tower which was a great success with visitors. Military re-enactors obviously have a major part to play whether with military vehicles for scene setting and being part of the convoys which drive through the site each day, or by setting up their encampments and scenarios relevant to the group they represent. All of this is vital to visitor's overall enjoyment of the event.

There are also a growing number of both civilian and military 'promenaders' who are not part of an organised re-enactor group and don't set up displays, but are content just to add a sense of reality, 'set-dressing' and bring the event alive by walking around engaging with each other and the public too, to brilliant effect. Members of the public are now visiting Salute to the '40s in vintage attire to really enter into the spirit of the event! Another significant element of 'keeping up morale' during the wartime years was entertainment for both the troops and those at home. Salute to the '40s recognises this with a full programme of music, dance and variety acts by some of the best '40s entertainers in the business. Some are programmed on one of the performance stages whilst others are more roving in nature as they sing, dance and generally entertain amongst the crowds.

It is so important that the re-enactors, entertainers and organisers work together to present an event that attracts and entertains the visitors. Chatham Historic Dockyard Trust is a charitable trust and Salute to the '40s is a fundraising event, therefore it is important to attract paying visitors in good numbers. They all expect a 'good show'. Whilst organisers accept that re-enactors do what they do best and have excellent knowledge of their particular group and activity, re-enactors must also recognise that the event is not their playground to do what they like when they like. Working together, under the careful direction and control of the organisers leads to a successful event from everyone's point of view, perhaps most importantly that of the paying visitor.

One of Chatham Historic Dockyard Trust's core objectives is to educate the public in the historical significance and importance of the Historic Dockyard Chatham. Organising an event such as Salute to the '40s and working with re-enactors is just one of the ways the Trust works towards meeting this objective.

Anthony Morse, Hospitality, Events and Group Trade Manager

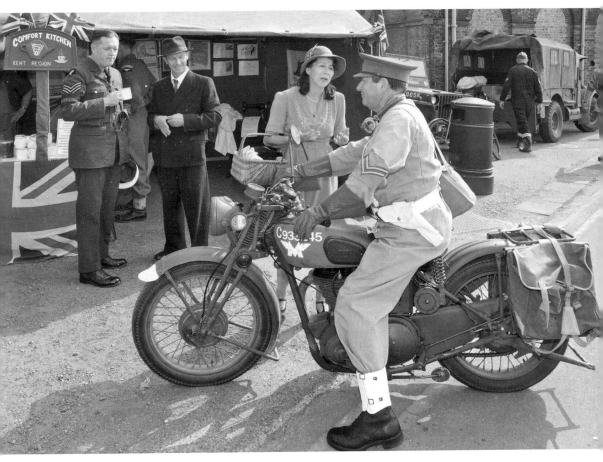

A civilian in conversation with a passing military policeman. Reproduced courtesy of Chatham Historic Dockyard.

For all the anecdotes, the stories, the news footage, the books and the television programmes about Britain's Home Front, we will never be able to understand fully and appreciate exactly how that generation was able to survive what seemed to be overwhelming and insurmountable odds. Words alone cannot describe and explain. However, their legacy perhaps we can better understand, for whatever we do today is created out of and from the freedom we all tend to take for granted. We cannot put a price on that, but what we can do is what we do well: 'Respect and Remember'.

Re-enactment by dedicated groups and individuals is a tangible and accessible mechanism by which we continue to remind our fellow citizens of the debt we owe to so many. To those who made the ultimate sacrifice, those whose endured the bombings of towns and cities across the country, the children taken from their parents and handed to strangers, the men and women in the intelligence services,

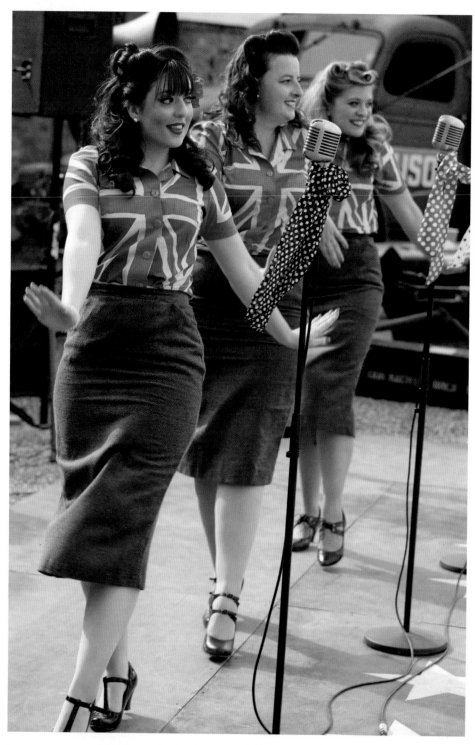

Impromptu concerts were a boost for the morale of the public and the services alike.
Reproduced courtesy of Chatham Historic Dockyard.

Remembrance passes from one generation to the next. Reproduced courtesy of Canda Images.

the factory workers, the builders of aircraft, ships and vehicles, the Home Guard, the welfare services, the emergency services, the merchantmen, the armed services of Britain and her Allies, the people who kept the transport running and dug the coal and to everyone else who played their part:

To forget would be to deny our history, to deny a generation, to deny those that made the ultimate sacrifice and this would mock our very existence in a free society.

Tom Naylor, Veteran, Manchester

They shall not grow old
As we that are left grow old
Age shall not weary them
Nor the years condemn
At the going down of the sun, and in the morning
WE WILL REMEMBER THEM

EPILOGUE

'SHE WOULD MAKE A
DAMN GOOD SOLDIER'

I consider it most appropriate that the closing words should be those of a person who is synonymous with life on Britain's Home Front, synonymous with keeping remembrance in the minds and hearts of our nation and whose energy, spirit and humanity remain an inspiration to us all. Just as millions of people were inspired by her songs during the war years, so too millions have been inspired in the decades since. Her songs comfort, excite, calm and cheer. She has remained one of this country's most accessible personalities, always happy to meet the public, always happy to answer questions and always happy to talk about the wartime spirit at home and on her visits overseas.

Her tireless energy and her personal appearances have given hope and raised smiles across the world, none more so than her wartime visit to Burma when she met the men of the Fourteenth Army, the 'Forgotten Army':

'C' Company 7th Worcestershire Regiment and the rest of the men of the 4th Brigade were divided in their opinion of her voice, but not after that hot steamy evening in 1944 in the Burmese jungle, when we stood in our hundreds and watched a tall, fair haired girl walk on to a makeshift stage and stand beside an old piano. It was Vera Lynn. She had travelled all that way with E.N.S.A to entertain our troops in the Far East. She sang half a dozen songs in a strong clear voice. We could hear every word. She tried to leave the stage, but men were clapping and cheering. She sang three more songs, but still they

went on cheering. She started to sing again, but whenever she tried to stop, they yelled the name of another tune. She sang until her make-up was running in dark furrows down her cheeks, until her dress was wet with perspiration and her voice had become a croak. She was the only E.N.S.A star we ever saw in the jungle. There were a lot of men who were grateful to Vera Lynn for having remembered them so far from home and for providing that evening of entertainment. As one of the lads said, 'With a couple of weeks training, she would make a damn good soldier'.

<div align="right">Unknown Diarist</div>

In contrast, a member of the audience at one of Vera's concerts on the Home Front said:

Vera seemed to embody all that we were going through. She was one of us, with her songs she helped to lift our spirits and take us away for a while from everything that we were having to deal with. She was certainly a ray of sunshine and made that audience so happy. What a wonderful person and a great asset.

<div align="right">Marjorie Unwin</div>

My conversation with Dame Vera was as fascinating as it was thought provoking; however, there are just a few of her words I would like to share here as a fitting tribute from a true 'British legend':

Remembrance Day, or as we used to call it Armistice Day, is very important not only because of those who died, but also for those who have suffered and still suffer today as a consequence of the war. They were the people who laid the foundations for today's generation. There were also many advances made in adversity like plastic surgery and the improved use of penicillin which came out of the war. It is important that we all remember our history and it is the re-enactors that help to make sure we never forget.

<div align="right">Dame Vera Lynn</div>

Re-enactors Sandy Pavard and Leigh Boys (left) meet with Dame Vera Lynn during one of her rare personal appearances at a 1940s event. From the author's collection.

Dame Vera Lynn DBE, LLD, MMUSs

Singer with the Ambrose Orchestra, 1937 to 1940, then subsequently went solo. She starred in *Apple Sauce* at the London Palladium in 1941 and had her own radio show called 'Sincerely Yours' from 1941 to 1947. Vera Lynn was voted most popular singer in a *Daily Express* competition in 1939. She was acclaimed the 'Forces' Sweetheart' by the troops during the Second World War and toured Egypt, India and Burma.

Among her many awards and accreditations, Vera was BBC Woman of the Year 1994, she won the Spirit of the 20th Century Award 2000, the Lillian Keil Award for Outstanding Service to the Allied Cause by a Woman in WW2 and was made an Officer of the Order of St John (OStJ) 1998, and was awarded the Dutch War Veteran Medal in 2010.

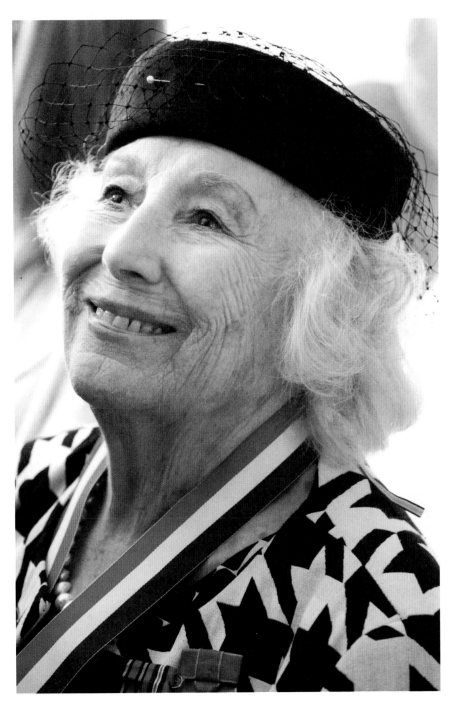

Dame Vera Lynn. Reproduced courtesy of Zoë Norfolk.

GETTING INVOLVED

United Kingdom Home Front Living History

This list contains a selection of useful contacts. Further listings and information can be obtained by emailing: homefronthistory@btinternet.com or by visiting www.40s-events.co.uk.

HM Queen Elizabeth, the Queen Mother
Tel. 01304 204646
www.homefronthistory.co.uk

George S. Patton Appreciation Society
www.georgespatton.co.uk

Iain Dawson
vivthespiv@hotmail.co.uk

roofoverbritain@btopenworld.com

Martin Struick & Jenny Hutchinson
www.candaimages.com

Ade Pitman
www.warco-photography.co.uk

A Vintage Life
(Annie and Jan)
avintagelifeteam@gmail.com
www.avintagelife.com

brian-a-marshall@supanet.com

www.barryjameswilson.co.uk

www.guychanningphotography.com

www.livinghistorypix.com

Nick Halling Photography
nickhalling@blueyonder.co.uk
www.nickhalling.co.uk

Veterans' Week
The Pavilion
The Esplanade
Weymouth
Dorset
DT4 8ED
Tel. 01305 785747
www.visitweymouth.co.uk

The Tank Museum
Bovington
Wareham
Dorset
BH20 6JG
Tel. 01929 405096
www.tankmuseum.org

Derek Herbert
Mr Churchill
Tel. 01513 368345
www.churchill-lookalike.com

Time Travel Team
Tel. 07984 969162 / 07901 528849
www.timetravelteam.co.uk

Timescape 1940s Singers
Tel. 07747 848203
www.timescape.synthasite.com

AFS and NFS Re-enacting
david@lowdhamstation.me.uk
www.nfs-afs.org.uk
www.nottsfirefightermemorial.org.

Chatham Historic Dockyard Trust
The Old Surgery,
The Historic Dockyard,
Chatham, Kent
ME4 4TZ
Tel. 01634 823800
www.thedockyard.co.uk

514 QM Truck Regiment
www.514th.co.uk

War Years Remembered
www.waryearsremembered.co.uk

Yesterdays Heroes
www.yesterdaysheroes.org.uk

Wartime Living History Association
www.wartimeliving.co.uk

Home Front History
www.homefronthistory.co.uk

The Real Dads Army
www.therealdadsarmy.co.uk

Autumn 44
www.autumn44.org.uk

Screaming Eagles
www.screamingeagleslhg.co.uk

16 Parachute Field Ambulance
www.spanglefish.com/16parachutefieldambulnace

21st Army Group Provost
the21starmygp@aol.com

25th Bomb Disposal RE
www.25thbombdisposalcorelhg.webden.co.uk

Allied Assault 44
Tel. / Fax: 01692 403158

Gressenhall Farm and Workhouse
Tel. 01362 860563
gressenhall.museum@norfolk.gov.uk
www.museums.norfolk.gov.uk
Tel. 01394 275542
catherine.stafford1@ntlworld.com

Debbie Curtis Radio Big Band
dcrbb@btconnect.com
www.debbiecurtis.co.uk

2nd Armoured USMP
armouredusmp@aol.com

29th Infantry Division
www.29th.co.uk

2nd Battalion Royal Ulster Rifles
www.2ndbattalionroyalulsterrifles.com

Blandford Boys 1st Airborne Div. Signals
www.blandfordboys.org.uk

Glamorgan Home Guard
www.glamorganhomeguard.webs.com

Home Guard
www.home-guard.org.uk

Lovat Scouts
www.averyspecialregiment.co.uk

Poor Bloody Infantry
www.poorbloodyinfantry.org.uk

Soldier Blue
www.soldierblue.homestead.com

South Wales Borderers WWII Re-enactment Group
www.re-enactmentww2sweb.co.uk

Spirit of Britain
www.spiritofbritain.net

The Cameronians Scottish Rifles
www.cameronians.com

The Garrison
www.thegarrison.org.uk

Victory in Europe Re-enactment Group (VERA)
www.vera.org.uk

Military Vehicle Trust
www.mvt.net

The Rifles Living History Group
www.c20warfare.org

Home Front Friends
www.homefrontfriends.org.uk

The Forties Family
www.the-forties-family.freeservers.com

UK Home Front
www.ukhomefront.co.uk

Northern Forties
www.nothernforties.ork.uk

Air Raid Shelter Enthusiasts
patterns3@blueyonder.co.uk

Northern Ireland WW2 Living History
www.wartimeliving.co.uk

Scotland
www.combinedops.com

South-west England and South Wales
www.wwiireenactmentsouthwest.co.uk

Wales 53rd Welsh
www.53rdwelshdiv.webs.com

The War and Peace Show
Beltring
Kent
www.thewarandpeaceshow.com

Military Odyssey Show (Multi-Period)
Detling
Kent
www.military-odyssey.com

Additional listings for groups, events, entertainers, museums and venues – indeed all things 1940s – www.40s-events.co.uk.

Information correct at time of going to print. The publishers cannot accept responsibility for the accuracy or content of third-party websites.

The poppy symbolises remembrance. Reproduced courtesy of Ade Pitman.

ABOUT THE AUTHOR

John Leete is an accredited journalist and author with published works about life on Britain's Home Front during the Second World War. His interest in re-enacting spans over twenty years during which time he has advised television and filmmakers, and given support to a number of high-profile living history and veterans' events.

He writes regularly on the subject and also gives talks about life on the Home Front. His preferred portrayal is that of a civilian police officer; however, he also portrays other characters, including a Redcap and a Royal Navy officer.